GW01445146

To Dad + Dessie
Good Reading
Lots of Love
Darnell

BANC

STAN SARRIS RODNEY ADLER

RECIPES LIAM TOMLIN
PHOTOGRAPHY ADRIAN LANDER
EDITOR JUDY SARRIS

FOR OUR DADS,
GENTLEMEN WHO LOVED
GOOD FOOD

NEW
HOLLAND

First published in Australia in 1999 by
New Holland Publishers (Australia) Pty Ltd
14 Aquatic Drive, Frenchs Forest, NSW 2086, Australia
218 Lake Road, Northcote, Auckland, New Zealand
24 Nutford Place, London W1H 6DQ United Kingdom
80 McKenzie Street, Cape Town, 8001, South Africa

Produced by Eaternity Pty Ltd, Level 11, 5 Elizabeth Street, Sydney 2000

Concept: Stan Sarris
Editor: Judy Sarris
Recipes: Liam Tomlin
Text: Judy Sarris, Liam Tomlin, Chris Muir
Photography: Adrian Lander
Design: Jenny Pace
Copy Editor: Peter Wilton

National Library of Australia
Cataloguing-in-Publication data

Sarris, Stan
Banc
Includes Index

ISBN 1 86436 569 2

1. Banc (Restaurant). 2. Restaurants – New South Wales –
Sydney. I. Lander, Adrian. II. Adler, Rodney III. Tomlin, Liam.
VI. Sarris, Judy. V. Title

647.659441

Publishing General Manager: Jane Hazell
Publisher: Averill Chase
Reproduction: Colour Symphony
Printer: South China Printing Company

CONTENTS

PREFACE

Giving birth to a restaurant is rather like giving birth to a child. The conception is a lot of fun. It's wonderful conjuring up in your mind's eye what your creation might look like. At this stage anything is possible. There are no boundaries to your imagination — just endless dreams in your head.

The gestation period, however, has its ups and downs. You feel so warm, so positive, when you discover your new charge has hidden treasures such as a grand, high ceiling hidden under a false one, or when you watch the crumbling marble pillars reinstated to their former glory. Other times you feel sick in the stomach when you find there's not enough room to build the kitchen you'd hoped for, or when the builders drill through a water main. Like all periods of creation, some days are diabolical and others provide moments of pure joy.

Then comes the real labour — pulling all the pieces together to be ready on time and meet the outrageous deadline you have set yourself. This is when tempers are stretched and exhaustion sets in. As the finishing touches are put in place, team members tolerate each other's ill-humour, and buoy one another with words of encouragement.

It's nearly time for the opening. Everyone is nervous. Will the place be well received? Is the food really all right? What if no one turns up? What if the staff lets us down?

At last it happens. The doors open and the people flood in. The force of life is breathed into the walls, and a new restaurant is born.

– Stan Sarris, Sydney, NSW, Australia

FOREWORD

Every once in a great while I encounter something magical in a restaurant. This was absolutely the case with my one and only visit to *Banc*. (I simply must find a way to get back.) Everything came together in perfect harmony — original and superbly crafted food, sincere and strikingly attentive service, brilliantly chosen and served wines, and an utterly provocative and exuberant atmosphere. The result was an experience greater than the sum of the parts. Indeed, it was transcendent.

This is the kind of place you are excited to tell people about: they will quite simply be overwhelmed! The opportunity for more *Banc*, though, can now be had merely by immersing oneself in these pages, thereby encountering a virtual day behind the scenes.

This stunning work is as electric as the restaurant itself, modern and timeless simultaneously. Chef Liam Tomlin's passion and personal cuisine jumps out more with each ensuing chapter, allowing the reader to observe a true maestro.

And the daunting efforts and energies of Stan Sarris and Rodney Adler can be felt as well, for they exquisitely round out the *Banc* leadership team, perfectly pulling the strings and leading the troops onward and upward through another day in the most demanding of professions.

I do have one criticism of the book, however. Every time I thumb through it, I am cruelly reminded that I am sitting at home — not in *Banc*!

– Charlie Trotter, Chicago, Illinois, USA

One warm afternoon in late November, 1997, Rodney Adler who, at the time, was CEO of FAI Insurance took two phone calls from a real estate agent. One of the calls was destined to put him on a path he never imagined he would walk. The agent had been retained by the Overseas Union Bank to lease their unused, street-level premises in Sydney's CBD, at 53 Martin Place. The first of her calls to Adler was to confirm the financial detail of a restaurant development package that had been put to the Singapore-based company by restaurateur Stan Sarris.

Would Mr Adler please confirm that he was personally funding the project, and guaranteeing the funds for the proposal?

"I am indeed supporting Mr Sarris, and yes I do guarantee the funds," was the cool and succinct reply from a man who was obviously used to making multi-million-dollar decisions.

The real estate agent hung up, happy.

A minute later the same, but somewhat confused, agent was back on the line. Would Mr Adler please confirm that he was personally funding and guaranteeing the funds for another consortium which was after the same site.

"It has my full support, and yes I am guaranteeing the funds," replied Mr Adler, without even a hint of irony in his voice. "By the way," he continued, "are the two proposals you have mentioned the only ones being considered?"

"Yes," replied the confused agent. You could almost hear her scratching her head on the other end of the line.

Delighted with the news, Adler phoned Sarris to share it with him.

Sarris, although pleased he had come so far, after lobbying for the site for many years, decided to reserve his enthusiasm until a final decision had been made. Adler by comparison was positively up-beat.

"Stan, I don't know about you, but I can't lose," he continued gleefully, fully aware that his innately shrewd business acumen had paid off once again.

A few weeks later, Sarris won the bid for 53 Martin Place, and, of course, so did Adler — the difference being, he had already celebrated, but now it was Sarris's turn to uncork a fine champagne.

So began the odyssey to create a restaurant, that only a few months later, would change the face of the Australian culinary landscape and attract attention from around the globe.

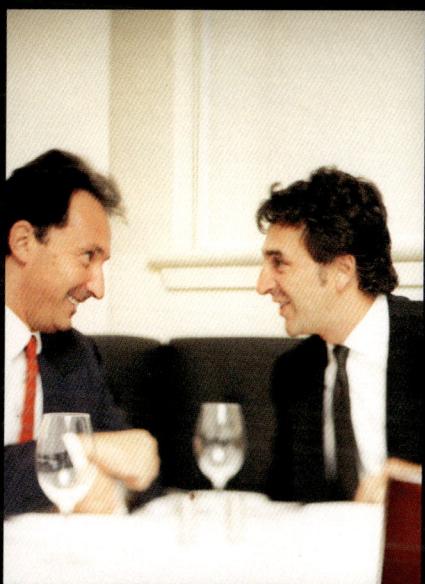

RODNEY ADLER & STAN SARRIS had known each other for 15 years. Nevertheless, up until late 1996, it hadn't occurred to either of them to go into business together. It all began when Sarris, an established restaurateur, needed extra funds to buy out a silent partner. He fronted up to see Adler, then CEO of FAI Insurance, to try and arrange a loan.

Unfortunately, restaurants were not something FAI wanted to be part of, but Adler was impressed by Sarris and his passion for the food industry. He offered to personally go into business with him. Obviously, Sarris's current project had too much baggage, but if something turned up in the future, Adler would be interested.

Four months later, Sarris was back in Adler's office, free from his previous commitments and with not one, but two new projects under his arm. To cut a long story short, their joint venture company, The Eaternity Group was born.

After acquiring the premises at 53 Martin Place, the building of *Banc* was their first major project, and one that is an outstanding success. But *Banc* was only their launching pad into every aspect of the food, leisure and entertainment industry.

As Adler explains, "Our retail outlets such as *Banc*, *Wine Banc*, and *The Mint Room* have allowed us to build a credible brand name. We can use them to make a statement about our quality, and prove we're good at what we do. Further down the track, when we move into other areas of the food, wine and lifestyle industry, we will have a strong and respected branding behind us. We just happen to have chosen restaurants and bars to start our venture."

The big picture for The Eaternity Group is based on alarmingly simple logic. As Sarris explains, "When we kicked off, the Sydney city leisure and entertainment infrastructure simply didn't exist, but the pent up demand was there. It's simple Keynesian economics — find demand and create supply."

When building *Banc*, with its timeless elegance and exceptional food and service, Adler and Sarris had the foresight to grab the right location at the right time, and to create a concept that capitalised on people's changing lifestyles. They have since dissected the market further. Almost as soon as *Banc* was built, there was an obvious need for *Private Banc*, their two private dining rooms, catering for larger parties of diners and corporate functions.

But first they created *Wine Banc*, a subterranean bar oozing with New York chic, and attracting a sophisticated crowd. More recently, at the same time as building *Private Banc* they created *The Mint Room*, a sexy London bar

LIKE THE THEATRE WE HAVE TWO SHOWS A DAY **STAN SARRIS**

environment that stays open until late and caters for a younger market.

Adler and Sarris have also substantially expanded their interests outside the *Banc* building. At the other end of Martin Place they snapped up the lower ground floor of the old Sydney GPO building in which they created a mammoth food hall, three new restaurants and a bar. But that's another story.

Adler readily admits that Sarris is the brains behind the inspiration and creation of their operations.

"This is all Stan's doing, I give my advice for what it's worth, but being a restaurateur is not my strength. This guy is a 'Restaurant Impresario'. He has more ideas in five minutes than most people have in a lifetime.

Sarris, on the other hand, considers Adler a financial whiz and a genius at clinching the deal. He also admires his innately astute skill of picking a winner.

"Rod has the uncanny knack of picking the right person to do business with, then backing them all the way. I've seen it pay off for him time and time again, no matter what industry he becomes involved in."

With this kind of synergy it is not hard to understand why a partnership born out of adversity, is as solid as a rock.

BANC STAFF

Stan Sarris likes to compare running a restaurant to a theatre production.

"Like the theatre we have two shows a day, we have a matinee and an evening performance. As with a stage, we too create a perfect set with players performing their various duties on cue. There are also the people behind the scenes, who you never see; but without them, the show couldn't go on."

On these pages we'll introduce you to the cast working at 53 Martin Place. They come from far and wide, many bringing with them expertise gained in the best kitchens and dining rooms in the world, others bringing knowledge from the vineyards, or the cheese-making areas of France. Highly trained in the art of food and wine, they are a team, and they take their chosen profession seriously.

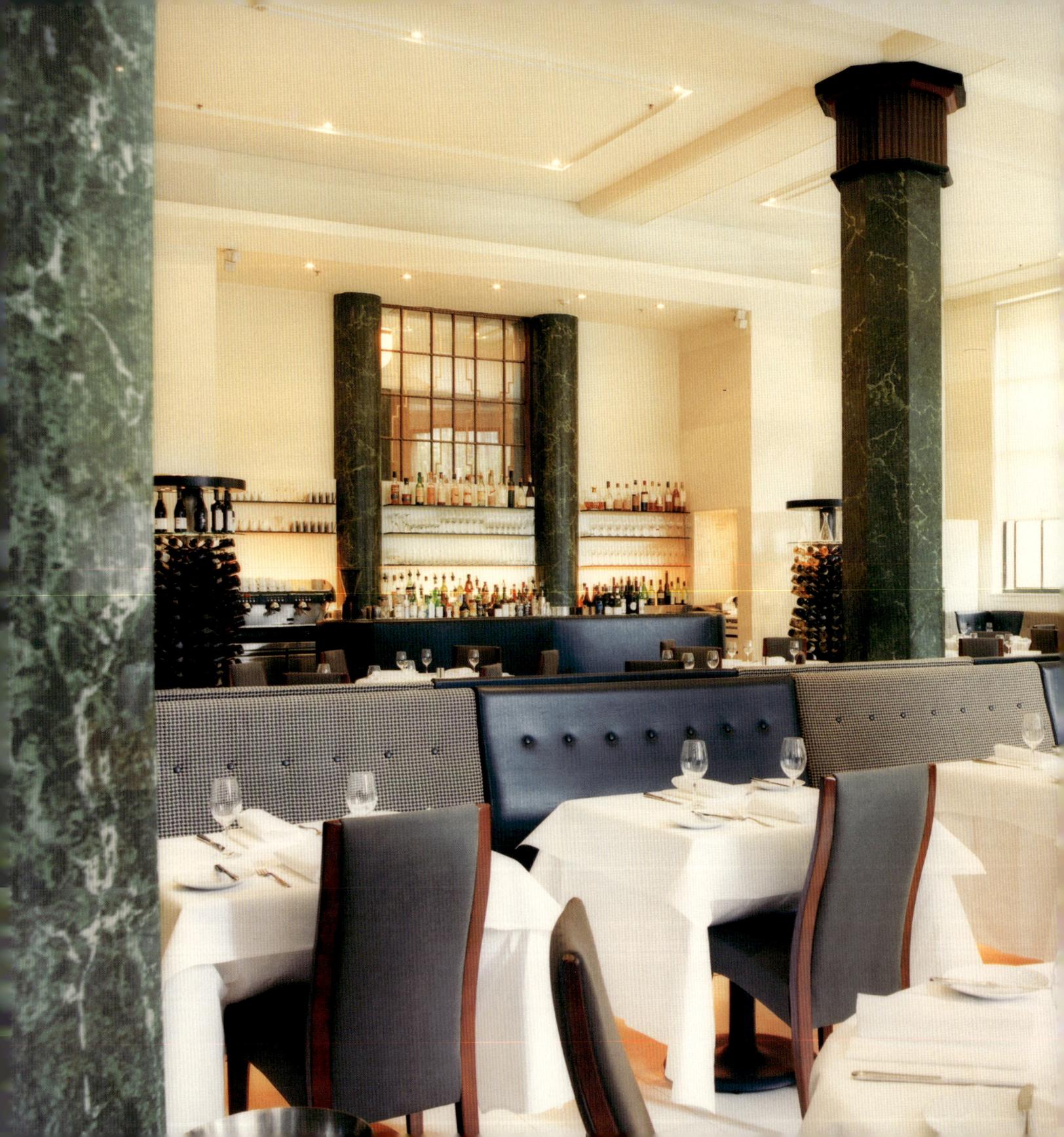

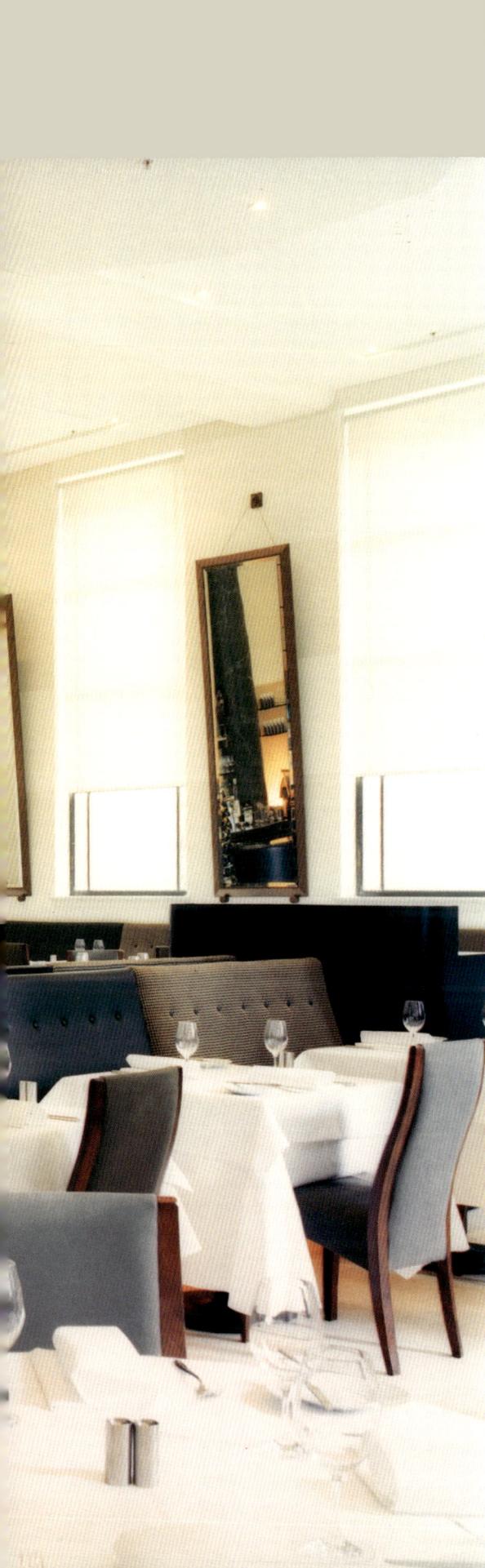

THE BUILDING OF BANC

The Bible tells us that God created earth in six days and on the seventh day He rested. The creators of *Banc* did not enjoy the same luxury. Creating heaven on earth calls for concentrated effort eight days a week.

Having secured the site, Rod Adler and Stan Sarris were keen to get things moving fast. They set themselves an impossible schedule. Nevertheless, *Banc* was open for trading just five months after the signing of the lease.

It was a mighty task, particularly when you consider that before they obtained the premises, no council approvals had been granted, no furniture had been ordered and no tradesmen had been booked. What's more, although Grant McConnell of architects McConnell Rayner had been in broad conversation about the design with Sarris for some time, nothing was on paper.

Now came the critical time. What was their vision to look like?

It was quite obvious to Sarris that *Banc* had to be a timeless dining space, and one with longevity. It had to be elegant and simple, comfortable yet moody, stylish yet understated, imposing but not threatening.

With all their self-imposed restrictions in place, work began, and knowing it would be the launching pad for their grand vision of a food, leisure and entertainment industry empire, Sarris and Adler had to get it right. There would be no second chances. The fickle diner would see to that.

A towering reminder of the 1930s, 53 Martin Place is an Art Deco building from, what was then, a new era in design. When first built, Sydneysiders would have marvelled at its imposing presence, and its gracious lines, fashioned out of red Calca granite. It certainly would have been one of the more innovative buildings of its time in the Harbour City.

Originally constructed in 1936 by the former Australian Provincial Assurance Association Ltd, the building marked the beginning of the development of the eastern end of Martin Place and Phillip Street as a major commercial and professional precinct.

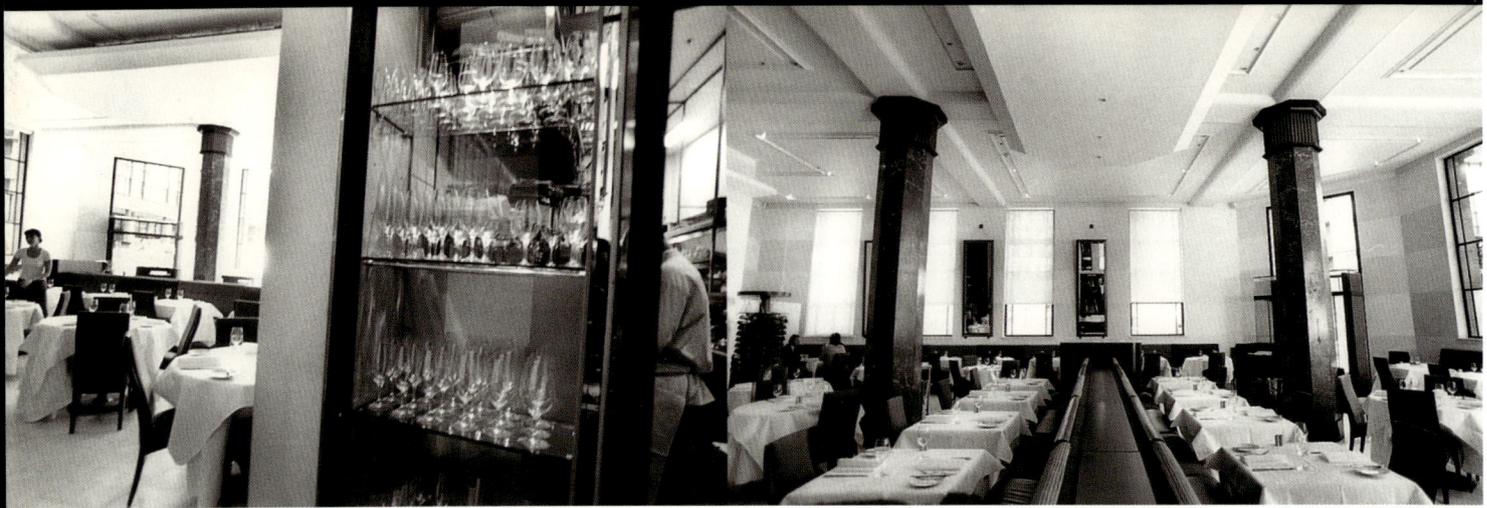

The block on which it was built was bought for £83,000 on May 23, 1935. David W. King, a young architect, was appointed to design the project and to oversee the construction. His brief was to erect a design in conformity with that of the surrounding buildings.

Once the plans were in place, Kell and Rigby were employed to construct the building, and began work in June 1936 after preliminary excavation. The construction of the building, which was completed by September 1936, was extremely rapid due to the use of the then common structural systems of steel frames and reinforced concrete slabs.

The building, in all its splendour, was opened in May 1937 with the Australian Provincial Assurance Association occupying the ground floor, the basement and part of the first floor, while other floors were taken by the legal firm of Allen Allen & Hemsley, a government department and several smaller organisations including the architect David W King.

Interestingly, the lower ground floor was occupied for many years by another restaurant, *Cahill's*.

Sarris decided to reinstate the dilapidated interior to its former glory, taking inspiration from the grandeur of old European coffee houses, but with a contemporary twist. It was obvious that the most had to be made out of the outstanding, existing Art Deco design elements. Much to everyone's delight, initial demolition revealed some wonderful surprises.

Perhaps one of the best was when a low ceiling that had been hung at some point in the building's history, was removed to reveal another of towering and magnificent proportions. Simultaneously, the tops of the four pillars, which form the centrepiece of the room, were exposed, ready to be reinstated to their original beauty.

People often remark on *Banc*'s amazing green marble pillars. In fact, to let you

in on a little secret, they are not marble, but *scagolia*, a fast-dying art performed by Italian craftsmen, where a unique combination of oil, water and plaster is trowelled on 2cm (¾in) thick. When dry, it is painstakingly polished back to imitate the limestone rock.

Extensive research was carried out to discover what the long-gone friezes around the top and bottom of the pillars looked like. Unfortunately, showing little respect for their ageless beauty, a philistine builder had removed them, so new ones had to be created.

The same low, artificial ceiling had also cut through the tops of the external windows. When removed, a massive sweep of glass surrounded by elegant Art Deco steel frames was uncovered on two sides of the building, allowing light to once again flood into the space.

While building got under way, the long list of building materials and furniture to be imported from Europe had to be ordered — the Regianni lighting from Italy, and the limestone for the floor and the Barcellonetta chairs, with their gentle curves, from Spain.

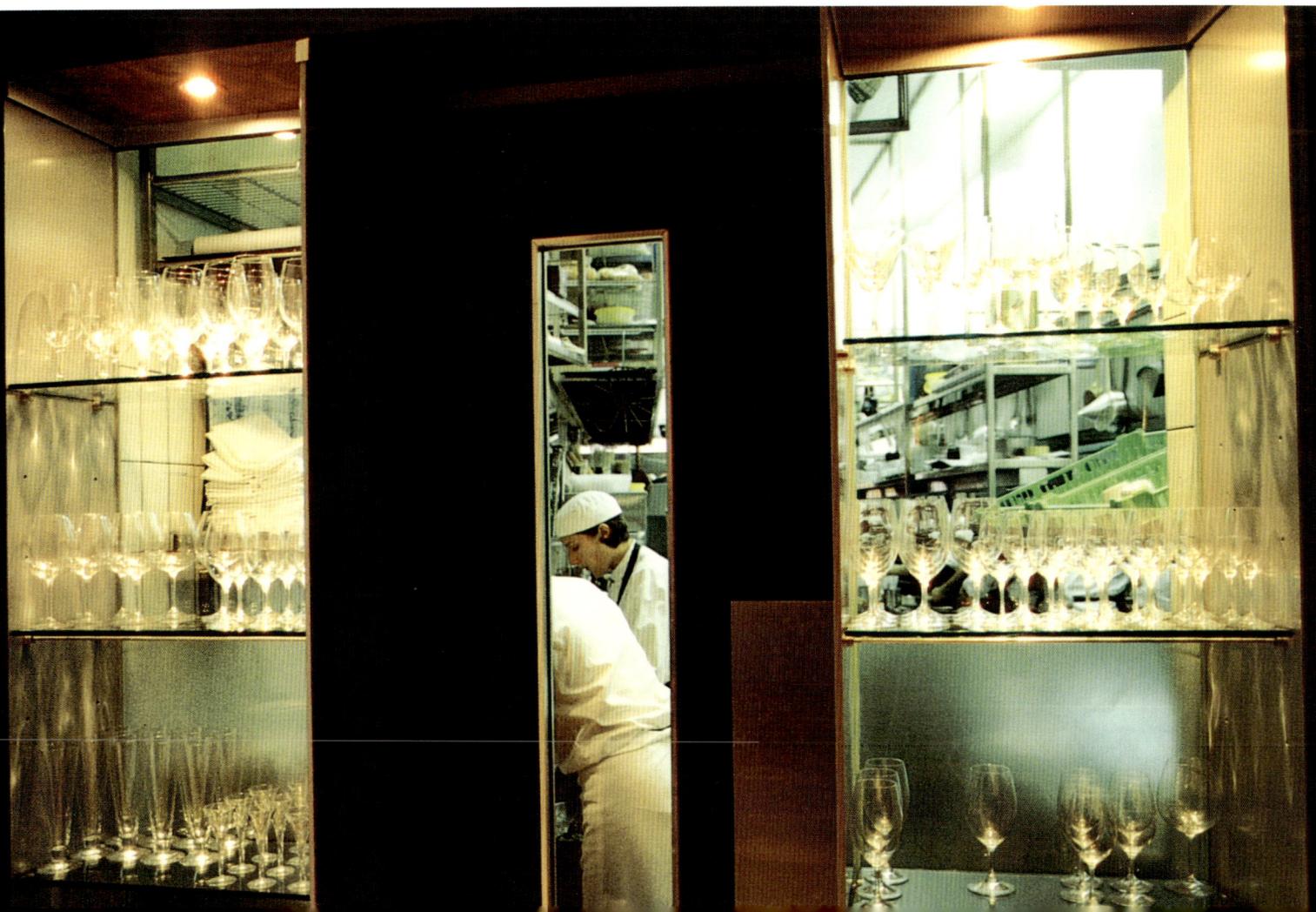

Timeless fabric designs were chosen for both the chairs and the banquettes, and to ensure the room didn't look cluttered, black leather was ordered to create a break between the design.

Although appearing solid as a rock, the banquettes need not be a permanent feature of *Banc*. They were carefully designed, so that they might be easily moved to create a large centre of space for major functions. For example, at the launch of the James Bond movie *Live And Let Die* held in 1997, they were replaced by a glittering stage.

Another impressive feature of *Banc* is its mirrors. While slender, 3.6-metre (12-feet) long examples from the Deco era line two walls, the largest known mirror in New South Wales provides an imposing backdrop at the rear of the room. Architect, Grant McConnell who had the mirror made, wanted to bring the back of the restaurant to the fore.

Patrons have other uses for the mirrors. It is actually possible to gaze at the various celebrities and dignitaries who regularly frequent the restaurant without appearing too obvious or rude. Mind you, they probably have an equally entertaining time mirror surveying the room too.

Banc's giant mirror is framed by a striking wall finished with another rare Italian craft called *stucco lustra*. From a distance it looks like black velvet, on closer inspection you can see it's actually plaster. But not just any old plaster. Paint and paraffin wax are combined with it, before being applied to the wall, and later polished back with a knife for an amazing effect.

When *Banc*'s wall was first created, Grant McConnell wasn't happy with the intensity of the black, but with a little improvisation and a tin of Nugget boot polish, the right mixture was achieved to create the desired effect.

Almost everyone has been in a restaurant where it's necessary to yell to be heard. An exhausting experience, to say the least. *Banc* was never going to be that kind of restaurant. With more than adequate room between tables, and a little space-age ingenuity, the potential noise problem was not an issue.

Hi-tech, sound-absorbent Barasol fabric lines the ceilings, neatly dampening the sound. All that can be heard at lunch or dinner is a warm and friendly buzz that builds to a gentle crescendo at the height of service. This is the rhythm of the restaurant, one Stan Sarris believes should never be interrupted with music. Gentle saxophone music might break the silence before lunch, but as soon as the room begins to fill, it is turned off.

Noise, however, was a potential problem in another area. The Citibank banking

chamber, at the time of building, was situated directly below the restaurant, and the bankers didn't want to be disturbed by the lunchtime crowd. To overcome the problem, the limestone floor was laid over a sound-insulation bed.

To finish off, creamy-coloured paint was applied to *Banc*'s walls. A subtle chequerboard effect was achieved using matt and satin finishes on alternate blocks of the stone. The end result gives the walls a previously unapparent dimension and scale, but still providing a strong comfort factor.

During the day, the light, dappled by the trees outside, dances across the room and onto these elegant walls, giving the space an ethereal quality that has to be seen to be believed.

Even as an unfinished shell, *Banc* so impressed passers by, that reservations flowed in before it was complete. As if to put an exclamation mark after that simple claim, Moët & Chandon insisted on having their annual dinner in the half-finished restaurant. No one seemed the wiser, as they dined from new Limoges crockery and sipped from sparkling Riedel glassware.

Behind the scenes, a first-class kitchen with room for 18 to 20 chefs at a time, had to be fitted into a limited space. Executive chef Liam Tomlin plotted and planned with the architects to perfect every detail. As it turned out, the space allocated for the kitchen would not hold all his requirements. As often happens in times of crises, brilliant lateral thinking took over.

Next to the kitchen space was a light well, a void, built in the 1930s, to run through the entire height of the building. In its day, it provided ventilation but was now redundant because of air-conditioning. Using a complex form of structural engineering, extra kitchen space was suspended out over the light well to hang above a two-storey void. This now houses the cool rooms and the wash-up area.

Massive expanses of stainless steel were tailor-made to fit the kitchen space, refrigeration was custom built, and banks of Garland stoves, ovens and burners were imported from the United States of America.

Like the restaurant, the kitchen features high ceilings, and the space above the work areas could not be wasted. Rows and rows of shelves, accessible through the use of a stainless steel 'library ladder', were installed to store dry goods.

Downstairs, the same attention to detail had to be duplicated in an even smaller space — the kitchen to service *Wine Banc*, which is sometimes also used for food preparation for *Banc* when things are really busy. The kitchens are connected by stairs.

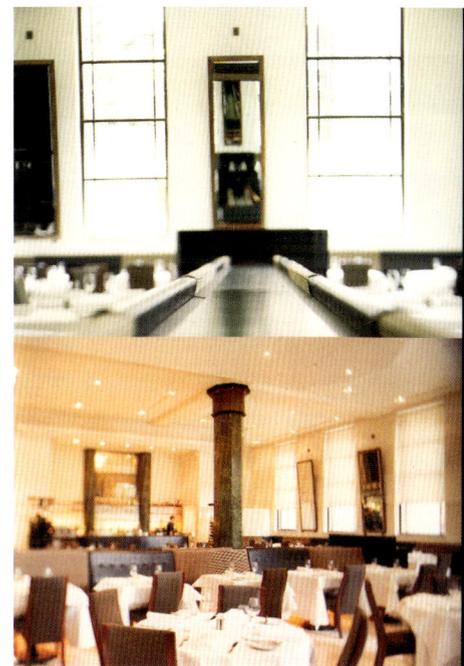

WINE BANC
A BASEMENT BECOMES A BONUS

The other group tendering for the site had earmarked the basement as a store-room. But not Stan Sarris, who had seen an opportunity where no one else had. The natural flow and shape of the space reminded him of the classic, handmade brick wine cellars of France. The challenge was to use it in a contemporary way, turning its various limitations into opportunities. For example the existing air-conditioning ducts necessitated a curved wall. To look at the room today, you would swear that the curve was a specific design feature.

The space has been skilfully developed to allow a number of art forms, including architectural design, furnishings, lighting, fine wines, cigars, music, and even ever-changing walls of contemporary art to synthesise.

Every possible element of the room has been turned into a functional, but yet exquisite design feature. For example, the wooden racks of wine lining the walls create texture and interest, as well as valuable storage space, and the industrial-strength steel goods hoist, situated beside the main staircases, transforms into a coat rack from lunchtime onwards. The service hatch from the kitchen, which could have easily been an eyesore, has been surrounded by a chequerboard timber wall and converted into, what is now, one of the best features of the room. Even the limited wall space that was once allocated to provide a break of creative white, has been snapped up by art dealers Olsen Carr to display an ever-changing gallery of contemporary art.

The spectacularly simple space is further enhanced by ingenious lighting. The white vaulted ceilings are swept with arcs of light from chrome cones, and the opaque, translucent glass bar which runs down almost the entire side of the room, is lit with fibre optics from inside and subtly changes colour as an evening progresses. Every light is connected to a dimmer, allowing the staff to create the appropriate mood for the time of day.

The furnishings are slick. Smoky-coloured leather lounges and white leather Spanish 'club' chairs offset an intricate black and white circular mosaic floor, while a rare touch of colour is provided by a 1960s-style fabric of green and black ovals, used to cover the banquettes lining one wall.

Under the tiled staircase leading into *Wine Banc*, sits a magnificently stocked

cool room where wines requiring specific temperature control, or those too valuable to line the walls, are kept. Stocking more than 930 different wine labels requires an almost ingenious use of storage.

A controlled atmosphere is also required for the cigars which languish in a custom-built humidor made from the same timber, and featuring the same chequerboard design, as the far kitchen wall.

The attention to detail in this bar is remarkable, with each understated design feature combining with the next to make *Wine Banc* perhaps one of the most sophisticated subterranean spaces in the world.

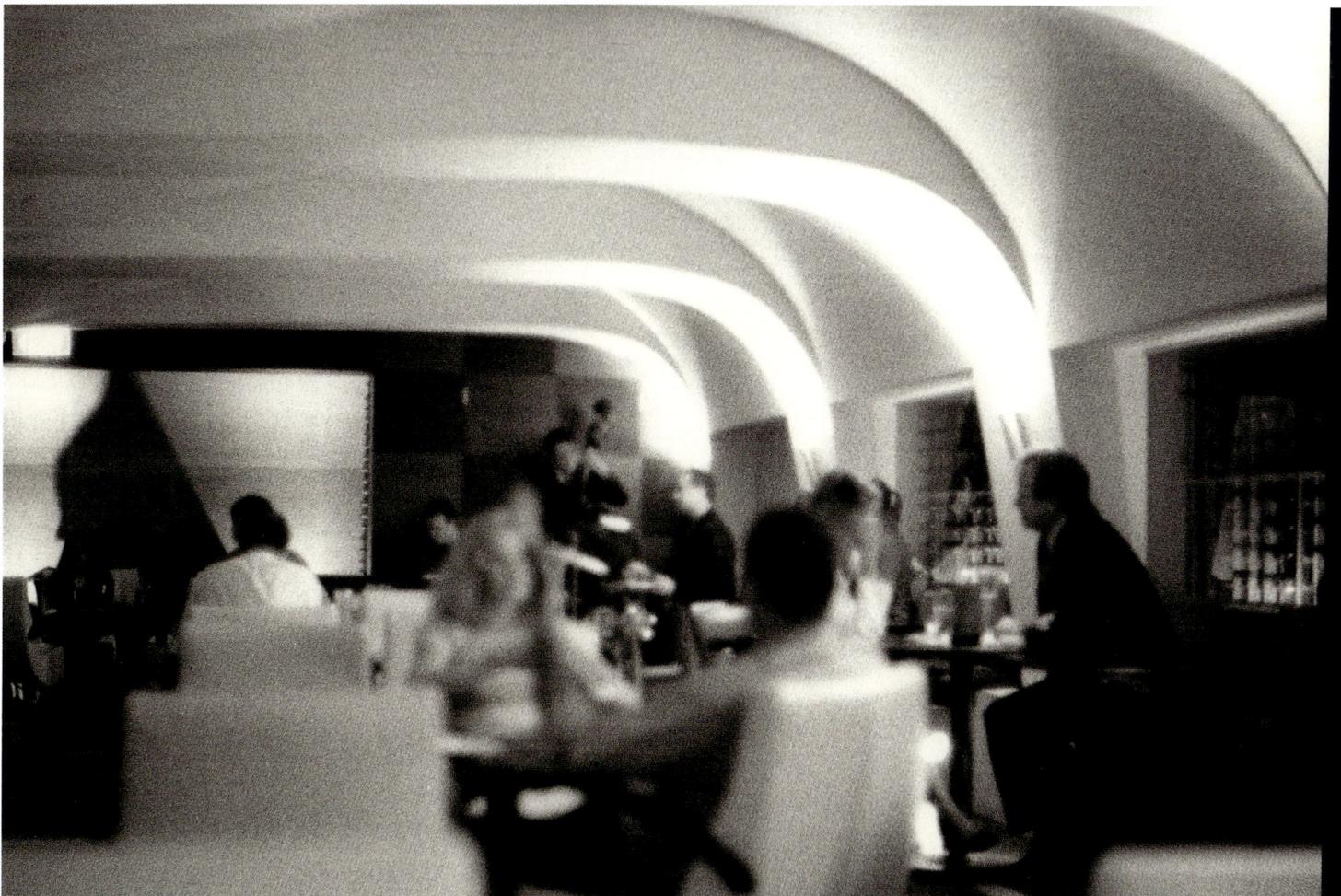

LIAM TOMLIN'S KITCHEN OPERATES ON A FINE-TUNED VERSION OF THE EUROPEAN 'PARTIE' SYSTEM IN WHICH THE KITCHEN BRIGADE WORKS IN SECTIONS

EXECUTIVE CHEF Liam Tomlin

Liam is adept at running not one, but three kitchens simultaneously, working excruciating hours to ensure everything is just right. He is passionate about his food and a total perfectionist who insists that his impossible standards are met. Anyone who can't stand the pace is out. Needless to say he goes through kitchen staff almost as quickly he does cleaners.

He spends most of his time in the main kitchen at *Banc*, calling orders and checking every single plate before it is allowed to go out. Heaven help anyone who over-cooks a vegetable, messes up the succinct timing of a dish, or even leaves a finger mark on a plate, because Liam misses nothing.

He is a master of his craft, and renowned for creating ingeniously flavoured and exquisitely presented food for his customers to enjoy. He works hard at being extraordinarily good, and after a gruelling service, it is nothing for him to stay well into the night, experimenting on new dishes with his trusted Senior Sous Chef, Matt Kemp.

Whether his staff love him or hate him, they respect his special talent and covet their positions in the *brigade de cuisine* of one of the best.

SENIOR SOUS CHEF Matthew Kemp

Matthew has worked under some of the best chefs in Europe and is fully aware of what is expected. He is not only responsible for ordering the produce and controlling the staff rosters for all three kitchens, but also is in charge in Liam's absence.

As expert as a surgeon with the knife, Matt can usually be found working on fish preparation, although he moves from section to section during the course of the day. At the height of service, it is Matt who calls the orders away, in his unmistakable cockney accent.

THE PASTRY CHEF

In charge of the total sum of desserts and baking required for all of the kitchens, the pastry chef schedule is relentless. Assisted by a chef de partie,

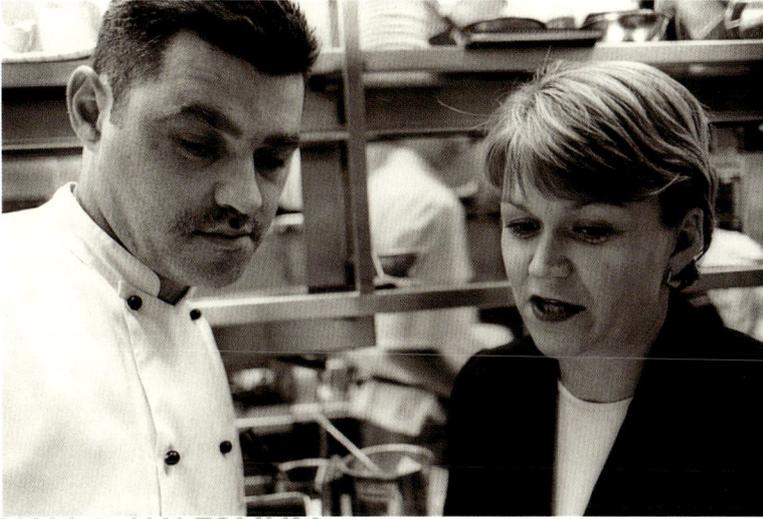

LIAM & JAN TOMLIM

MATTHEW KEMP

a commis and a fourth-year apprentice, she is responsible for making every single dessert from scratch, including the coulis, crème anglaise and ice-creams required for garnishing each dish.

SOUS CHEFS

Both *Wine Banc* and *Private Banc* have their own sous chefs who oversee those particular kitchens on a day-to-day basis, reporting back to Liam or Matthew. Another sous chef is in charge of all stock and soup making, butchery and cooking all the meat, game and fish during service. He has a chef de partie or commis working under him.

CHEF DE PARTIE

Each part of the kitchen performing a specific task is called a section, or a *partie*. The head of each section is called a chef de partie.

The vegetable section at *Banc* is either run by two chefs de parties or a chef de partie and a good-performing fourth-year apprentice. They are responsible for all the vegetable preparation, pastas and risottos. This is a very busy section as it is required to provide garnish (vegetables) for almost every dish on the menu.

The *Garde Manger*, or larder, is also run by a chef de partie, assisted by two apprentices. They look after all cold entrées such as terrines, marinated fish and salads, as well as preparing the herbs, dressings and cold sauces.

APPRENTICES

The work apprentices are given is determined by how far they are into their apprenticeship.

First-year apprentices pick herbs, wash salads and perform basic vegetable preparation such as mirepoix, peeling onions, garlic and asparagus. They are sometimes required to wash dishes and clean fridges whenever the kitchen is very busy or short of porters.

Second- and third-year apprentices spend time in each section, gaining knowledge, doing prep and becoming involved in service.

Fourth-year apprentices work in the saucier or vegetable section. A good fourth-year apprentice is also able to cover for Chef de Parties in other sections of the kitchen.

KITCHEN PORTER

In charge of pot washing, plate polishing, cleaning the floors and performing basic vegetable preparation when the kitchen isn't too busy.

MASTER SOMMELIER Remi Bancal

Born into a French wine-making family, and training as a sommelier at the *Ritz* in Paris, it was obvious from the start that Remi Bancal would devote his life to the grape.

Assisted by four sommeliers, he is in charge of the vast cellars that service *Banc*, *Wine Banc*, *Private Banc* and *The Mint Room*, in which there are around 930 different wines, collectively worth more than $500,000. Remi knows each and every one of them. After all, he tasted and selected all the labels himself. It would be hard to find anyone more passionate on the subject of wine, or anyone as willing to share his/her incredible knowledge. Remi likes nothing more than to take a customer through his wine list, describing the characteristics of each variety. He is highly skilled at matching exactly the right wine to a dish or an occasion. But, more than anything, he loves to introduce patrons to new wines that will surprise and delight them.

MAITRE'D Jan Tomlin

From the moment Jan greets you at the door, you know you are in the hands of a professional. Her quick precision and cordial manner are hallmarks of many years spent working in leading restaurants around the globe.

REMI BANCAL SEAN JONES

As Jan is well aware, managing a restaurant means far more than simply serving customers, training and controlling a large floor staff, co-ordinating operations with the kitchen, and arranging bookings. An exceptional Maitre'd must be astute. Jan knows the foibles of all the regular customers, and is able to make each and every one of them feel special.

ASSISTANT MAITRE'D, BANC TANYA POLES

Tanya is Jan's right arm and is in charge of running *Banc* when Jan is elsewhere. Jan and Tanya have a special relationship after working together through countless services for almost six years: they understand what each other is doing or thinking, without even speaking. They are a totally synchronised team.

BAR OPERATIONS MANAGER SEAN JONES

It's probably fortunate that Sean Jones used to win gymnastic trophies in his early years since his job could only be endured by the fittest. When Sean isn't organising vast deliveries of wines, beers and liquor — most of which he has to physically lift on arrival — he is pouring drinks and shaking cocktails faster than lightning when *Wine Banc* is pumping late into the night.

Sean is in charge of the bars in both *Wine Banc* and *The Mint Room* and takes care of stock control, staff and function co-ordination, as well as developing ideas for the drinks and cocktail lists. In quieter moments, he uses his other talents as a freelance copywriter and graphic artist, to develop marketing and promotional ideas for the group.

Below: *Banc*'s youngest honourary staff member, Bella Sarris, aged 8.

LET US TAKE YOU ON A 24-HOUR JOURNEY THROUGH A TYPICAL DAY AT

THE PINNACLE OF DINING, TO OBSERVE HOW, FROM A STEAMY HELL ON

EARTH, SUBLIME TASTES ARE BORN. WATCH AS THE PRECISION-PERFECT

TEAM WHICH ORCHESTRATES THE SPACE, THE FOOD, THE DRINK AND THE

SERVICE, DELIVERS AN EXPERIENCE TO EXHILARATE ALL OF THE SENSES.

05:30

At 5.30 in the morning, when the Sydney streets are still shining wet from the council sweepers, and a solitary pigeon pecks at the pavement in search of breakfast, the only sound you can hear outside 53 Martin Place is that of the traffic lights changing.

Every few minutes they flash red, amber, green for the non-existent cars and the non-existent pedestrians. And, every time they change you hear the gentle 'banc, banc, banc' of the 'walk' signal.

It's almost as if the owners of *Banc*, in their quest for perfection and attention to detail, have even programmed the traffic lights to help guide you to their home of fine food and wine.

Most people don't even acknowledge that there is a 5.30am on their clocks, but at *Banc*, it's when the day begins.

05:35

As the sun creeps over the tarnished bronze spire of a nearby church to dry the freshly cleaned road, the rattle of a diesel engine disturbs the silence of the city and momentarily drowns out the 'banc, banc, banc' of the changing lights.

The air brakes of a garbage truck 'whoosh' and bring the mobile monolith to a sudden halt outside the back door of *Banc*, where black bags of the ravaged remains of last night's dinner form an Everest of refuse, glistening in the morning light.

05:37

The first delivery van pulls up, quickly drops a box on *Banc*'s freshly cleared doorstep, and disappears into the uninhabited canyons of buildings.

It is the first of many deliveries of crisp starched linen, wine and fresh produce to arrive throughout the morning.

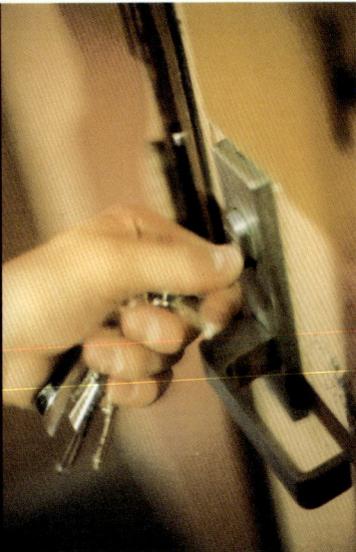

05:45

No sooner is the first box dropped than a figure appears, and a key is turned in the back door of *Banc*. Annie Sapforth, the pastry chef, has arrived to begin to weave her magic. She looks a little sleepy, but her white starched uniform is pristine as usual.

She wastes no time with a heart-starting coffee, but turns on the radio to 2DayFM, which will continuously buzz in the background until just before service. She lights the ovens and, with a yawn, unlocks the fridges, checking what is left from yesterday. Not much! A quick look at the *mis en place* list from the evening shift confirms that last night was busy. She needs to make:

2 lemon and 1 chocolate tarts; 80 apple jellies for pre-dessert; Calvados sabayon; white chocolate mousse; chocolate curls; 4 litres of plain crème anglaise; 1 litre of mint anglaise, puff pastry for feuilletées; 2 litres praline ice-cream; 2 litres saffron ice-cream; 2 litres orange mascarpone; chocolate sorbet; praline; 1 tray of poached pears; petits fours; chocolate truffles; orange twirls; jelly for trifle; 20 litres sugar syrup; raspberry coulis; allumettes glacées.

The note finishes by telling her the sabayon needs more Calvados, and that she should start a dry store list: 'we need flour, glucose, gelatine and butter'.

This is all mouth-watering reading to everyone, except perhaps the pastry chef. She gets started.

She enjoys the peace and quiet of early mornings at *Banc*. But, perhaps the main reason she elects to start at the crack of dawn, is her dedication to a quality product. She knows that later, when the rest of the kitchen staff come in, the ovens will be constantly opening and closing. She needs exact temperatures for her creations, and near enough is not good enough.

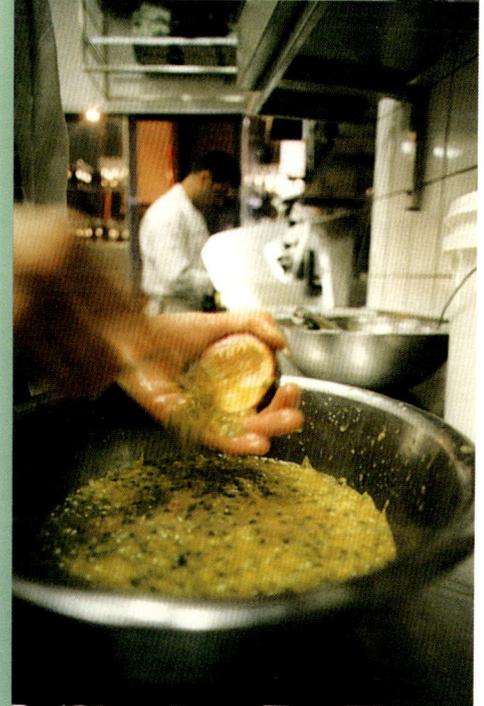

06:15

The bleary-eyed plongeur, better known as the dish washer/kitchen porter, wanders silently in past the pastry chef. His first unenviable task is to hose out the garbage bins and wheel them inside. His second job is little better. He must hand polish every single plate, then deposit them all in the hot box and the various sections in the kitchen, ready for lunch.

Things don't improve for him. After a general whiz around the kitchen to make sure the night porters have done their jobs, he looks forward only to washing every pot and pan in the place about six times, as they are used throughout the morning. Whenever he's got a moment, he will be required to sweep the floor. At last count he did it a dozen times before lunch. A good kitchen porter is worth his weight in gold, but a bad one can cost the kitchen brigade dearly.

06:30

A pale apprentice chef has picked up the delicate aroma of the pastry chef's concoctions half way down the street. As he swings open the door, he takes a deep nose full and surveys the shining stainless-steel kitchen he would, one day, like to run.

He has arrived half an hour before scheduled to try and get ahead, otherwise he will be up the proverbial creek without a paddle yet again.

For now, he must be content with lighting the sparkling clean hobs and preparing the huge pots of bones which will simmer for what seems like days to make the never-ending litres of stock required for each service. He glides, in a dreamlike trance, up and down the narrow aisles of the long galley, collecting large plastic containers of veal bones, chicken carcasses, and vegetables from the cool room to meticulously clean, slice and chop. He must also make the endless coffee for the chefs and anxious-looking apprentices who are beginning to filter in.

06:50

Executive chef Liam Tomlin strolls in, momentarily stopping to make sure his favourite hidden nook has been cleaned. It's his daily test for the cleaners. He heads straight for the pastry chef, who is now elbow deep in passionfruit pulp, to let her know he needs two extra brioche for a last-minute cocktail party at *Wine Banc*, as well as a lemon tart for Rodney Adler's wife, who is holding a dinner party at home tonight.

After checking how the commis is doing, Liam makes a beeline for the coffee machine. He unfolds a European trade magazine on the bar, lights a cigarette and buries his forehead in his hand as he catches up on the latest overseas restaurant news. The familiar names of some of the world's leading chefs leap out at him. He has fed many of them at *Banc*.

London's renowned Anton Mosimann, Wolfgang Puck of *Spago* in Los Angeles, Jean-Georges Vongerichten from *Vong* in New York, Yoshiro Murata, who is Japan's foremost chef, and British television personality and raconteur Ken Hom have all enjoyed Liam's food when visiting Australia. *Banc*, it seems, has become part of the worldwide food circuit for the high priests of food.

The end of the cigarette burns Liam's finger, he returns to the real world and the coffee and magazine are quickly discarded in favour of yesterday's paperwork.

An important part of a chef's job is to keep food costs under control. Liam's are high this particular week, but he knows why. A cocktail party for a large banking corporation called for 2000 canapés — 10 different types and 200 of each — and *Banc* hasn't received payment yet. In a restaurant like *Banc*, food costs should be about 33 per cent of sales, and Liam likes to be on top of every dollar.

07:00

Banc's head chef, Matthew Kemp, bounds into the kitchen like an atomically charged super ball. He is a long, lean streak of English energy with a cheeky, cockney twang and a quick one-liner for everyone.

He immediately joins Liam to discuss last night's service and the day ahead. Chef wants him to chase up somebody to fix a door on the oven, increase the bread delivery and to deal with a forgotten prawn order. Over a quick cup of coffee Matt reminds him there's a lad trying out and another just arrived from London coming in for an interview later in the morning. Their meeting is brief.

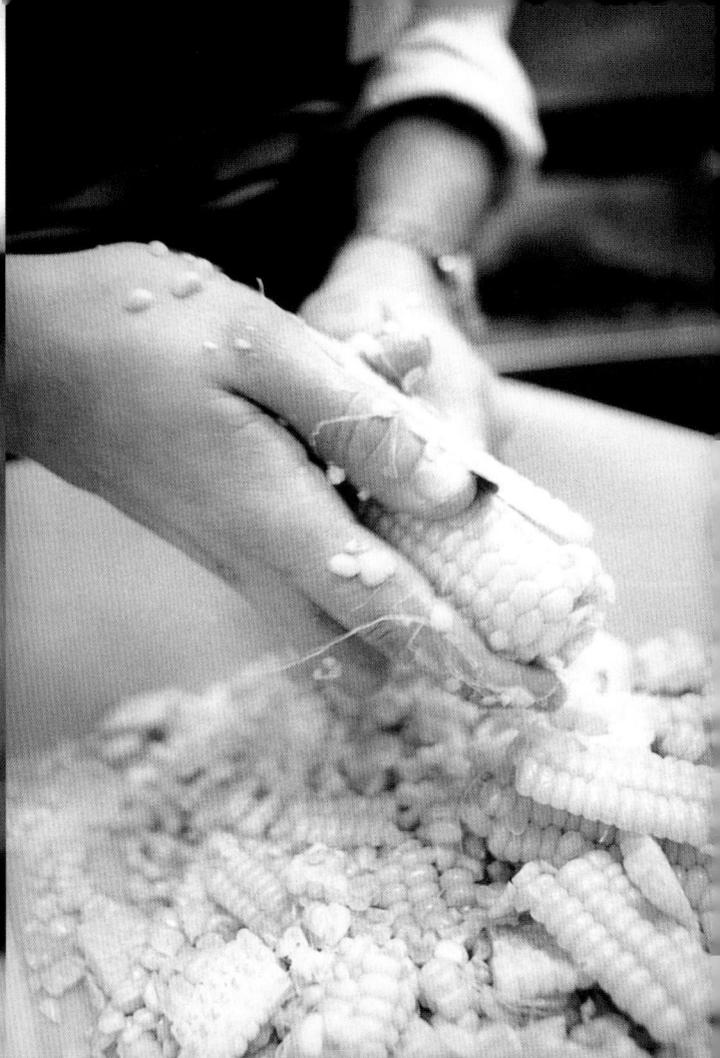

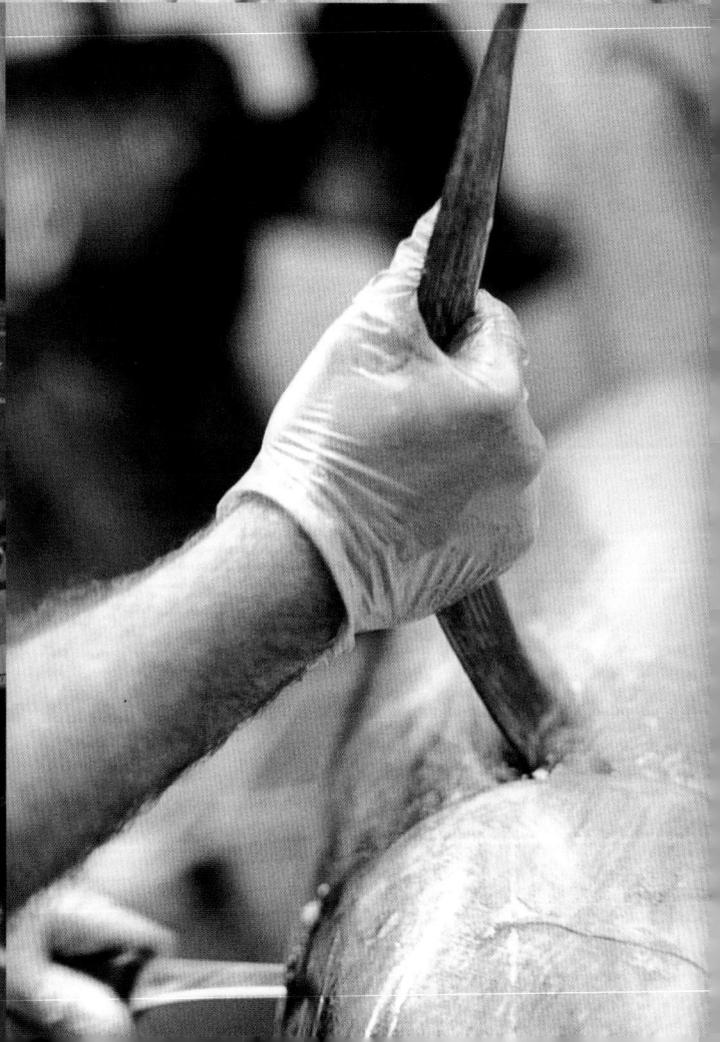

07:15

Matt makes a remarkable transformation from T-shirt and jeans to a crisp black and white uniform and goes to the kitchen where he is greeted by the first phone call of the day.

It's Con the fishmonger ringing to say the lobsters have been delayed at the airport, but should be at *Banc* by 9am. He also advises Matt to up the order as, due to bad weather conditions, lobsters are altogether scarce and there won't be a second delivery. Matt doubles the order.

07:20

The main kitchen staff are filtering in. That is all except Cameron Wallace, a chef de partie, who is religiously late. This will put a smile on Liam's face. Cameron's been late three times recently, so loses his rostered day off, thus solving Liam's staffing problems for the week.

Two chefs de parties stumble in. One nursing a self-inflicted headache. He groans as he struggles into his crisp white coat. Another sous chef tells him to quit complaining, simultaneously producing the burn he received from the oven the previous night. "That's what you call pain, you big girl's blouse!" he says. A quick inspection of his forearm reveals that it's not the first time he's been branded in the kitchen.

The chefs and the nervous-looking apprentices start checking their *mise en place* lists:

Prepare 2 litres shallots; 2 litres brunoise; roesti; fondant potatoes; turned potatoes; cucumber spaghetti; pesto noodles; ravioli; peas; morels; shallot purée; lamb potatoes; asparagus; aubergine caviar; spinach; mushroom stock; risotto; mushroom shimeji and oysters; colcannon garnish for cod; spaetzli; and the list goes on.

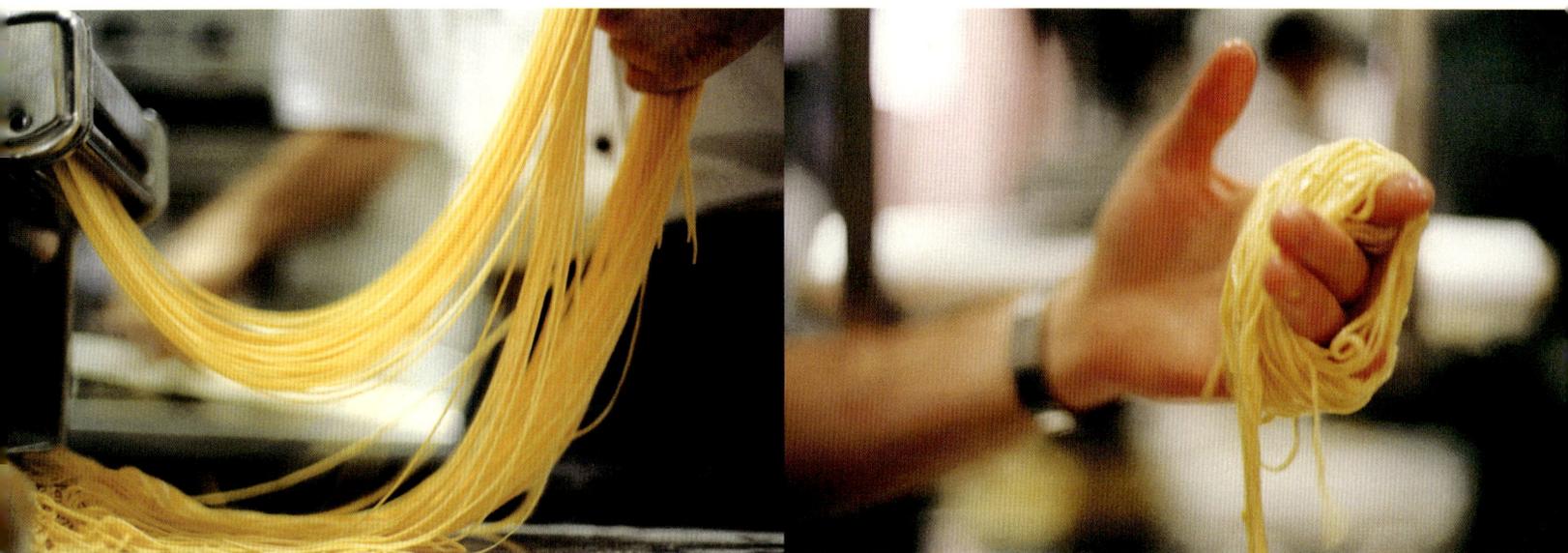

07:30

Liam strolls into the kitchen and announces that he needs *mise en place* for 80 at lunch and 70 for dinner, and that six of the tables need to be out by 7.40pm for the theatre. "Oui" chef. Everyone is racing against the clock to get ready in time. Liam returns to his paperwork.

The kitchen is now operating at a high speed hum. Nobody is talking much, but tomatoes are being peeled, fresh strips of pasta are being made, shredded through the machine, peas are being puréed and a variety of potato dishes are being prepared.

Downstairs at *Wine Banc* veal, chicken and vegetable stocks are simmering nicely on the stove. Most of the stocks take two days to make, being reduced many times to ensure maximum flavour.

07:40

Cameron tries to sneak into the kitchen unnoticed. Liam catches him through a reflection in one of the mirrors and erupts. The team in the kitchen spends a riotous 10 minutes taking the micky out of Cameron who blames senior sous chef Warren for keeping him at the pub too late!

A nervous young lad arrives, amidst the hilarity, for a trial in the kitchen. He's put on the vegetable section, and his first job is to slice a 2-litre tub of shallots, and a 2-litre tub of brunoise of shallot.

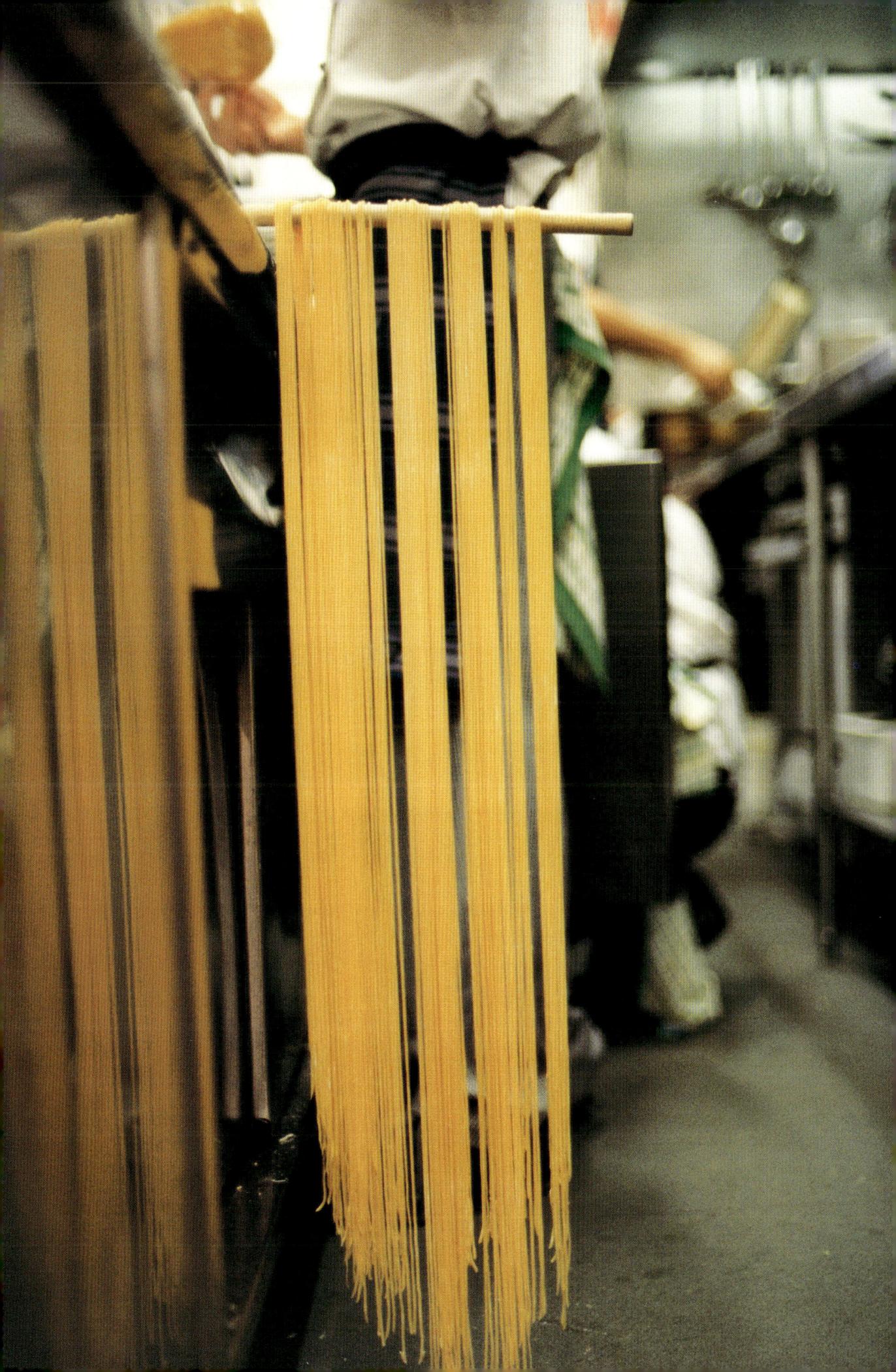

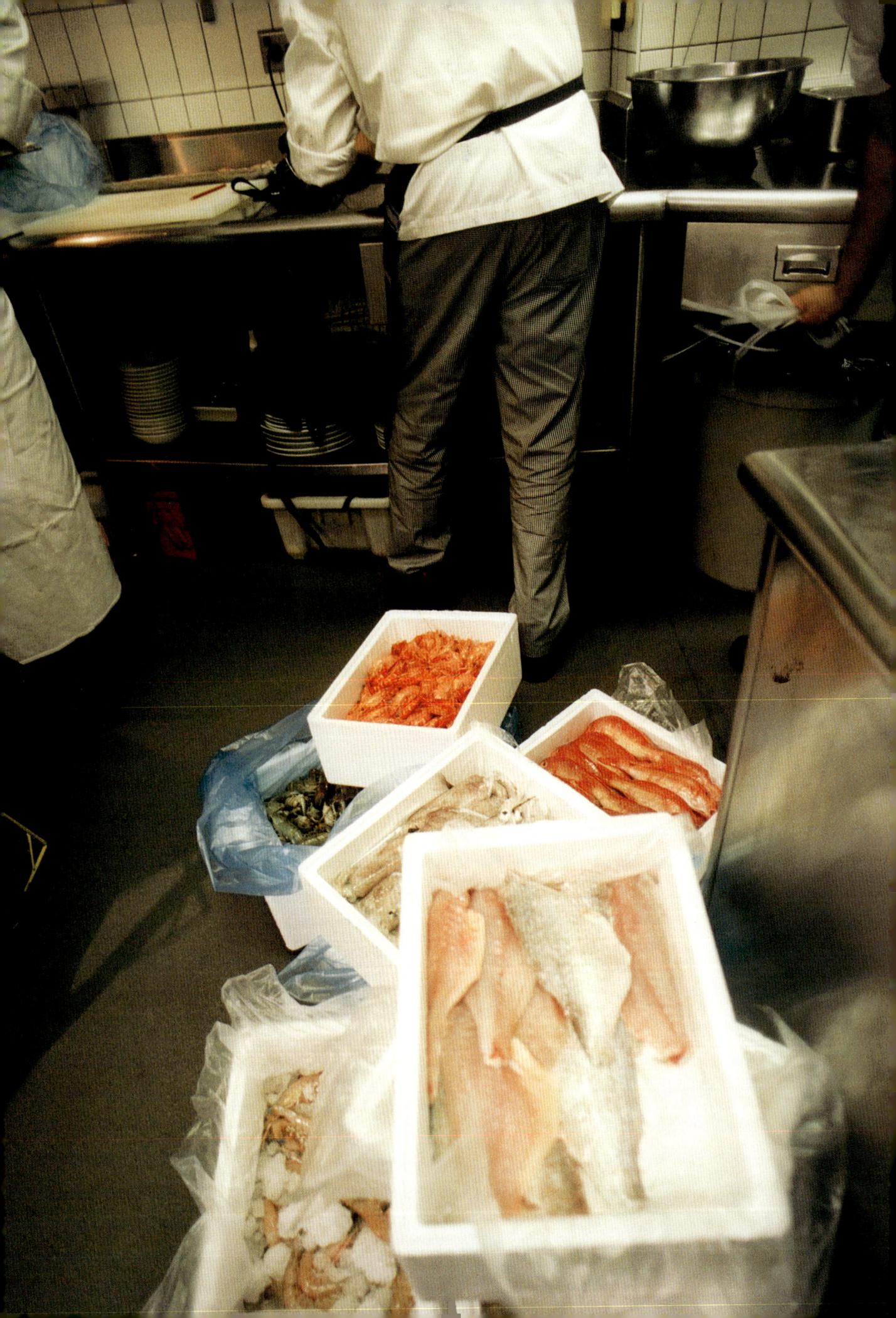

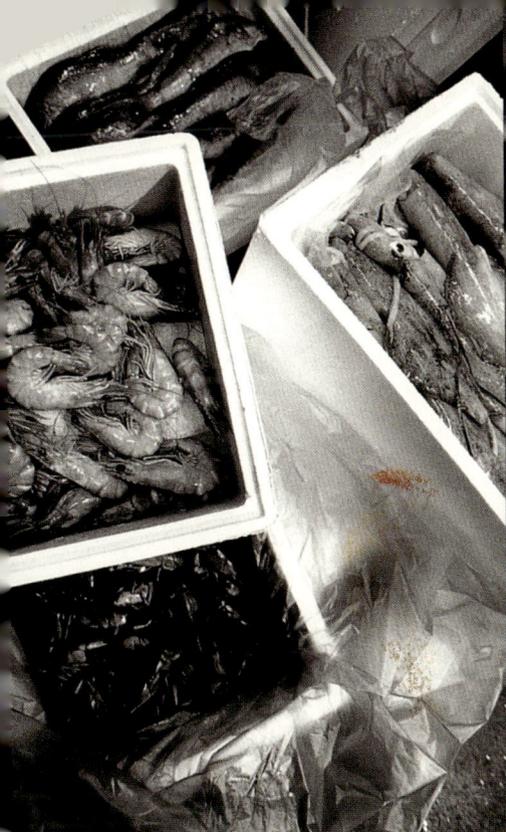

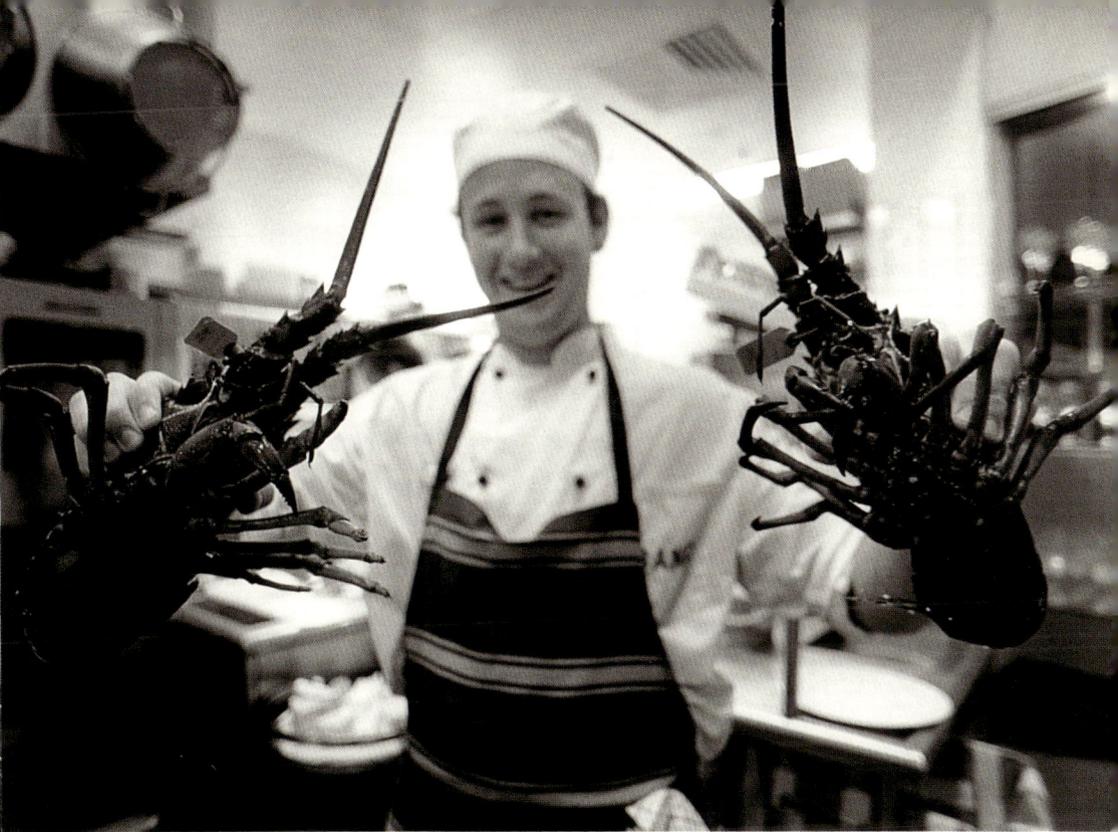

07:45

The delivery man from Vic's Meats arrives with:

12 veal tenderloins, 5kg (11lb) of chicken wings, 2 strip loins of beef,

18 chickens, 6 calves' hooves, 48 quail, 1kg (2.2lb) chicken mince,

2kg (4.4lb) crépinette, 25kg (55lb) lamb bones, 12kg (26lb) venison saddle,

1 box of beef tender loins, 3 sides of pancetta, 18 squab, 48 veal shanks.

Sous chef, Irish Sean, will have this all trimmed, tied, portioned, and wrapped in

time for service at 12.30.

07:55

Liam has changed into his uniform and is on the phone to *Wine Banc*'s chef.

He'll be down later to discuss tonight's cocktail party.

A trolley full of polystyrene crates is wheeled in through the door. 'Demcos

Seafood Providores' reads the label. There's something scuttling about inside

the boxes and, as Liam flips the lid to check the order, wriggling yabbies try for

a quick escape.

The forgotten prawns turn up, and orders are quickly sorted. Rolls of cling wrap

disappear around everything. It's easy to see how 220 kilometres (137 miles) of

the stuff is used in the kitchen every year.

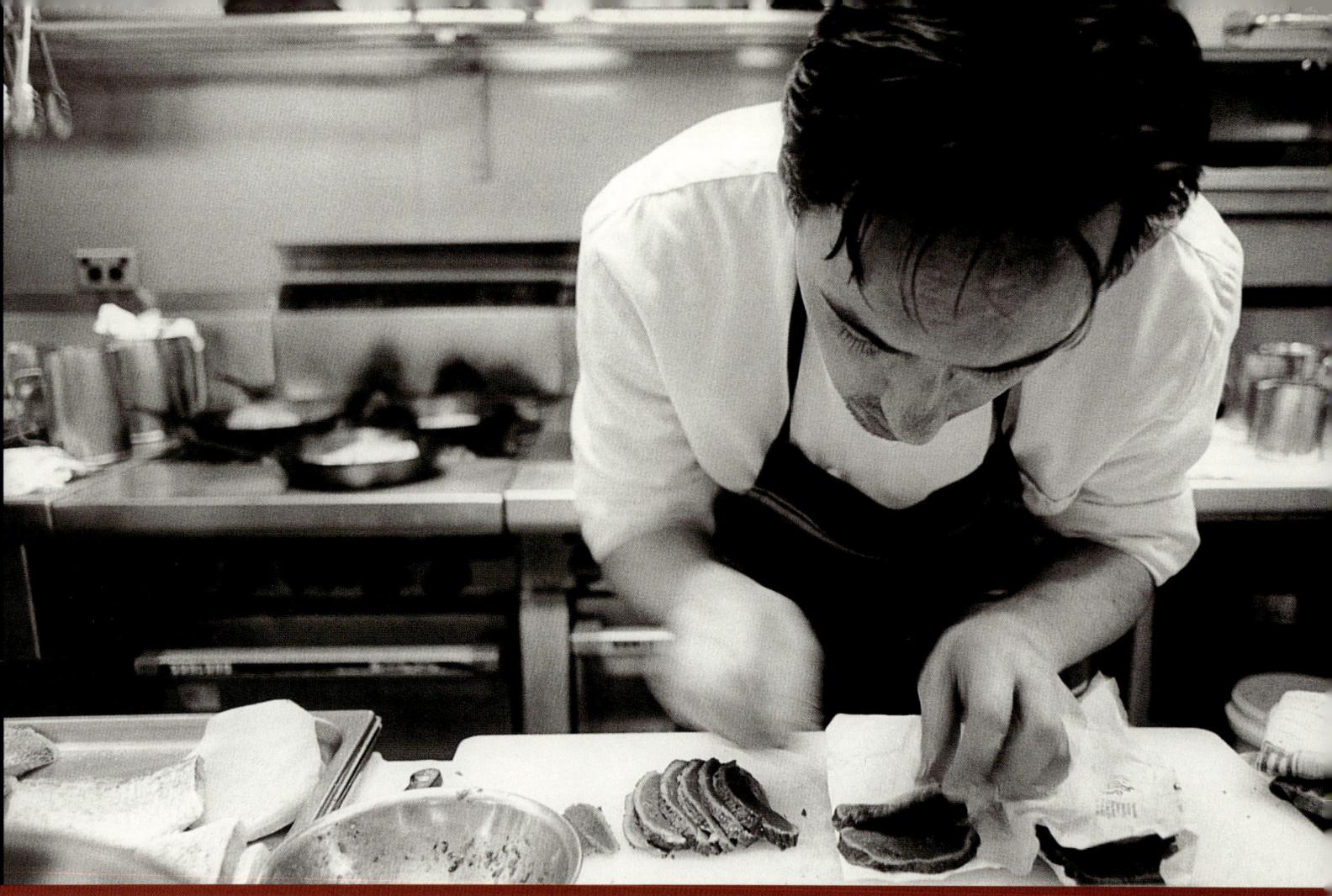

08:00

The kitchen porters are ferrying produce between *Banc*, *Wine Banc* and *The Mint Room*. The boys on the vegetable section in the kitchen are arguing about who's turn it is to make the staff meal, and Liam is giving his wife, Jan (aka the front of house manager), the first of her three wake-up calls.

Head Sommelier Remi Bancal has arrived downstairs in *Wine Banc*. He makes himself and Darrell, in the *Wine Banc* kitchen, an espresso, and they chat about the day. Coffee finished, Remi checks the sales from the previous shift, and prints reports on liquor and food sales. He makes sure all is in order and that there aren't any 'surprises' such as there being no Krug left.

At the far end of *Banc*'s kitchen Irish Sean is preparing parsley crust for stuffed, grain-fed chicken. Watching him lift the skin on the breast and pipe in the mixture or parsley, breadcrumbs and butter, one can't help but think he must have been a plastic surgeon in a previous life.

Meanwhile, head chef Matt has finished his razor-sharp one-liners for the morning, and his razor-sharp knife has taken over where his tongue left off. Wings and legs are whipped off, and within minutes 18 squabs are ready.

"Do you know how much these bloody squab cost today? Bloody $11 each. When you take into account the sauce, the ravioli and all the bloody time we take to make the dish, we're bloody giving it away. Back in London, we'd charge 25 quid for this," Matt announces, to no one in particular.

There's no time for complaining. A large tuna has just walked in through the door, and needs to be prepared for **Seared Tuna Niçoise with a Tapenade Beurre Blanc**. 'Whoosh' goes Matt's knife, and in one smooth operation no head, no tail and neat fillets are drawn off the sides.

08:15

A box of cheese from provedore Simon Johnson makes a highly aromatic entrance, and is quickly checked. *Banc*'s custom-made, marble-topped cheese trolley is one of the best in Australia, and plays host to around 30 cheeses at each service. Liam sees to it that the range of cheeses is changed on a regular basis, and estimates that more than 130 different varieties have been presented in the past 18 months. This poses quite a challenge to the front of house staff members, who are required to describe the qualities of each cheese in detail to their customers.

By now, more than $3000 worth of produce has arrived, been either unpacked and put away or prepared for lunch. The cool room has turned into a United Nations of food packaging. The shelves are lined with cheeses from the United Kingdom, Spain, Sardinia and the rest of Italy, while boxes of morels sit amongst tightly wrapped parfaits, terrines, and jars of polenta and rice infused with fresh, imported truffles.

08:45

The kitchen is fully awake and the guys are taking the micky out of Warren the sous. Apparently he got so pie-eyed on Saturday night, that whilst staggering home over Pyrmont Bridge, he sat down on a bench for a five-minute rest, and didn't wake up until 10am on Sunday morning.

Liam chuckles as he helps Matt fillet the fish. The kitchen is getting a full head of steam. The washing, peeling, chopping, mixing appear effortless, but are all done with measured precision.

The pastry chef is now elbow deep in flour, sugar, butter and water.

Downstairs at *Wine Banc*, bar manager Sean Jones, who's a dead ringer for French actor Christopher Lambert, rocks in, eats his bacon and egg roll and drinks his chocolate milk. He updates Remi on the previous day in the bar, and then grimaces while he attacks a daunting pile of paperwork.

A delivery from Blue Hill arrives. All of a sudden there are some 40 or so boxes to shift out to the back.

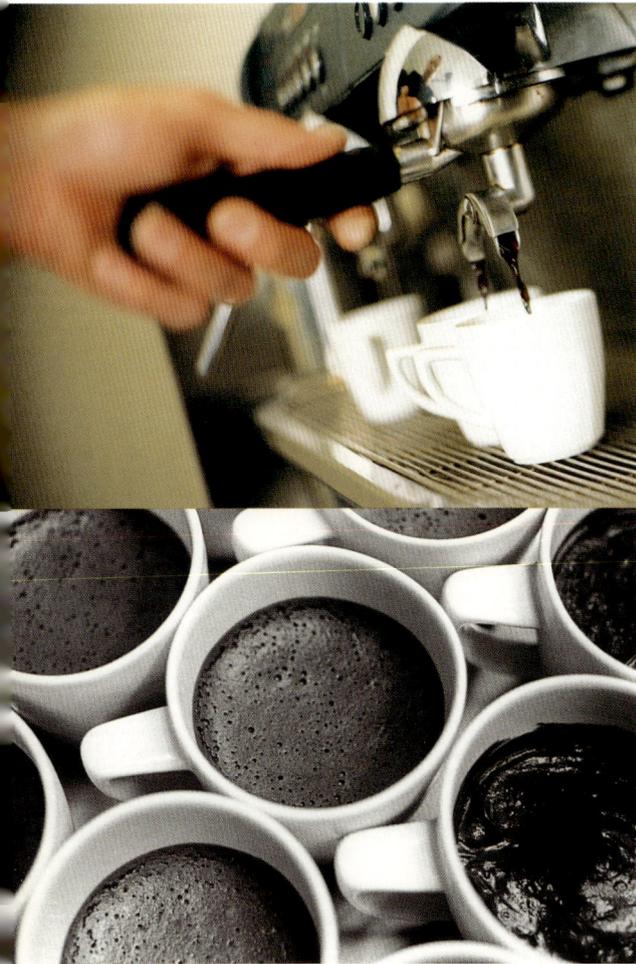

09:00

Co-owner and operator Stan Sarris elegantly makes his entrance through the back door. He's dressed to simple perfection in his signature Armani, Guccis rest on his nose, and his spiky black hair is jelled perfectly in place.

"Now I know what it's like to be raped," he booms as he makes his way toward the coffee machine.

Heads turn as he disappears behind the bar.

As he smoothly removes the tails off the yabbies, Liam explains to the whole kitchen that the previous night Stan had made a visit to a new restaurant and that he had been extremely disappointed.

"A hundred and fifty dollars a head, and that didn't include wine," adds Stan knocking back his ristretto. "I think we need to look at our prices," he jokes.

Now, Matt is in on it. And holds up one of his limbless squab.

"We should be charging. . ." but he's cut off mid sentence by another box of wriggling yabbies Liam has dropped in front of him.

Stan heads for a quiet corner of the restaurant and out comes the mobile phone. It might as well be surgically attached to his head for the rest of the day.

09:15

Front of house manager Jan Tomlin, dressed in jeans and a large shirt, sticks her head in the kitchen door to say good morning. Liam's three wake-up calls have finally done the trick.

Jan and Liam make an excellent team, she running the floor and he the kitchen. There is an unspoken understanding as to how each likes to operate, making for an unusually cordial relationship between the kitchen and the restaurant.

Aussie Sean the cashier has also turned up and is making the second round of coffees for the boys in the kitchen. They take the micky out of him, but most of them envy his pleasant lifestyle. Working lunch shifts means he's well-rested, well sun-tanned, has a regular girlfriend, and is up on all the best TV programmes.

The phone is already ringing with bookings. Aussie Sean informs the kitchen that now there are 84 for lunch and 80 for dinner at *Banc*. Meanwhile, downstairs, bar manager Sean Jones is fielding calls for lunch tables at *Wine Banc*, and trying to find a replacement for a staff member who has called in sick.

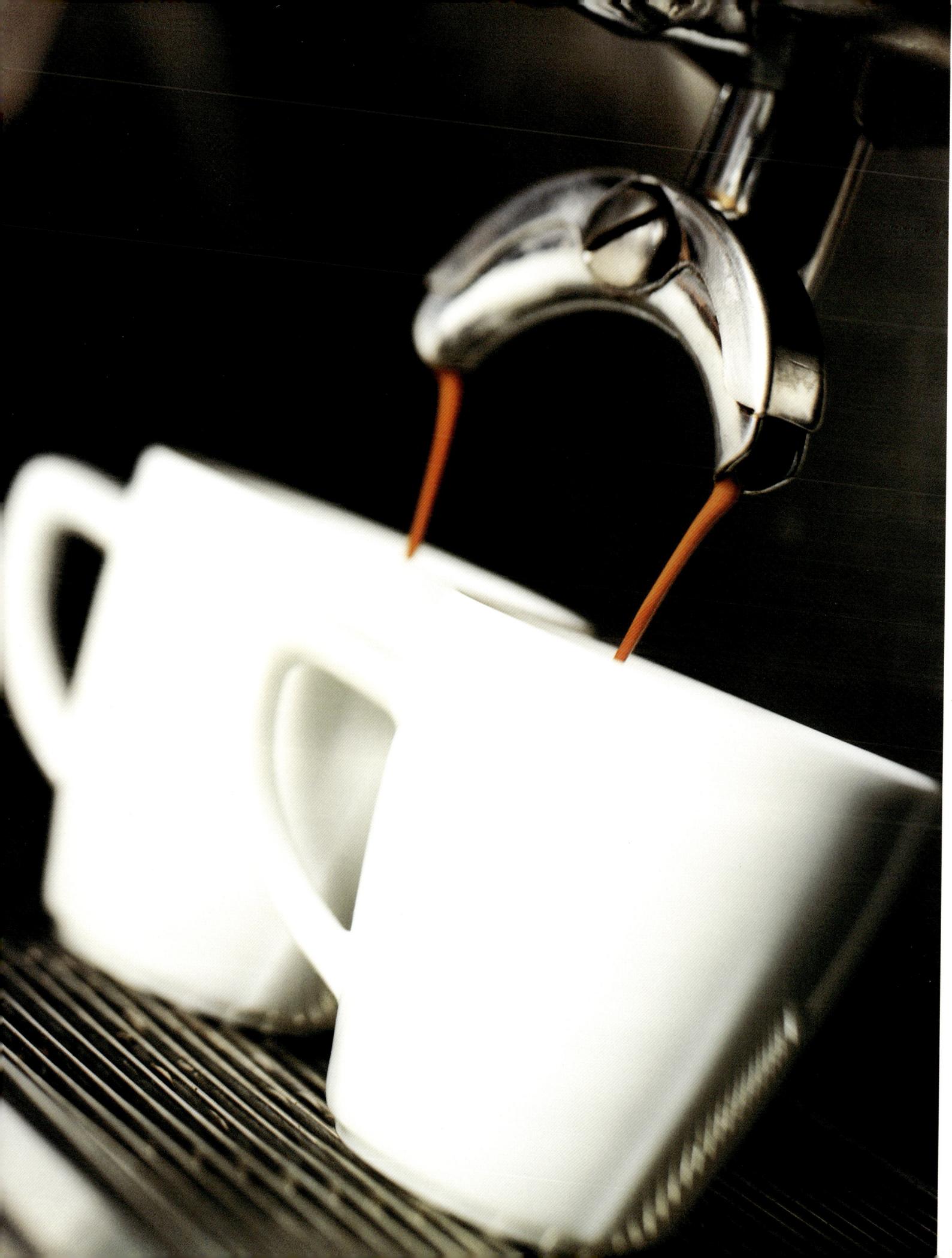

WE ARE ABOUT CREATING
PURE SPACES
STAN SARRIS

09:30

Jan tugs at Liam's jacket.

"Job interview. The bloke from the UK." She points to the bar where the hopeful is waiting. He has been told by the chef at London's *Pied de Terre* to make *Banc* his first stop when looking for a job in Australia.

Liam and Matt quiz him about the kitchens he's worked in and who with. They like his energy and invite him in for a trial for lunch and dinner the following Friday — the two busiest shifts of the week.

No one is employed at *Banc* straight off. They must be tested to see if they meet the high standards required, and get along with the team who will not tolerate a weak link in their chain.

The kitchen porter is on his fourth lap of the floor.

Interview over, Liam joins Stan Sarris at table 11, where Stan is presiding over the weekly operations meeting. Along with Liam, Jan, Remi, bar manager Sean, accountant Rebecca and promotions co-ordinator Jackie Blundell, he's getting things sorted out.

Known as 'Mr Detail' to his staff, Stan runs a tight ship, using a combination of street smart and gifted lateral thinking to find solutions where none seem to exist, like the time a burst water main flooded the whole restaurant on a Friday morning when it was fully booked for lunch. Stan managed to orchestrate a strategy to resume normal trading in time for dinner — and all from his hotel room in a remote part of Bali.

The other team members at the table are dedicated and dynamic. They are not only in charge of *Banc*, *The Mint Room* and *Wine Banc*, but also oversee their specific areas at The Eaternity Group's other massive venue, The GPO, at 1 Martin Place, where there are three more restaurants, a bar and a food hall.

At this meeting they've decided to fire the cleaners. The fifth set of cleaners in 14 months. The reason? Standards and to help lower Liam's blood pressure. There is nothing that irks him more than a badly cleaned kitchen.

There is also an update on how each restaurant and bar is performing, profit and loss figures are gone through and promotions are discussed. Jackie updates everyone on the functions and special dinners booked for the future. A major advertising agency wants a cocktail party upstairs and Cartier wants a Melbourne Cup Lunch. The meeting is quick and to the point. However, later in the day each department head will have time to discuss their specific areas with Stan.

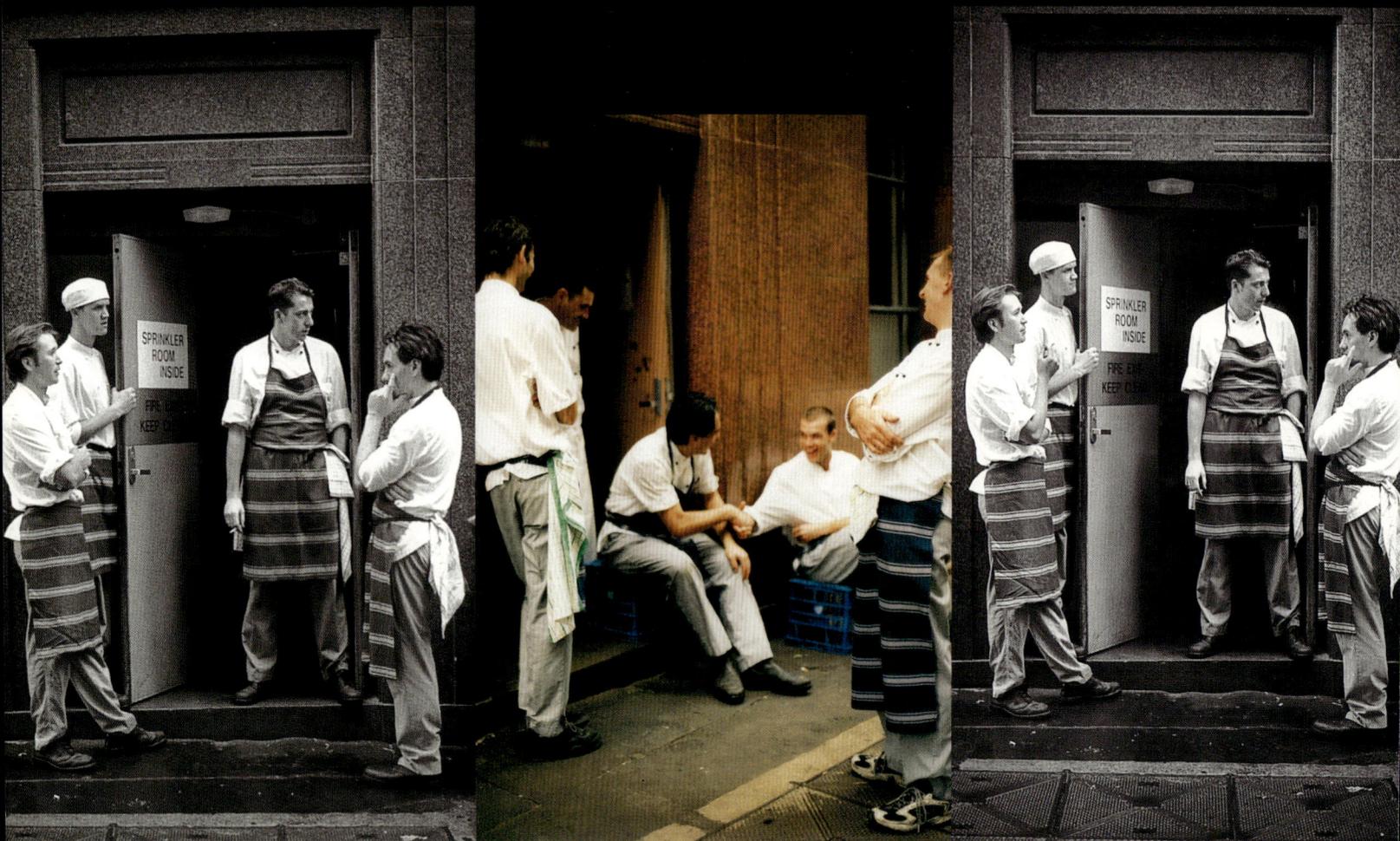

09:45

As everyone starts to head for their stations, Stan asks "Did anyone see the story in the paper about 'Bobbies at The Banc'?"

"Yes," chips in Jan "I couldn't believe it. Two cops arrived in the middle of lunch with a big yellow envelope. Just about everyone in the restaurant ducked for cover."

Stan laughs, "It was only the licensing boys, with the paperwork for the new bar."

"They didn't know that!" chortles Jan.

09:50

A delivery from the greengrocer arrives in the main kitchen. The goods are sorted and some ferried, by the porters, to the kitchens at *Wine Banc* and *The Mint Room*. Citrus fruits are sent to the bar fridges and fruit and berries go straight to the pastry chef. The vegetable section is already preparing the different types of mushrooms, almost before they are unpacked.

10:00

The kitchen is pumping. Irish Sean has all the meat ready in the back fridge. Matt has painstakingly removed all the bones from the fish with tweezers, and has it portioned and wrapped for service. The vegetables have all been blanched, the tomato terrine is setting in the fridge, the sauces have been 'passed' and the team is now concentrating on rolling out pasta to make ravioli.

The pastry chef is already three quarters of the way through her daunting list, and is now making petits fours for lunch.

The kitchen porters have been designated to 'pick' (remove the leaves from the stalks) two boxes of spinach.

10:15

While the crescendo builds in the kitchen, head sommelier Remi Bancal is calmly tasting champagne at *Wine Banc* with a rep from Remy Australie. They are also discussing a corporate tasting and wine dinner to be held at *Private Banc*. Some would say Remi has the perfect job, getting paid to sample the best wines in the world. But it has taken many years to develop his fine palate and amazing knowledge.

With more than 930 different wines on the current wine list, and 150 others aging, keeping track of every label and every vintage is not a task for the faint-hearted. Remi not only has to be a connoisseur, but also part accountant, part cellarman as well as a muscle man to get the job done.

Bar manager Sean joins Remi at the tasting and then rushes off to take charge of more deliveries. At the same time a representative from The Alexander Group arrives with cedar boxes of cigars for the humidor.

10:30

Today's waiters arrive just in time for lunch. Plates of sandwiches are unceremoniously plonked on the bar in *Banc* and on the kitchen bench. Everyone eats while they work. Cameron misses lunch in preference of a cigarette out by the garbage bins. At least his head is clearing now. Ricky the plongeur is buried in pots and pans. Even now, they are being used faster than he can wash them.

CLOUDS OF WHITE DAMASK
ARE THROWN IN THE AIR,
AND COME FLOATING GENTLY DOWN
TO REST ON THE PADDED TABLETOPS

11:00

The waiters are setting up the dining room. Clouds of white damask are thrown in the air, and come floating gently down to rest on the padded tabletops. Within minutes there is a chequerboard of crisp, white, double-layered table-cloths through the room. Starched, white damask napkins are meticulously folded with their creases precise enough to please an army sergeant major.

Silver cutlery is polished and repolished until you can see your face in a knife blade. The elegant Riedel crystal glassware has an equal gleam, while white Limoges side plates complete the setting on each table.

Sugar bowls and salt and pepper shakers are filled, menus are sorted, and ones with even the tiniest mark are binned. Stocks of toothpicks, matches and ashtrays are checked — even though the restaurant in non-smoking until after 2.30pm at lunch.

Silver crumbers are cleaned with a hot cloth, while docket books and spare plates and cutlery are distributed to the workstations. There are countless small jobs to be done, but each is an important part of the giant jigsaw that will fit together to make lunch and dinner a success.

11:10

Remi has bid the rep from Remy Australie *adieu*, and is now chatting to Olivier and Joellen from Pommery Champagne about their Summertime Blanc de Blanc NV. Five minutes later Ben from Penfolds arrives with a case of sample wine for Remi to try. Together they try all of them.

The phone rings. Jan wants to know which of Remi's team of sommeliers is on duty in *Banc* for lunch? Today, it is Remi himself. He changes and coifs his hair and giant moustache 'for the ladies', to be ready for restaurant by midday.

11:30

A stills photographer has arrived to check out *Banc*. Stan has given him permission to use the dining room as a location for a fashion shoot the following day.

He launches into a creative diatribe about wanting to change tables around. No one is really sure what he's talking about, but Jan politely smiles and tells him he can do whatever he wants as long as he's finished by 11am as lunch begins at 12.

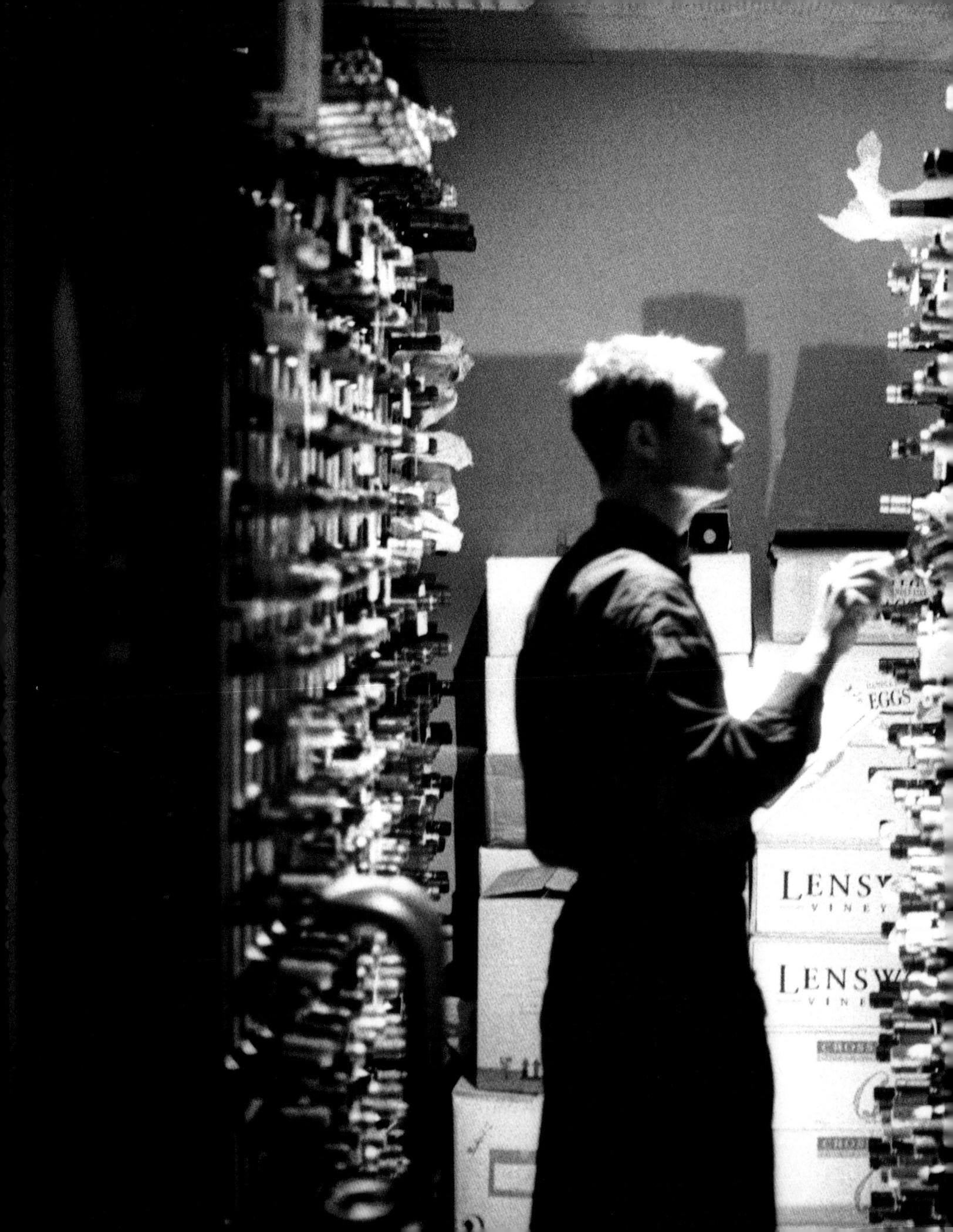

11:40

The final touches are put to the restaurant, while in *Wine Banc*, head barman Sean Jones is overseeing the polishing of glasses, the stocking of bar fridges and checking his inventory. Those requiring a cold glass of wine and a quicker, more casual lunch, will soon be arriving down the stairs. He still hasn't been able to find a replacement waiter, so warns the kitchen and asks them to go easy with the orders, so that he and his staff can cope.

11:45

"Staff briefing and menu testing," yells Liam, and all the waiters gather around. He takes them through all the menu. "We've only got 14 portions of salmon today. There are four new cheeses on the trolley. Does everyone know what they are?" Every six weeks, when the menu is changed, Liam drills the staff on the new dishes, explaining how they're made, what's in them, how they are presented and how they should be served. Liam and Jan are most insistent that the staff gets it right every time. At *Banc* you won't find a dish being served upside down, or a waiter unable to answer questions about the menu. Liam tests the staff regularly and anyone not up to scratch is not allowed to work.

11:55

Jan sticks her head into the kitchen once more — this time to tell Liam lunch bookings are up to 88, that Mr Adler is on table 77 for three, and that a special regular customer is on table 41.

The kitchen is performing all the last-minute jobs before service. Bread is trayed-up, the larder, including vinaigrettes and fish ready for cooking, is taken out, and the cheese trolley is set-up and covered with a piece of damp muslin cloth to keep everything fresh. The bench used for fish preparation has been converted into the salad section for service. Liam goes down to *Wine Banc* to make sure their kitchen is also ready.

Members of the kitchen brigade dive out of the back door for one more quick fag, while Ricky the plongeur gives the kitchen floor its final mop. It's easier this time as all members of the kitchen team are on the doorstep puffing away.

12:00

All are at their station. The restaurant is ready. The kitchen is ready and the bar is ready. Now, for a few moments, there is deathly quiet. Then, ever so softly, the gentle note of a saxophone breaks the silence. The giant green pillars, the sparkling tables and the waiters in their crisp white shirts and long black aprons are all ready for lunch.

Suddenly, the room is cold. Very cold. Jan has turned the air-conditioning on full for a few minutes, giving the restaurant a chilling blast to freshen it up. It's an old trick, but it does the job.

As owner Stan Sarris says, walking into a restaurant should be like getting into freshly starched sheets. Nothing beats the feeling.

12:10

As the gentle summer rain starts to fall outside, the first lunchers arrive. The top end of town is out in force. Judges, barristers, bankers, and business people file in, to be greeted by Jan and her deputy, Tanya — now themselves besuited in black. The room is soon a monochromatic sea of business attire, punctuated, every now and again, by a colourfully dressed female luncher.

Rodney Adler is ushered straight to table 77. It's known as the power table and is in such demand that people keep track of when Mr Adler is out of town so they can book it.

12:30

The restaurant is three-quarters full. The lunchtime crowd is prompt, hungry and mostly in a hurry. The corporate lunch is a quick one with deals to be done, deals to resurrect, ideas to unfold. The conversation level builds to a crescendo, taking over where the pre-lunch music left off.

Orders are taken, and Remi Bancal, the ever-helpful sommelier, is dispensing advice on wine and vintages. He is multi-functional. He can swiftly remove a cork, pour a beer and update waiters on additions to the wine list without ever taking his eyes off the restaurant.

Jan, who also doesn't miss a thing, gently taps his elbow. The gentleman on table 12 would like to see him. He's off again.

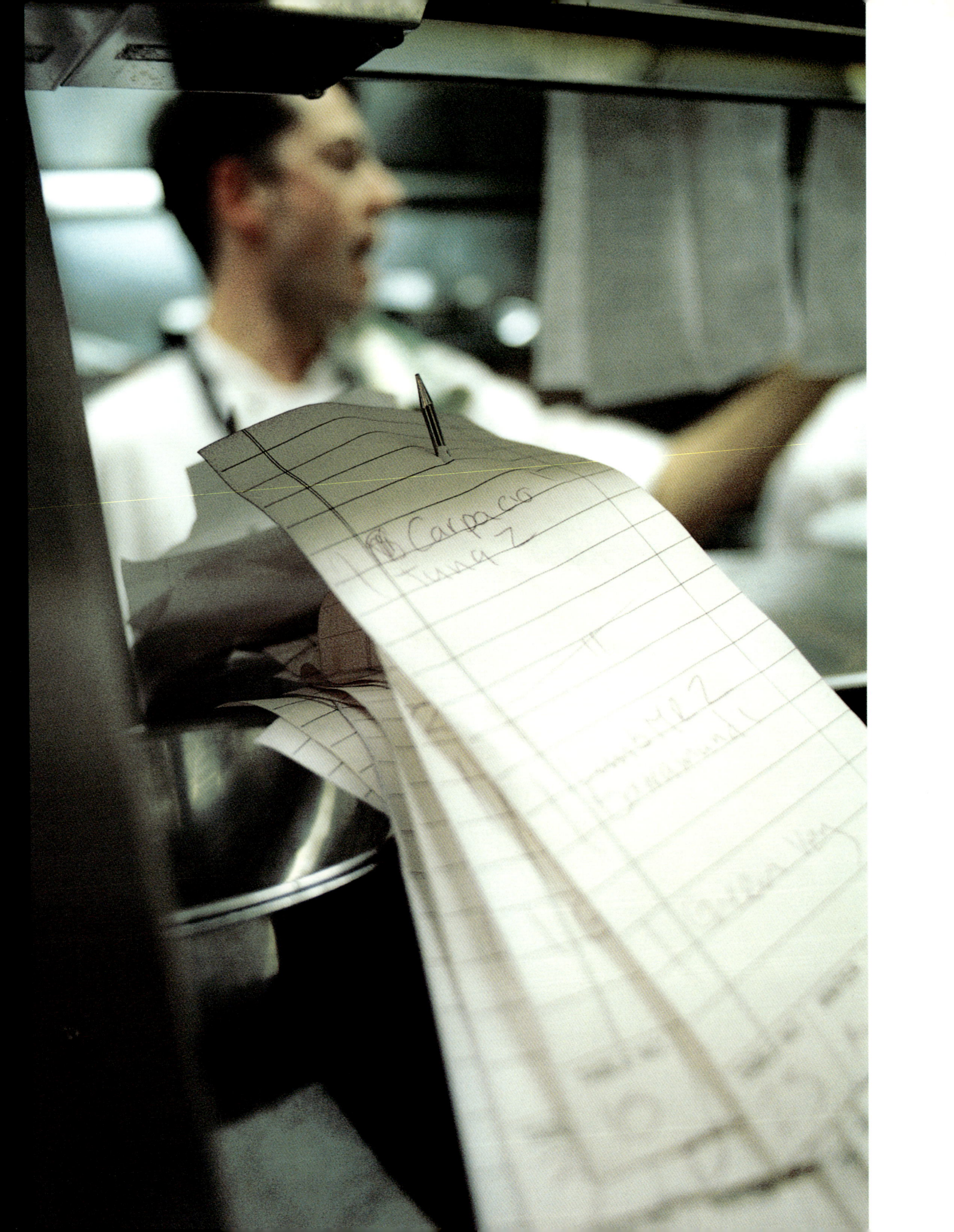

12:45

The general calm of the restaurant belies the explosion of activity in the kitchen. Liam has it pumping like a well-oiled machine. He personally takes care of every order that arrives in the kitchen, and sounds like an Irish version of racing broadcaster Johnny Tapp, calling them as fast as they hit the kitchen:

"Two salmon, Dory ready!" he yells.

"OK, next, table 8, special, snapper, kipfler.

"Straight after that one Dory, Rossini times two, medium rare!

"New order, two consommés, get two bowls!

"I said two bowls.

"To follow, one John Dory, one tomato salad.

"Don't boil the hell out of those yabbies!

"How long on the special snapper?

"No, not like that — the yabbies go on top!

"Three snapper, two chicken, one salmon, one green salad."

Meanwhile, at the other end of the kitchen, Matt is competing in broad cockney, calling the orders away (sending the ready food out of the kitchen).

"Away on 62!" yells Matt.

"Ready! Away!

"Black pan, black pan!

"Sauce for special, now, now!

"41 away

"Daryll have you got the chicken up?

"Table 11, away

"More plates, more plates, give me more plates."

The only reply Liam will consider to any of his orders, and the only response any of the team would dare give is a simple and respectful "Oui, chef".

After all, he's the master. He has eyes designed to fly and is able to watch every corner of the kitchen at once. At the same time as calling the orders, he gives each of his dishes its final touch. The hours he spends bent over the many plates, perfecting every detail, probably means huge chiropractic bills later in life. He doesn't care, nothing leaves the kitchen without his signature of approval.

He is a true artist and he puts his very soul into every dish, so it is understandable that, if on the odd occasion a customer is not well pleased, it cuts him to the bone.

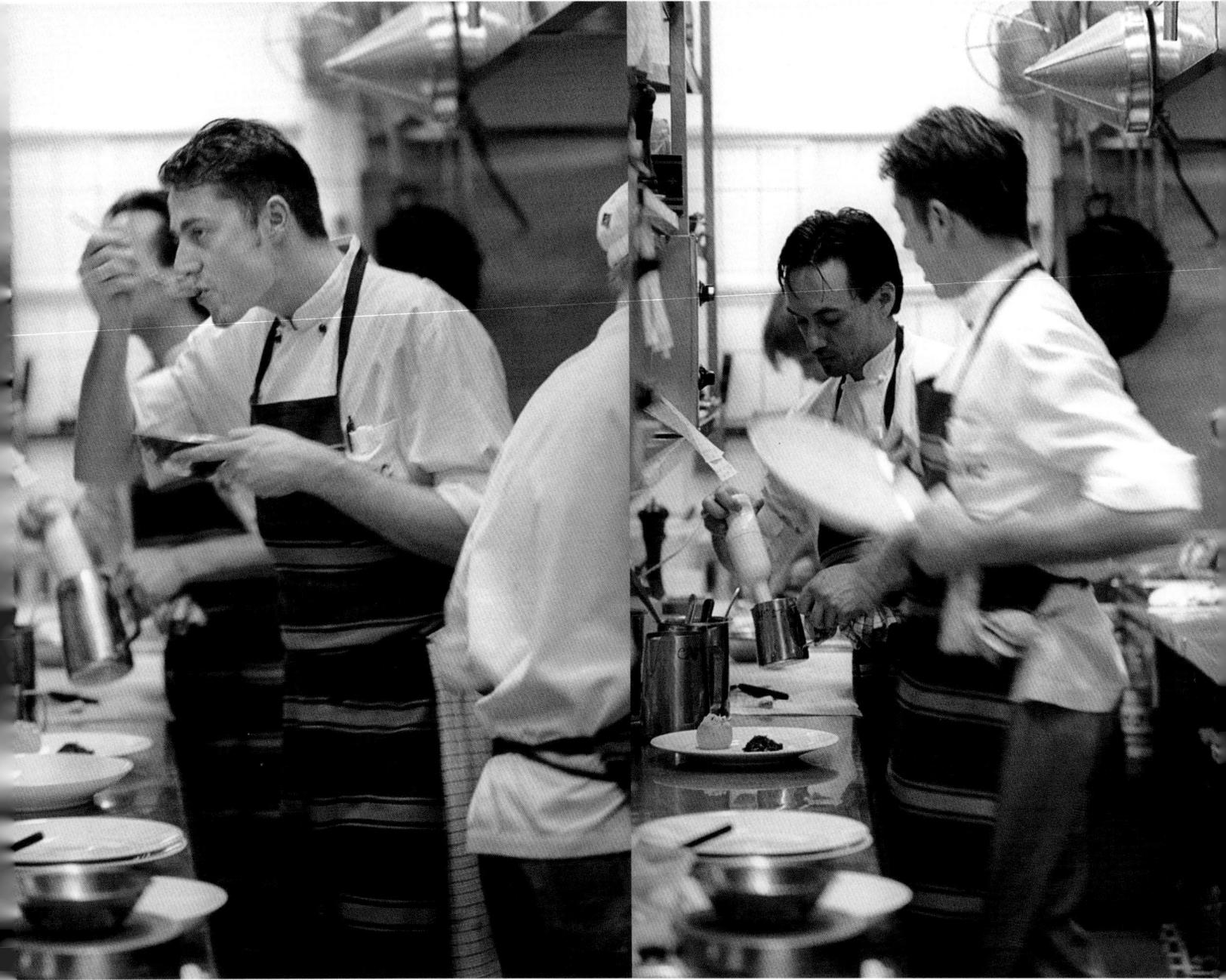

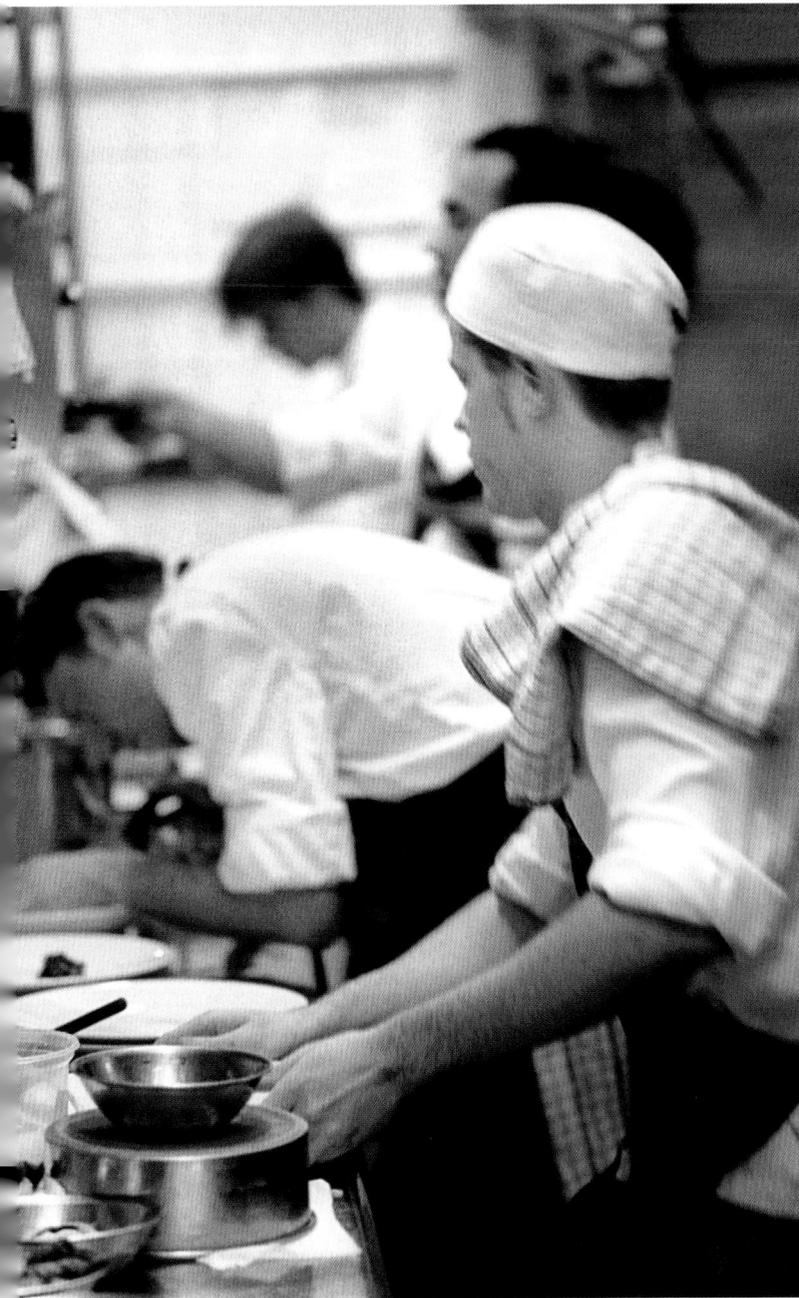
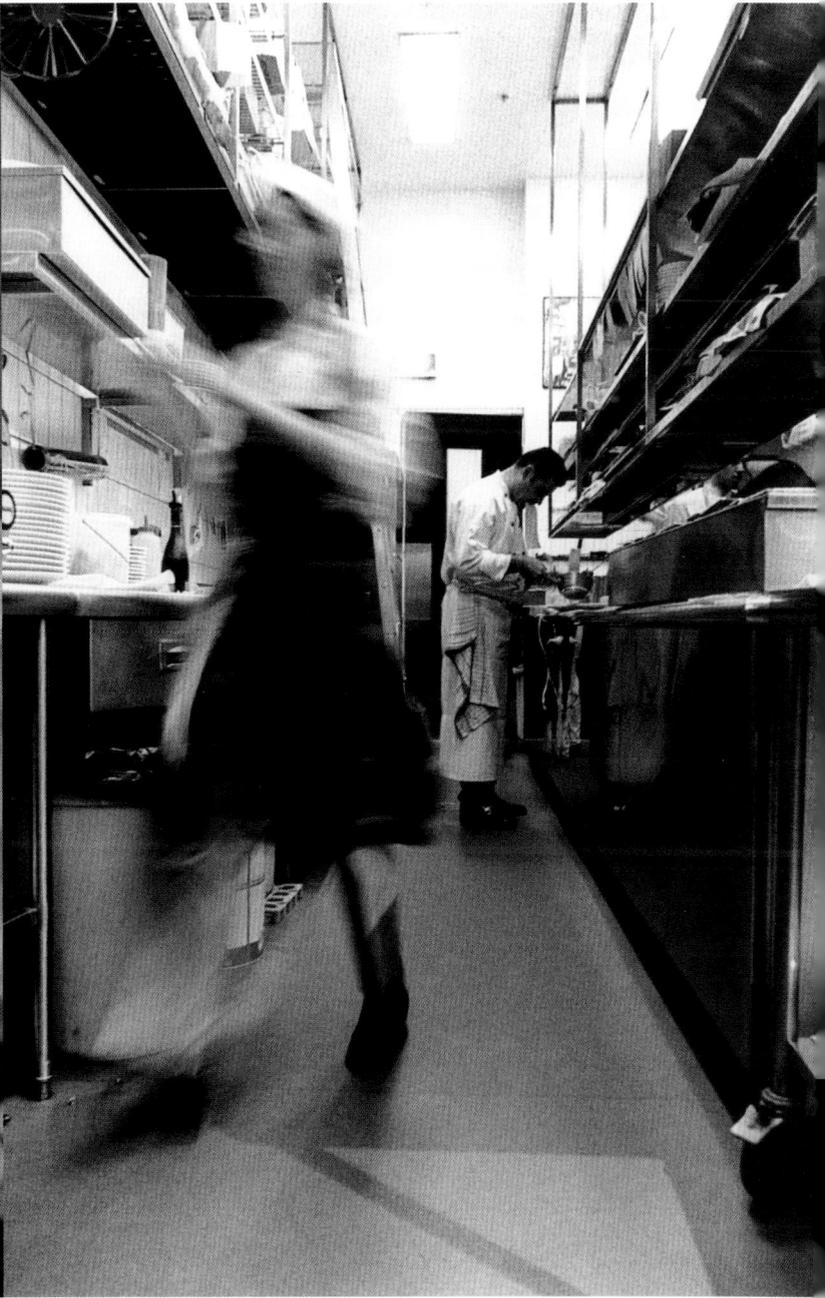

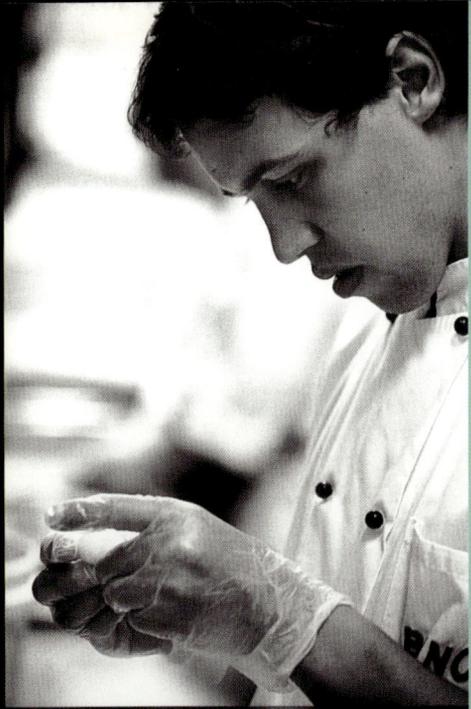

13:20

Front of house, Jan cruises through the room. She scoops up the finished plates from a judge's table, and continues on past Rodney Adler's table to check he is enjoying his tuna and Bannockburn Semillon.

Stan is entertaining an overseas food writer at another table. They are sampling plates of assorted mini-starters and a splendid bottle of Sancerre.

News of an exceptional restaurant spreads like wildfire throughout the ranks of the food mafia. Like bees to honey the international food writers come in their droves to savour the cuisine. All, so far, have declared *Banc* a success.

International food writer, Robert Carrier was so impressed he asked Liam for two of his recipes. Jane Adams who writes for *Cuisine* in New Zealand gave *Banc* the thumbs up, writers from the French magazine *Savoir* gave *Banc* rave reviews, while writers from New York's celebrated *Food & Wine* magazine listed *Banc* and *Wine Banc* amongst the best restaurants and bars around the world, and Britain's *Wallpaper* dubbed *Wine Banc* one of the globe's best bars. It is little wonder the world is sitting up and taking notice of *Banc*.

13:30

The kitchen door swings open again and again, and each time there are two neatly curved Limoges plates resting easily on the waiter's arm. Each plate has survived Liam's scrutiny, and is now ready for the hungry customers.

There is, by now, only one unoccupied table. It's probably a 'no show'. No shows are the bane of any restaurant that has daily waiting lists for tables. Nobody has figured out a way to solve the problem, although there's talk of embracing the British system where, in the better restaurants, a credit card number is required on booking, and a fee is charged if the customer doesn't turn up. But, for now, Jan places their names on her 'black list' of unreliable customers, those who are never to be given preference over others for tables.

13:45

The first bill has already been paid, and a table of six has beaten a hasty retreat. One of their group has a plane to catch. The table is quickly reset to accommodate late lunchers.

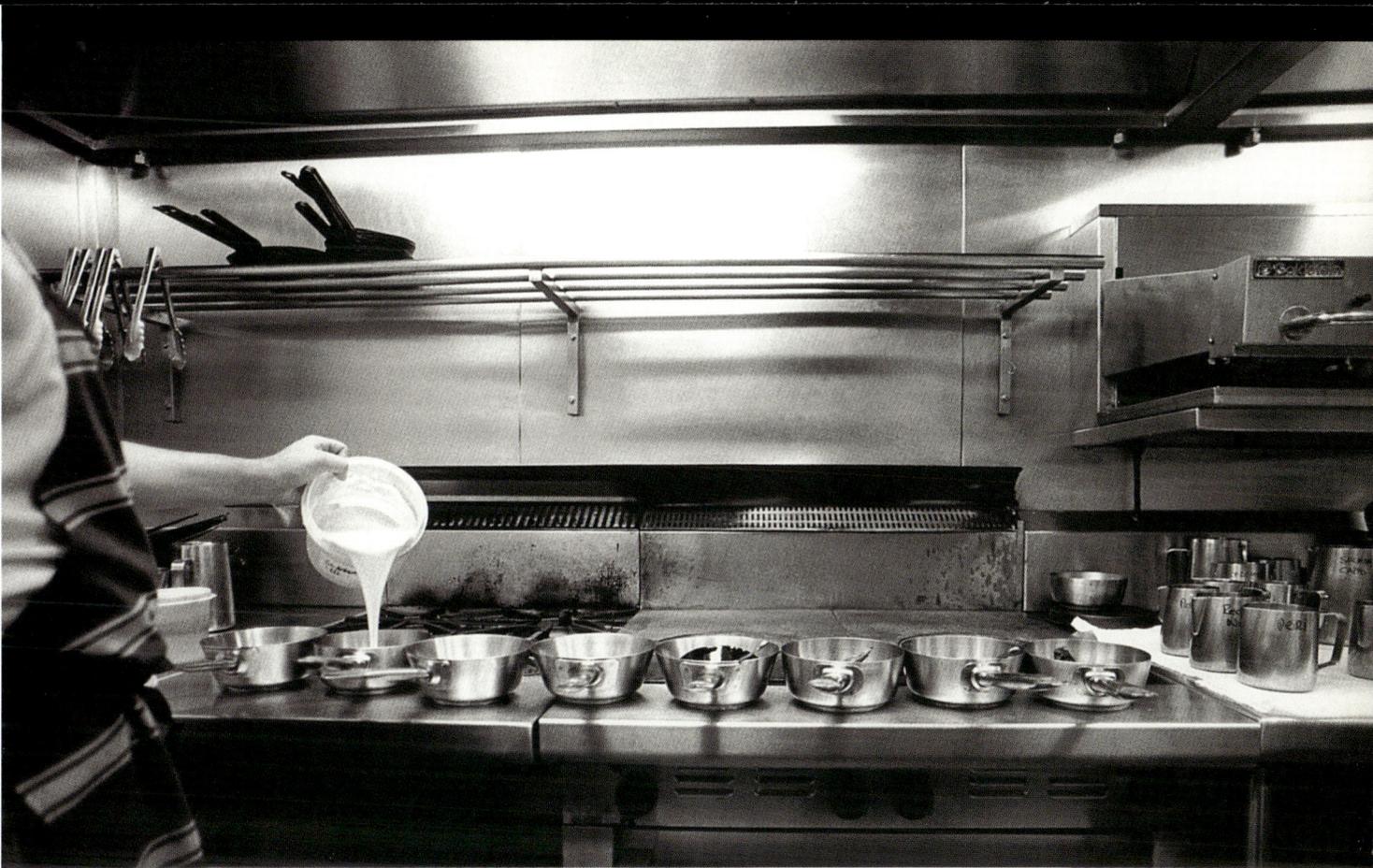

Jan's team is working with precision, akin to the US marines on parade. Menus are delivered, plates are served and wine is poured without missing a beat.

13:50

Down at *Wine Banc* the restaurant is three-quarters full. Two waiters, dressed in black, are moving calmly, albeit quickly, through the tables. Nobody would guess that they are short-staffed today as drinks are poured and plates of freshly shucked oysters, juicy steaks and plates of Tuna Niçoise appear on the tables.

13:55

Disaster in the kitchen! A new runner has dropped the fish dish for a table of four. This means the other three meals will have to wait. Detesting the idea of serving cold food, Liam insists on doing all four dishes from scratch, so that everything will be ready at the same time.

The disgraced runner is sent in search of Jan, who will have to explain there has been a delay to the customers. She offers complimentary canapés to ward off hunger pangs. The diners smile and return to an animated conversation. They probably weren't quite ready to eat yet anyway.

14:00

Although the rest of kitchen is beginning to slow down, Liam has lost none of his verve and is now calling the dessert orders. Names of delicious-sounding dishes such as 'Chocolate Plate, Passionfruit Jelly, Lemon Tart, and Poached Pear' resound. The pastry chef prepares each one to perfection.

14:05

While some customers sit back and take in the full beauty of their dessert, others are inspecting the cheese trolley.

Two 'walk ins' appear and are shown to the single empty table. Judging by their shopping bags, they have been doing some 'retail therapy' at the nearby Gucci, Prada and Chanel boutiques. They quickly order the chicken and the Yarra Yering Rosé without even glancing at the menu. It's safe to say they've been to *Banc* many times before.

14:10

Liam wipes his forehead, finally stands up straight and takes a deep breath. Another lunch, another happy crowd and another bad, aching back. He's at full stretch as the order from the 'walk ins' appears on his spike. He barks out instructions, and the team, most members of whom had been hoping to sneak out for a quick smoke, springs into action once again.

The kitchen porter is wearily sweeping the floor for the tenth time.

14:20

An unfamiliar calm descends over the dining room as customers sip coffee and enjoy the pastry chef's delicately constructed petits fours.

Jan is at the cash register running through a Gold American Express Card. It's been rejected. What will she do now?

Smiling, she smoothly approaches the table and informs the cardholder there is a telephone call for him. Once at the phone, she discreetly informs him of the problem, and he pulls out another credit card. The problem is solved and his guests are none the wiser.

14:25

Downstairs at *Wine Banc*, despite being short staffed, Sean and his team have managed a busy lunch without any hitches. He's back behind the bar making coffee for the last few tables of lingering guests. A group of bankers orders a bottle of Cristal. Sean grins and takes a wild punt that they won't make it back to work.

14:30

As far as the kitchens are concerned, lunch service is over. In the main kitchen, they've done 88 covers. Matt phones down to *Wine Banc* to check its numbers. He needs to assess what extra produce to order on the afternoon delivery.

The larder section has bailed out for a welcome hour's break, but things don't look as good for the vegetable section who have to work straight through because they got hammered at lunchtime, meaning their stocks of freshly prepared produce are low. The sauce section has been assigned the duty of making the staff meal today, while the ever-serene pastry chef is quietly preparing a list of chores for her assistant commis to get on with. Liam joins the boys outside for a quick smoke, before rushing off to a meeting with Stan at the office. On his way, he sticks his head into *The Mint Room*. The open sign has just gone up, and the barmen are readying themselves.

Today, the stock market has gone berserk with some of the heaviest trading in recent times, so the bar staff is expecting a rush of stressed out, perpetually thirsty brokers to arrive at any moment.

14:45

The phone rings in *Wine Banc*. It's Jackie from promotions. Stan wants an urgent meeting with Sean about tonight's special function.

By now, his customers have nibbled their way through, amongst other things, Squid Ink Risotto, Coq au Vin, Duck Confit, and Veal and Bacon Terrine, and have departed, all except the bankers, that is. They are now well into their second bottle of Cristal.

Sean leaves his assistant, Sally, in charge of the bar and heads over to the Eaternity head office to see Stan.

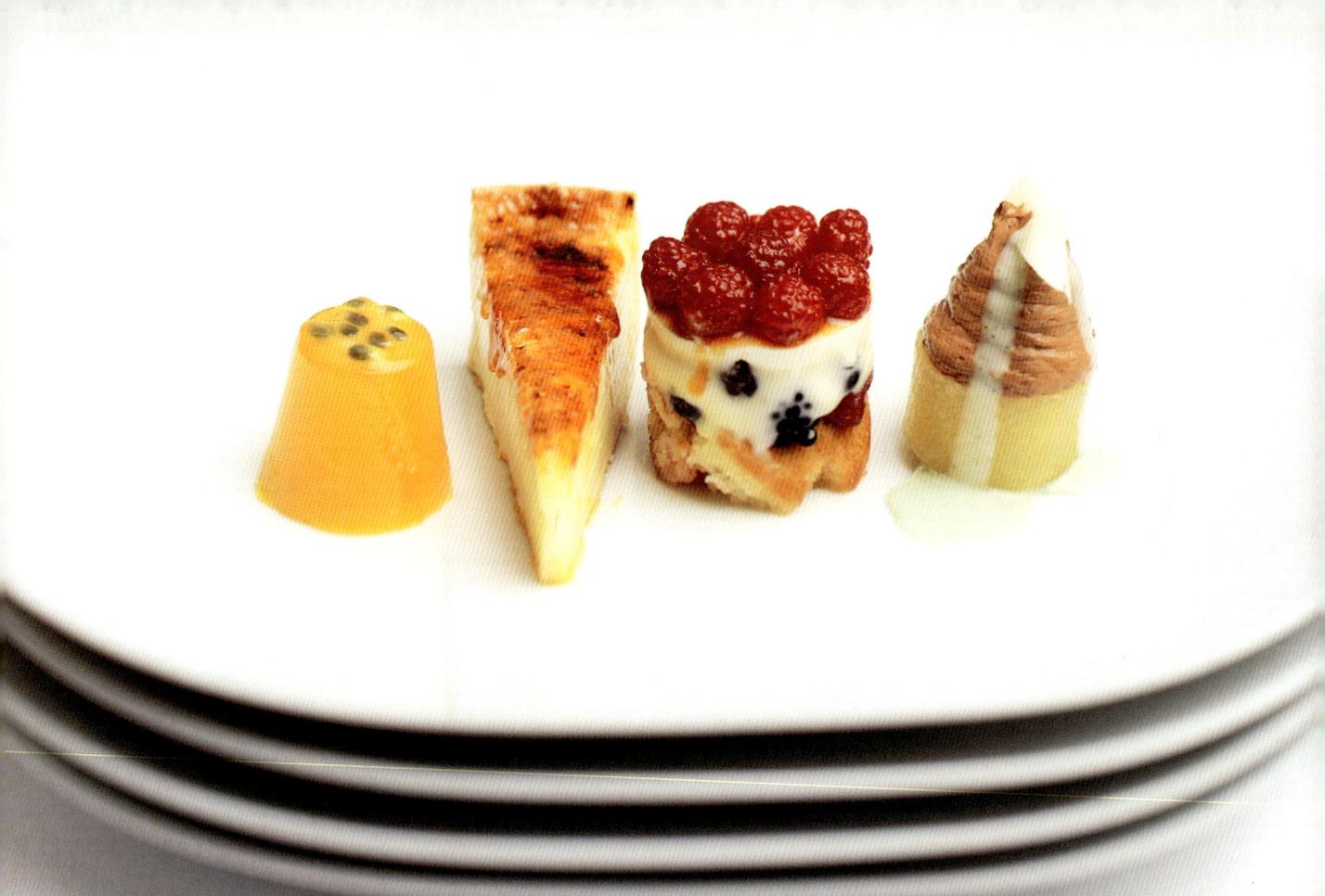

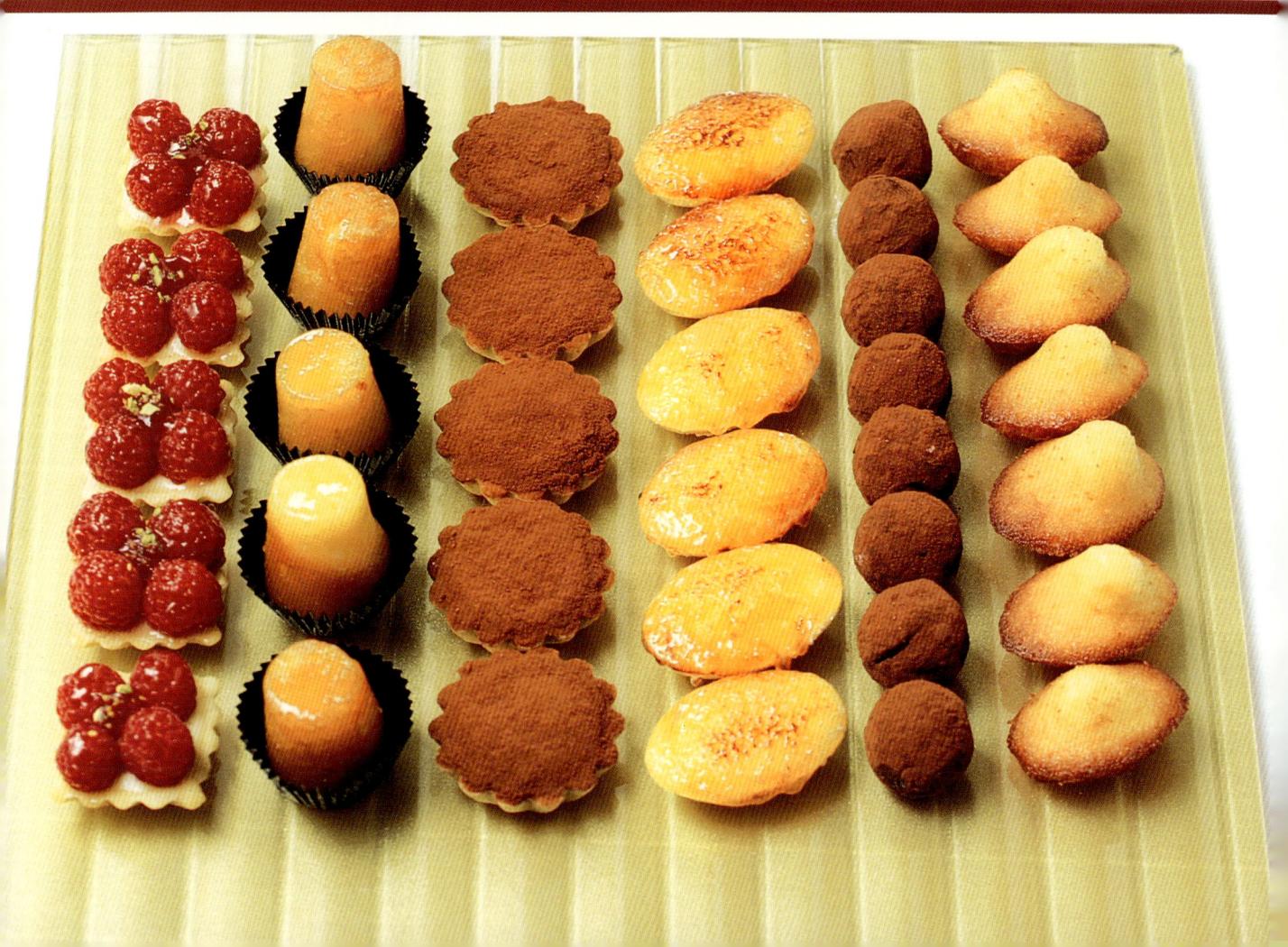

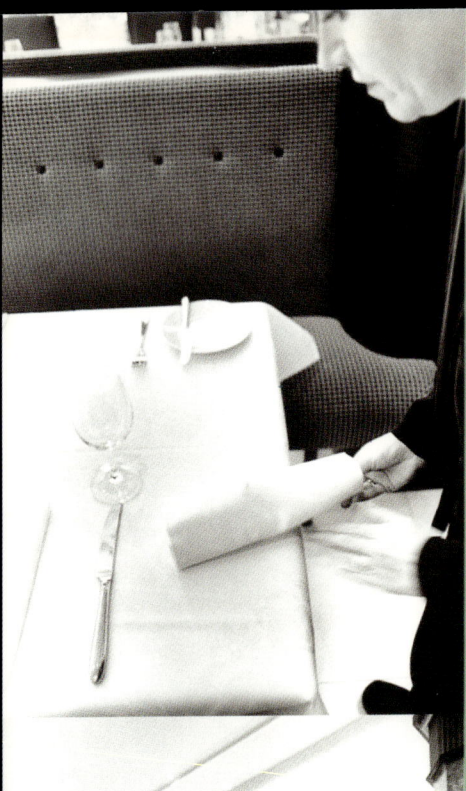

15:15

The last of the lunch crowd is leaving *Banc*, and the waiters start to reset, but not for dinner. Tonight, there is a cocktail party scheduled between 5 and 7pm. This time it's for one of the better international cosmetics companies. They've chosen *Banc* to reflect the quality and style of their product. Jan builds herself a temporary office at table 12 to go through the afternoon's dockets, while simultaneously yelling instructions to the staff.

Remi Bancal organises glasses, chills champagne and makes sure the martini recipe is to his liking. One can't help admiring the fact that he can sip alcohol throughout the day without any adverse affects to his person or his performance. Perhaps it has something to do with being brought up on a vineyard in France.

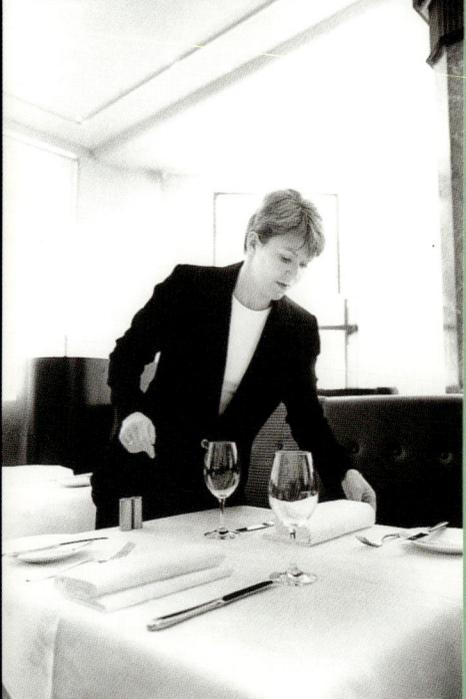

15:30

Reinforcements arrive in the kitchen in the form of two more lanky chefs. Due to the impending, action-packed evening, everyone else is on what is affectionately called the AFD (all frigging day) shift. The only staff members allowed to escape are the now totally exhausted kitchen porters. They are replaced by their evening shift counterparts who have taken over the interminable sweeping of the floors and polishing of the plates.

The afternoon produce begins pouring in from the butcher, baker, fishmonger and greengrocer. Under Matt's watchful eye it is quickly sorted before Liam returns to his stainless-steel domain to check that the 2000 canapés required, have been prepared to his specifications.

Wine Banc is setting up for a promotional night called 'Whiskey Banc.' A liquor company wants to educate the customers on the joys of prestige double and single malts, and how they can be matched with specific types of cigars.

The barmen are expecting more than 100 thirsty guests at around 6pm. So, shot glasses are being polished, while a Latin American jazz band sets up in one corner, and glamorous cigarette girls load cigars onto their trays in another.

Sean returns to discover one of his staff is running late, and that Stephan, a sommelier from upstairs, is having trouble with the new Jetz computer system. Despite being flat tack, as well as short staffed, Sean spends the next hour educating him on the finer points of the 'inward goods' program.

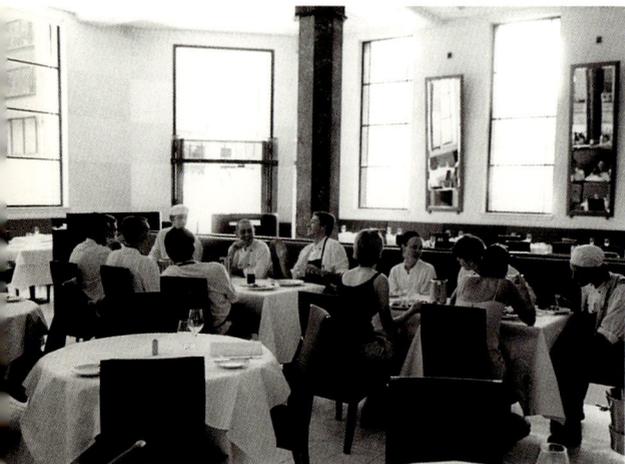

16:00

In *Banc*, assistant maitre'd Tanya Poles interrupts Jan's overworked calculator to let her know that the PR from the cosmetics company holding this evening's function has arrived. The PR has already launched into a swirl of perfumed activity, and is directing a celebrity room designer, employed to dress the room for the occasion. Unfortunately, they seem to have forgotten *Banc*'s 'no signage on the wall' rule. Stan is discreetly called upon to head off what could potentially become a problem.

Five minutes later, he arrives from his office and diplomatically suggests that the designer abandon his signs in favour of armfuls of the cosmetics company's signature red roses arranged on the shelf behind the banquettes. The effect is sensational, and everyone is happy — until the PR begins to rearrange the furniture. Again, Stan diffuses the problem by charmingly reassuring her everything will work perfectly the way it is. Jan and Tanya have had enough and have disappeared behind the bar to devour copious amounts of Cadbury's chocolate, their 'sweet fuel' to get them through the evening.

A waiter preparing for tonight's function is busily going about his duties when Liam walks into the restaurant for one of his spontaneous checks.

'Where the hell are your socks?" he booms. The room goes silent as the waiter in question explains that the reason his bare feet are crammed into his black Cox's is because he's forgotten his socks. The aberrant staff member is immediately led to the kitchen where Liam produces a large, black felt pen and, with help from his lads, proceeds to colour-in the waiter's feet.

"That ought to do," Liam announces, admiring his own handy work. The black-footed waiter is amused, nevertheless he won't forget his socks again.

16:30

The staff meal is up half an hour early today because of the function. Members of both kitchen and front-of-house staff congregate around one table to eat a hurriedly prepared pasta dish. This is downed in 15 minutes with the clatter of cutlery punctuated only by the usual bawdy repertoire from the boys in the kitchen. Tonight they're discussing the pros and cons of a full body wax. At the same time, the cleaners, who are either immune to base humour or don't speak English, are giving the room a quick spit and polish in preparation for the night.

THE KITCHEN TEAM
WILL NOT TOLERATE A
WEAK LINK IN THEIR CHAIN
LIAM TOMLIN

THERE'S A BIG DIFFERENCE
BETWEEN DINING AND EATING

17:00

Rows of immaculately turned-out waiters, who are now dressed in their evening attire of black cropped jackets and long white aprons, line the entrance of *Banc* as the media and the social 'A List' floods through the door. Flutes of Bollinger are dispensed almost as fast as the obligatory 'air kisses'.

Exquisite delicacies emerge on trays from the kitchen, and nimble waiters move through the throng offering Oyster Vichyssoise with Oyster Beignets, Mini Beef Tartare and Duck Liver Parfait, careful not to cause a spill on wayward wisps of Chanel or Gucci.

Stan arrives and moves effortlessly through the room greeting guests, appearing to remember every name and face. Outwardly he is relaxed, but in truth he is keeping an eye on every detail of the function to ensure it runs like clockwork.

17:30

Liam's team in the kitchen has snapped back into professional mode, simultaneously sending out tray after tray of intricately prepared delicacies, as well as preparing for tonight's service. Liam rings down to *Wine Banc* to check that the kitchen is under control for the 'Whiskey Banc' function set to commence in half an hour. He then checks the kitchen at *Private Banc* where

AT BANC YOU DINE

LIAM TOMLIN

preparation is being made for a corporate dinner for 16 scheduled for 8pm.

A waiter whispers something in Stan's ear. Apparently, one of the 'A List' guests has locked herself in the ladies' room, and can't get out. Perhaps a little too much champagne and too few canapés means her co-ordination isn't what it should be. Despite all efforts, Stan is forced to send a waiter over the door to rescue her. Exit Stan, waiter and guest as if nothing has happened. She probably won't be able to look Stan in the face again tonight. It hardly matters, he's off to *Wine Banc* where Sydney's young and beautiful have started to congregate to sample whiskies and cigars.

18:30

The cosmetics PR is attempting to wind the launch down. Media and socialites are supplied with their 'showbags' crammed full of cosmetics and press kits as they wonder what to do next. The stylist who decorated the room has scooped up his red roses and is heading for *Wine Banc* with the cooler members of the press in tow. His massive bouquet will ensure he is popular with the women. Then again, some of the men who have sampled the whiskey a little too enthusiastically may need to take a small peace offering home later on.

19:00

Now it's a race against time; the first dinner reservation is for 7.30, so *Banc* needs to be starched and pristine within 30 minutes.

Under Jan's direction, the waiters sprint into overdrive, clearing, cleaning, polishing and preening in a whirlwind of precise action.

Billowing clouds of white damask engulf the room for a second time today, as tables are reset. A junior member of the front-of-house team, armed with white chalk, is covering any marks, such as wine spills, which have seeped through to the under cloths. This simple action saves the restaurant hundreds of dollars a month in laundry bills.

'Blast, blast' goes the air-conditioning. Jan's room freshening trick is put to good use again.

The PR person and her clients take up their pre-booked table for dinner, and a post-mortem on the function. Half of those on the social 'A List' suddenly decide they need tables too. Jan apologetically explains that *Banc* is fully booked, but offers to call a neighbouring restaurant to see if they can be accommodated.

19:30

The first of the evening guests arrives. He is a distinguished, older gentleman who has come to dine alone.

Jan greets him warmly; she knows him well. He has dinner at *Banc* at the same hour and at the same table at least three times a week. He is elegant and genteel and feels comfortable enough in this dining room to treat it almost as his own. To Stan and Liam, this is the ultimate compliment.

19:40

Guests are now pouring in. Unlike lunch, which is dominated by male diners in their serious business attire, the evening brings a colourful mix of men and women in elegant, and even sometimes eccentric creations. It is an animated and attractive gathering of people of all ages and all walks of life. A well-known film director has bagged the power table to entertain a young starlet. A stylish group of six is here to celebrate something, a politician is entertaining a journalist, various couples arrive each looking forward to an intimate evening of fine dining.

Everyone is happy with their table since there is no 'Siberia' in *Banc*. The square shaped room has excellent proportions, and the tables are skilfully laid out allowing all guests a generous amount of space and privacy of conversation without cutting them off from the rest of the room. To put it simply they are still able to 'see' and be 'seen'.

19:55

Well-dressed, well-kept bodies have filled the entire subterranean expanse of *Wine Banc*. The room is swaying to the exotic sounds of the Latin American band as shots of whiskey are slugged back and cigars are lit. Wisps of smoke waft up to the ceiling and disappear, drawn away by the special smoke filters. Almost as many women as men are puffing on hand-rolled Cubans and elegant Havanas. Tonight the cigars are complimentary, but normally they can range from $10 and $60 a piece.

The barmen are pouring shots as fast as they're consumed, at the same time keeping an eye out for those who may have over-indulged. As the law decrees, the intoxicated can only be served coffee, soft drink or a cab ride home.

20:00

As predicted, *The Mint Room* is awash with models, money market dealers, creative types and young executives on the way up. Most have come straight from work, and their loosened ties reveal it's been a hard day. Dry martinis and imported beers are the salve for the stressed and exhausted. As the DJ's cool sounds resound, bodies begin to unwind and hips start to sway.

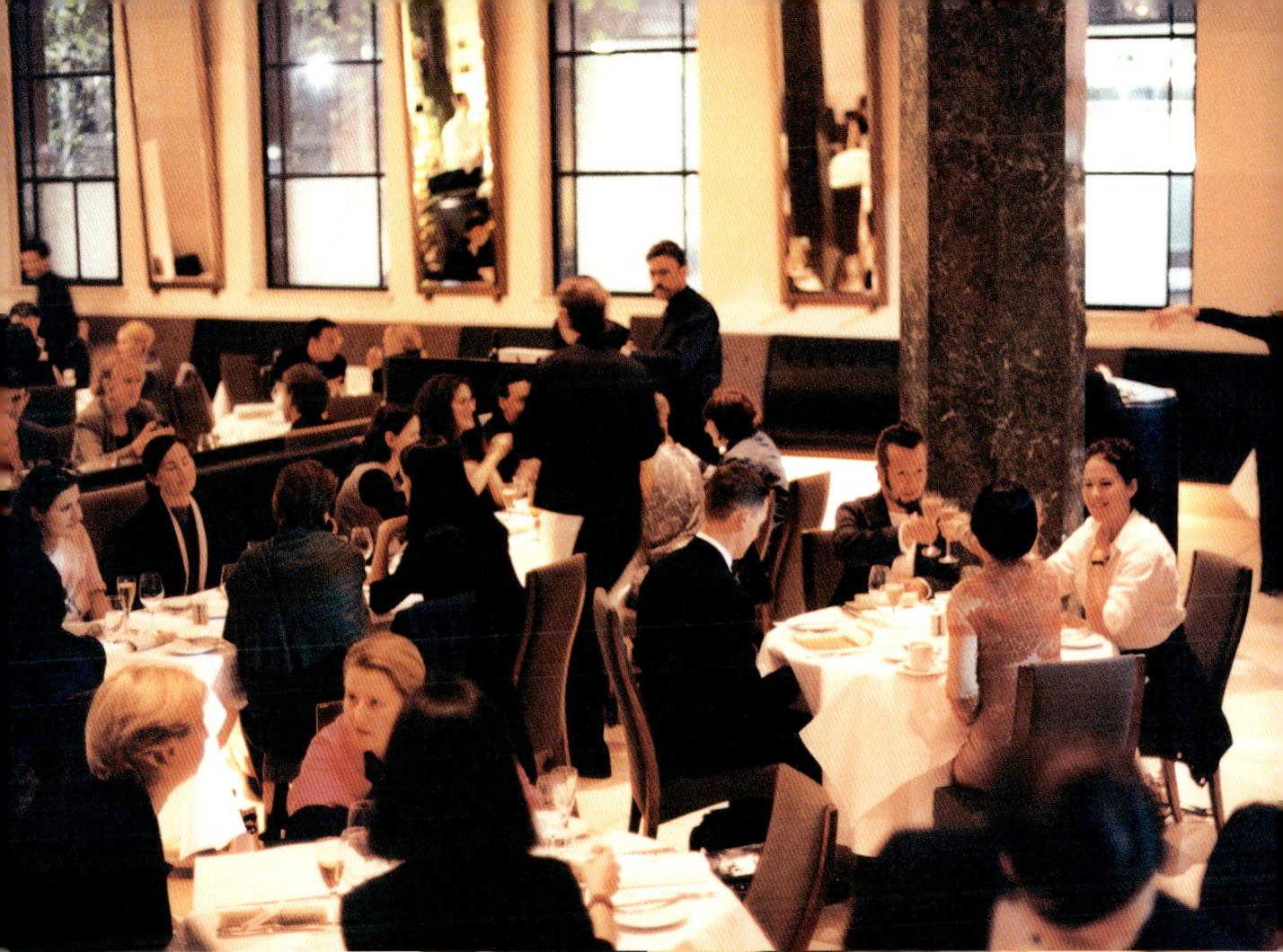
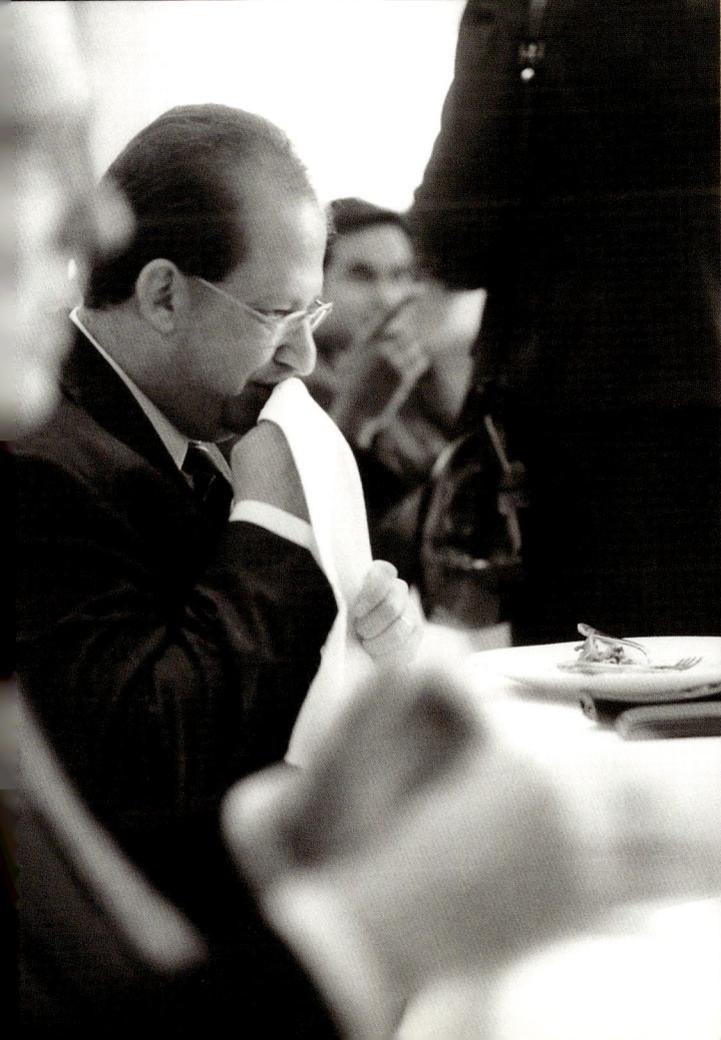

20:15

A booking for eight has arrived at *Banc*. The only problem is that there are 12 of them. Jan diplomatically explains that their largest table can only accommodate eight. Perhaps two tables of six would do? No, the group is put out, and leaves. Jan informs Liam in the kitchen. He rolls his eyes at the sheer stupidity of it, "You wouldn't turn up to the opera with eight people if you'd only booked four seats," he roars, and goes back to preparing his Rare Loin of Venison with Celeriac Purée and Spaetzli.

20:30

A fleet of limousines draws up outside the building and the 16 booked for the special dinner at *Private Banc* alight. Judging by their attire and the menu they have chosen, it is to be a very special night for the elite group. They will be enjoying a six-course degustation created by Liam, accompanied by some of the most exquisite wines in the cellar, of course selected by Remi.

They are shown into the softly lit, wood-panelled confines of the private dining room where they are seated at the imposing table to enjoy chilled glasses of Krug. Group members are effusive and in the mood to enjoy themselves. They know they can relax and speak freely, the walls and ceiling are sound-proofed and the waiters are non-intrusive and discreet.

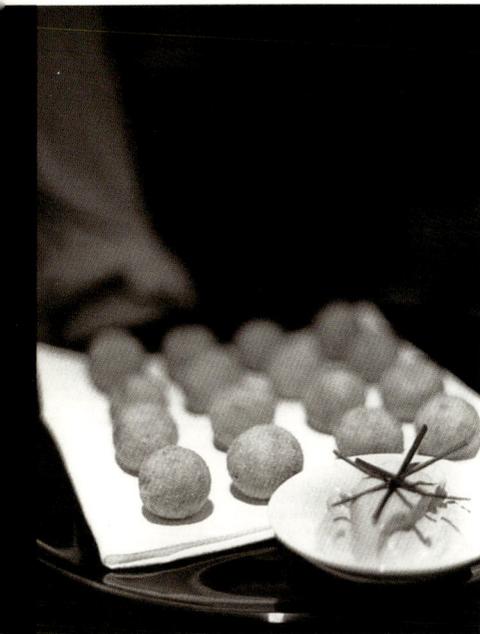

DEGUSTATION MENU

Vanilla-scented Nage with Oyster and Lobster Tail
'90 Lanson champagne

Warm Salad of Quail, Truffle, Bacon and Mache
'96 Bourgogne Rouge, Leroy

Pan-fried John Dory with Riesling and Mussels
'98 Clonakilla Riesling

Fillet of Beef Rossini
'95 Chateau Labegoree, Margaux

Fruit Sorbet

Selection of Cheese from the Trolley
'96 King River Merlot

or

Lemon Tart
'96 Jurancon Moelleux Clos Wroulat, Charles Hours

Coffee and Chocolate

20:45

Banc has filled and the kitchen is back in full swing. At least, at night, customers are not in such a hurry, and because the bookings are supposedly well-staggered, the kitchen should not be swamped with the majority of orders arriving at the same time. But Murphy's Law prevails. It only takes a couple of tables to arrive late and another to arrive early, and the whole schedule is thrown. This doesn't particularly bother Liam — in fact, he's come to expect it. Once again he's yelling orders and conducting the precision-perfect timing of the kitchen.

Tonight, however, Liam hands the reins over to Matt mid service. He wants to go to the *Private Banc* kitchen to personally oversee the preparation of the degustation he has created for the private dinner party.

21:00

Stan is well pleased with the way things are going at *Wine Banc*. The crowd enjoying the whiskey promotion is discerning and sophisticated and exactly who he created the bar for in the first place. Ever watchful, he cruises the room and finds himself popular with small groups of women who are enjoying the drinks and cigars as much as the men. Stan is not surprised, almost 60 per cent of *Wine Banc*'s clientele is female — women who have shunned the pubs and other city bars for a more international and refined ambience.

Stan can now afford to relax a little. He accepts a shot of single malt and a cigar as he settles down for a conversation with a businessman from New York who is telling him about the latest hot spots in the USA. Stan listens politely, but he knows them all. He, Rod and Liam regularly travel overseas to check the trends.

21:30

Instead of the dappled sunshine of the day, *Banc* is now swept with golden light and the room is mellow. The customers are enjoying all manner of modern French dishes appearing from the kitchen. Remi is pouring the wines he has recommended to match each dish. Soft merlots, crisp rieslings and fruity pinots fill the Riedel crystal glasses.

In the dining room the ambience is one of relaxed contentment. The atmosphere in the kitchen, however, couldn't be more different.

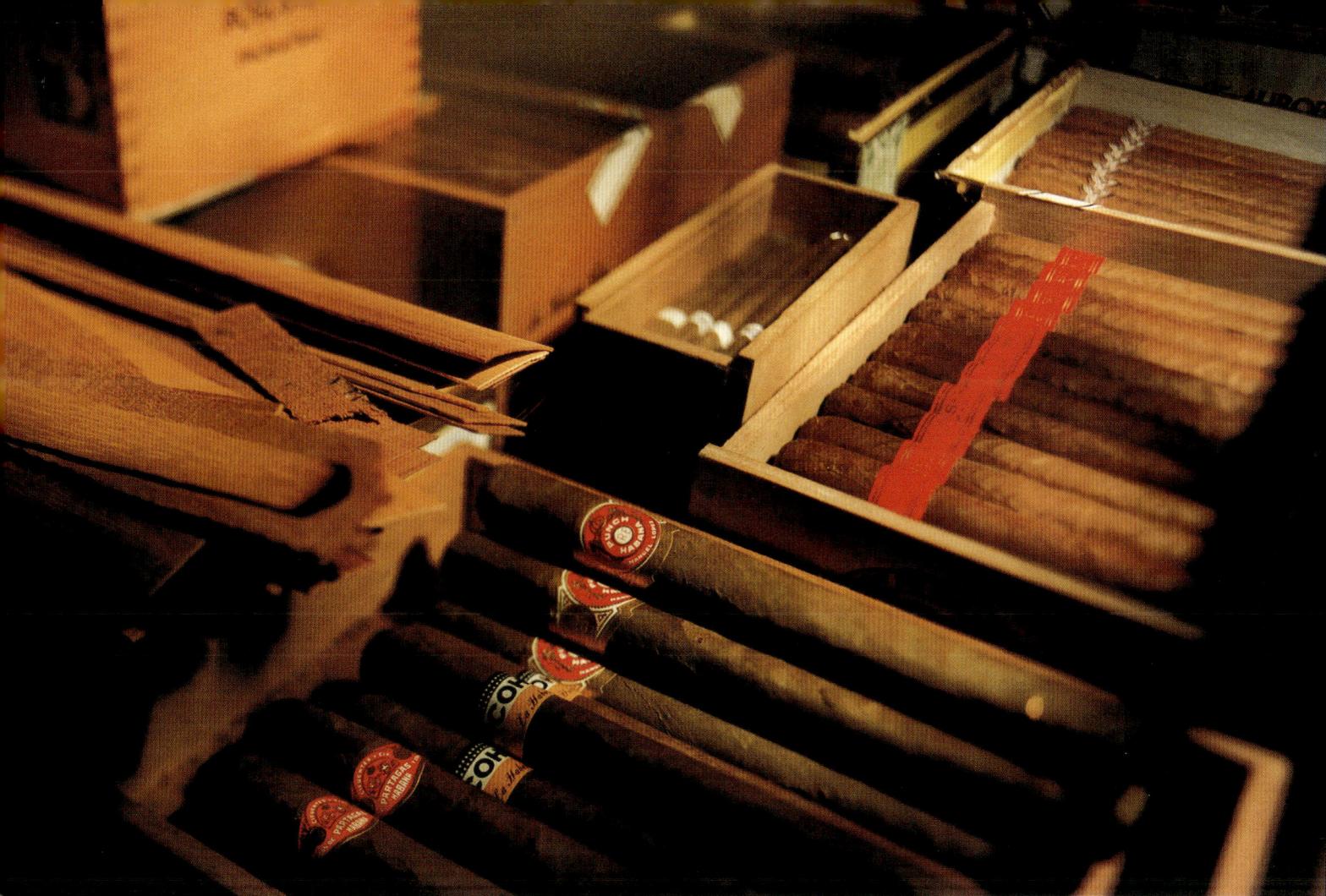

21:45

The stainless-steel galley is now at boiling point in every sense of the word. The ovens and hobs are exuding tremendous heat and the chefs are flushed and hot. They are moving at a frantic pace to keep up with the orders Matt calling.

Liam arrives back just in time to witness a dish being returned to the kitchen — a female diner claims her pork is pink and undercooked. She wants a new piece, she wants it now, and she wants it cooked properly.

Liam's previous good humour disappears and his Irish temper is on the boil. "Tell her, ever so politely," he instructs the anxious-looking waiter, "that the pork is pink because it is stuffed with black pudding."

The dish comes back again. The woman still insists her pork isn't cooked.

"Then bloody well tell her to order something else," Liam explodes, "because I'm not overcooking my pork."

The waiter knows he is caught between the devil and the deep blue sea, and so asks Jan to deal with the problem in her usual, diplomatic way.

Problem solved, the lady will have the Beef Rossini — Well Done!

22:00

At *Private Banc* the guests are enjoying dinner at a leisurely pace. As each course of the degustation arrives, the sommelier presents yet another exquisite wine, personally chosen by Remi earlier in the day.

The guests are a pleasure to serve. They are interested in what they are eating and drinking and ask many questions. The sommelier is delighted to be able to share his knowledge and, at their request, phones upstairs to ask Liam to visit them at the end of their meal.

22:30

The *Banc* kitchen has recovered its sense of humour. The mains have almost all been served and there's time for a couple of the boys to dive out the back for a cigarette. Desserts are calmly being prepared. The only people who now seem to be under any pressure are the kitchen porters who have just had dishes from ten tables dumped at their feet. There is nothing much to scrape off the plates into the bins. Obviously, everyone has enjoyed their meal.

22:45

Stan finally extracts himself from *Wine Banc*. He's tired and he's hungry and heads for *Banc* where Jan will find him a quiet table for a quick bite. But, as he enters the room, he is immediately engaged in conversation by a table of designers he knows.

He briefly joins them for a drink before poking his head in through the kitchen door to check the team.

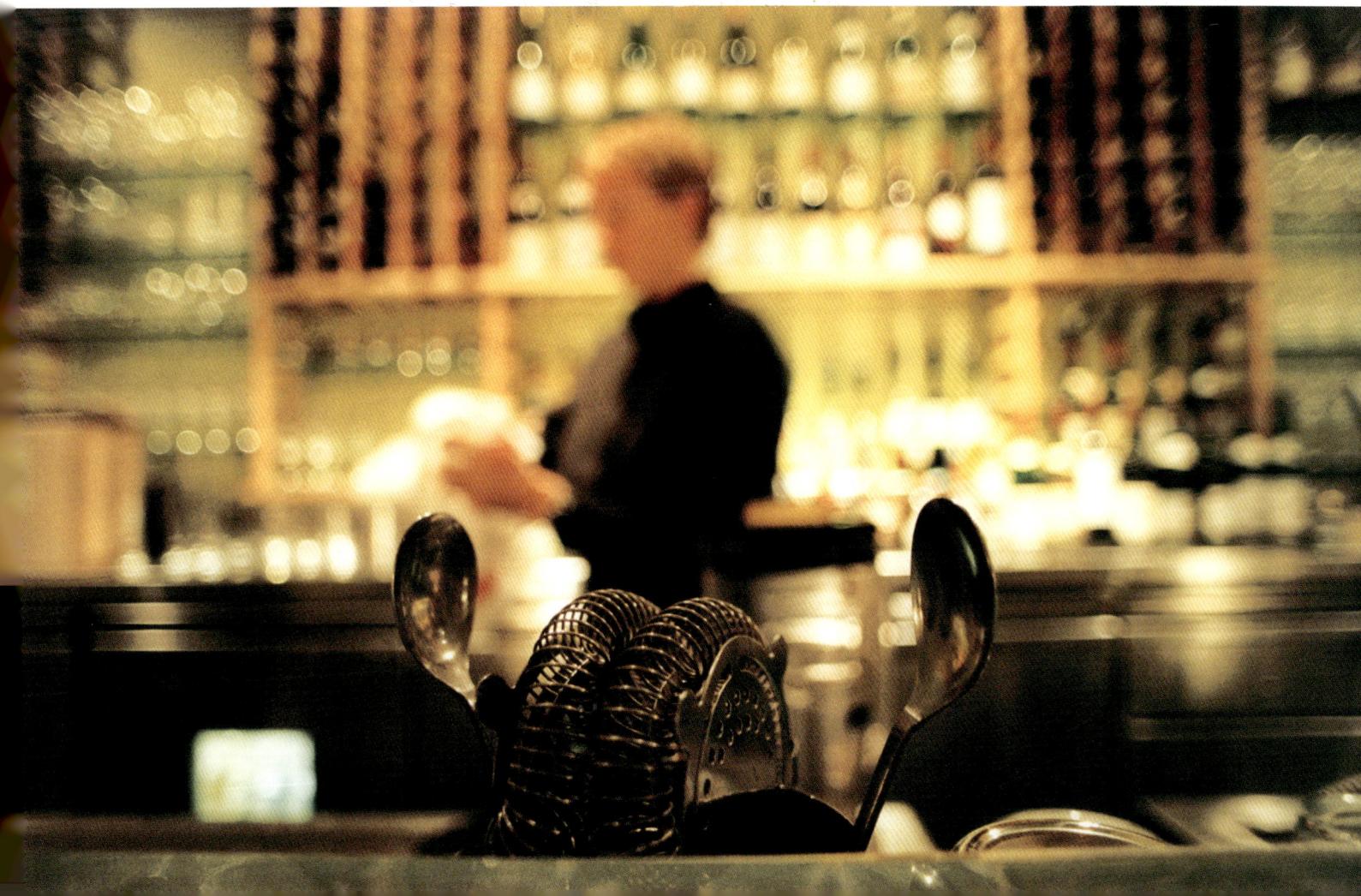

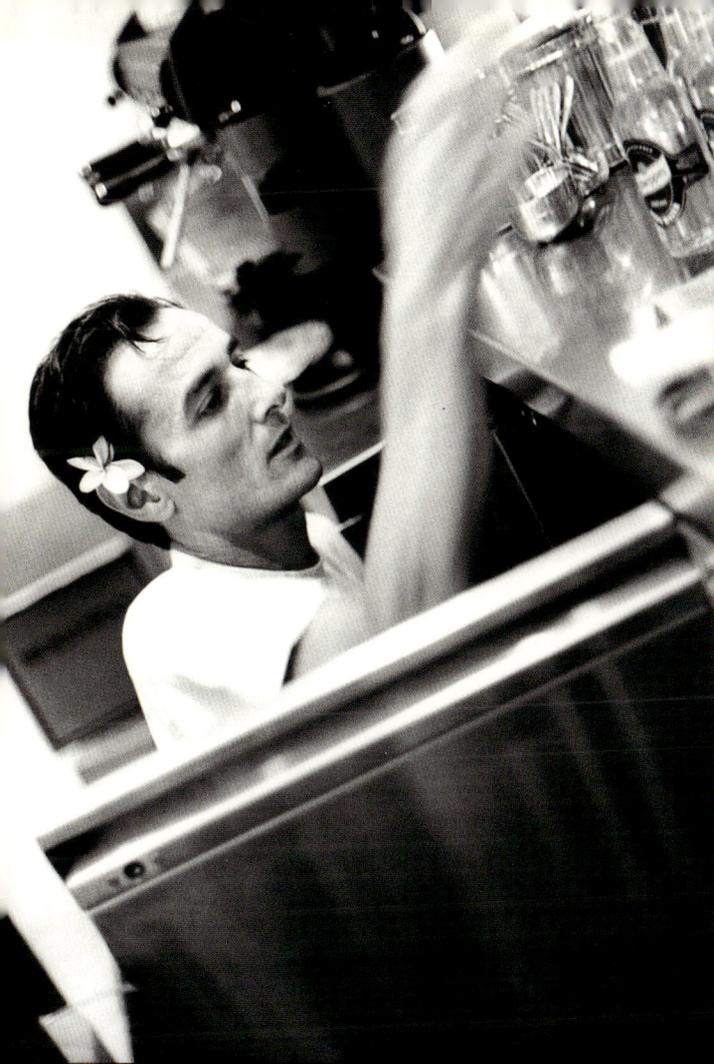

23:00

Remi Bancal is requested at table 25. They want to know about a particular wine — Château d'Y Quem. He explains the painstaking production methods before pouring the aromatic, oily drop into each of their glasses.

Some tables linger over slivers of cheese from the trolley, while others sip coffee and enjoy a delicate array of petits fours.

At a corner table, Stan wolfs down a Veal Zurichoise, accompanied by a spectacular drop of wine Remi insists he try. As Remi pours, he and Stan chat about the evening and the amount of champagne drunk by the cocktail party.

23:30

Liam, whose uniform is still remarkably crisp and unmarked, makes the requested visit to *Private Banc*. He is greeted with gentle applause. The guests have been delighted by the menu, and now want to each have a word. He is modest, unpretentious and genuinely pleased that his food has been well accepted. In fact, they have made his day. He happily wanders off to check *Wine Banc*'s kitchen.

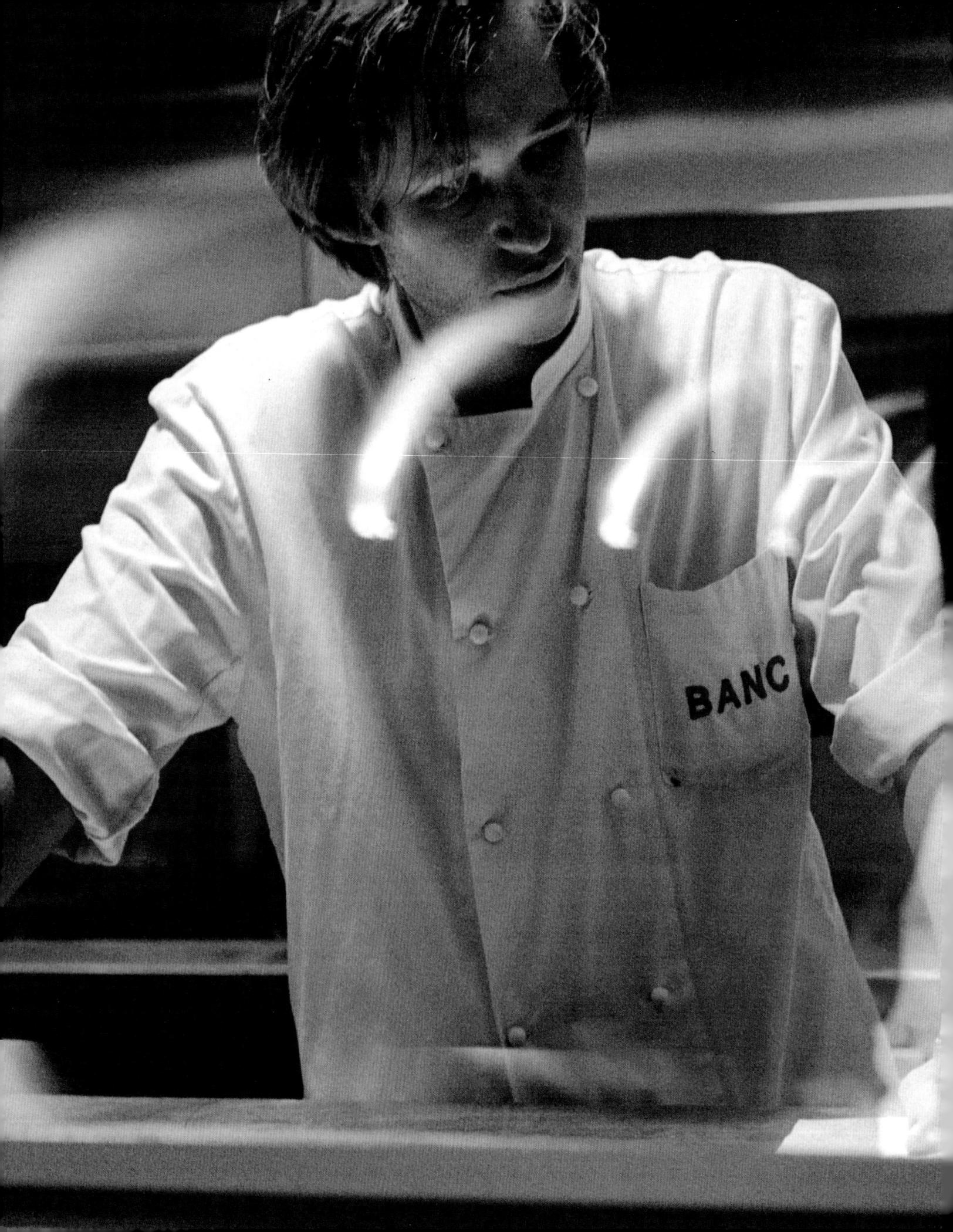

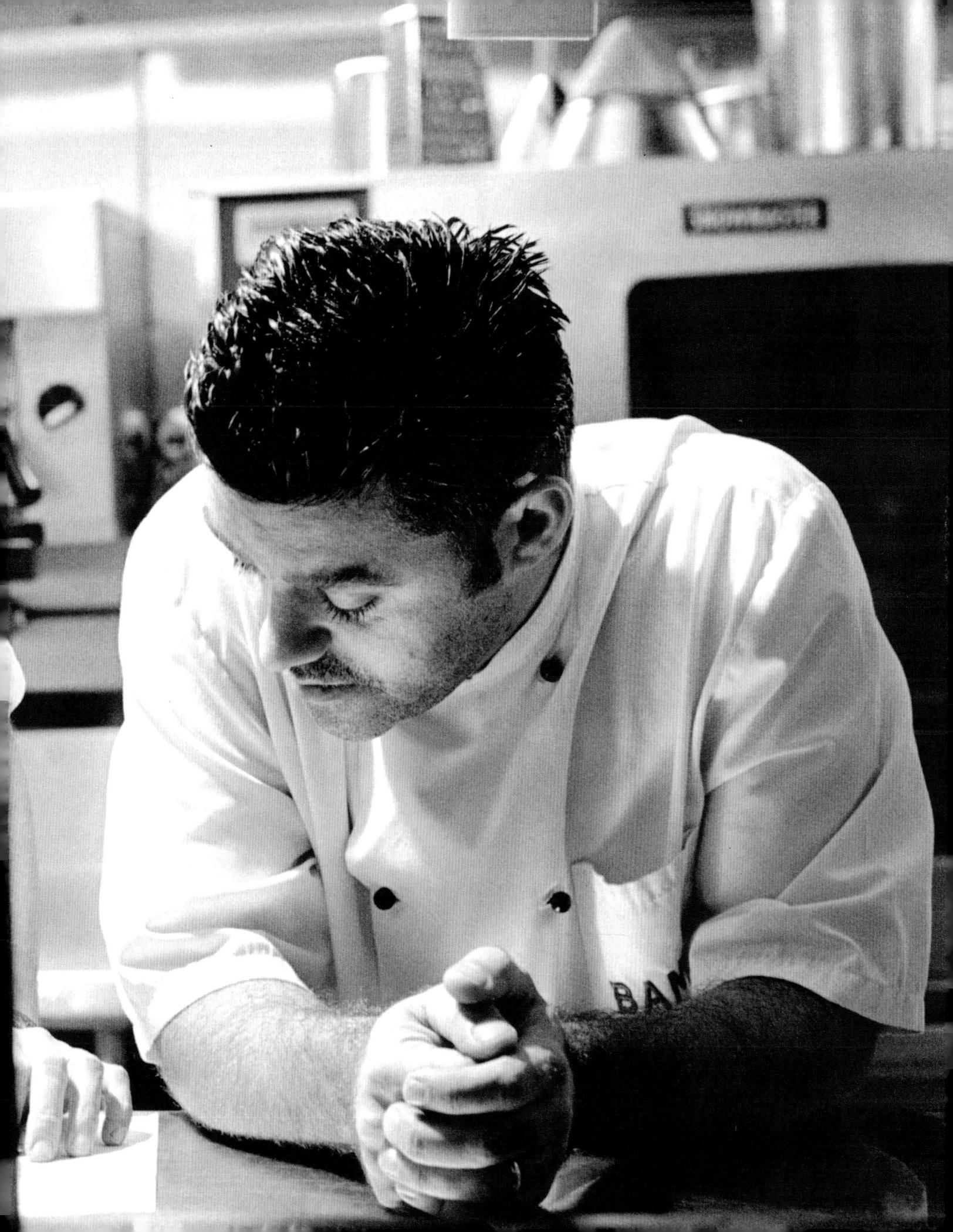

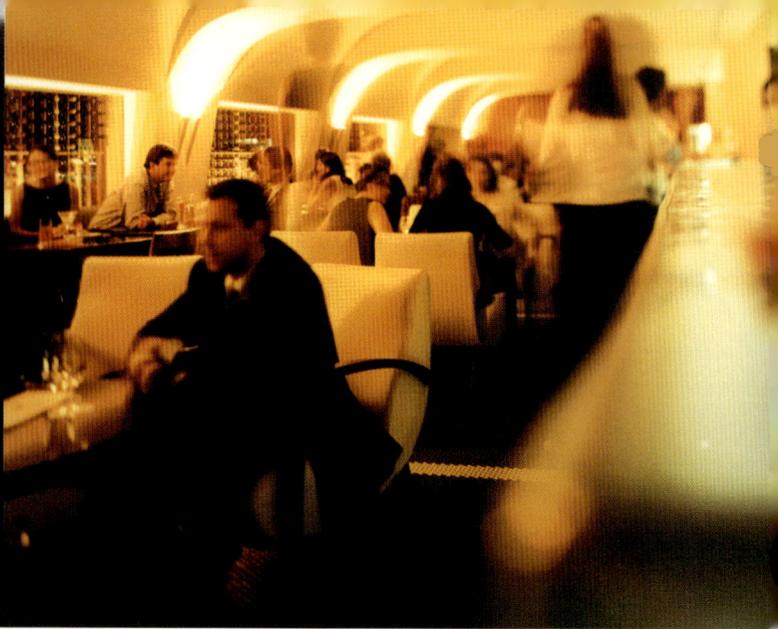

24:00

Jackets and coats are being delivered to departing diners as Jan farewells them at the door. The waiters are discreetly setting the tables for tomorrow's lunch as they wait for the last bills to be requested. It has been a good night, but now they want to go home. So does Stan. It's been a particularly long day, especially as he doesn't normally stay for the entire evening service. After checking the day's takings with Jan, he too disappears into the night.

00:10

Kitchen staff members have taken up residence among the garbage cans outside the back door for a quiet cigarette and some welcome fresh air.

Inside, the kitchen is being attacked with gusto by the cleaners, and within two hours will, hopefully, be showroom clean. No doubt, Liam will check his secret corner again, just to make sure.

00:15

Liam is slumped, exhausted, in a corner banquette with a cold beer. He is joined by Matt and they both light their cigarettes and begin to dissect the evening. Neither has forgotten the woman and the pink pork, or the socialite locked in the toilet. They have a good belly laugh.

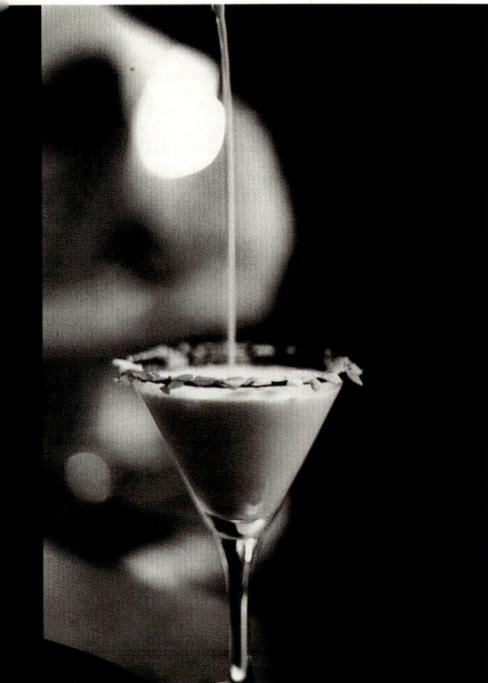

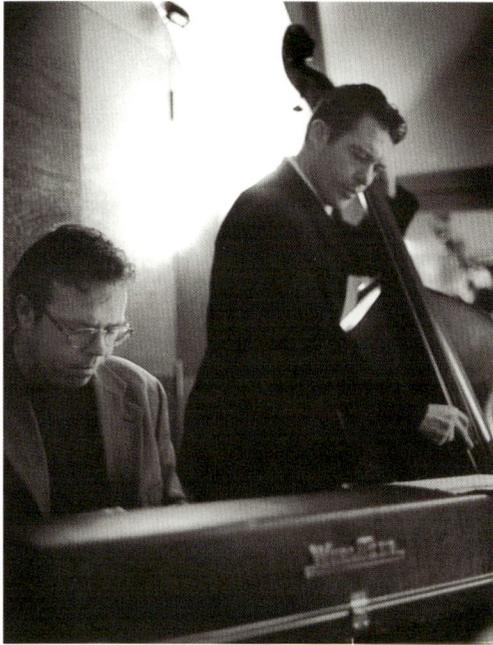

00:30

At *Wine Banc* the crowd has thinned, but groups still congregate around tables or at the bar to enjoy one last drink and the seductive rhythm of the Latin American band. Staff members have been run off their feet all night, and now they are nearly dead on them, but you'd never know. The same standard of service has continued throughout the evening and every reasonable demand has been met. Behind the bar, Sean is once again polishing glasses, while sharing a joke with a group of glamorous women. His assistant, Sally, mixes martinis for the after-theatre crowd who so often drop in for a drink or three on their way home.

00:45

Jan lets the last weary waiters out of *Banc*, sets the alarm and locks the imposing brass doors. She and Liam, who have barely had time for chat since morning, link arms and make their way home to collapse into bed. It's been a hard day's night for them both.

01:00

At *The Mint Room*, things are far from over. Patrons are either dancing to the DJ's beat or have taken up residence on the low ottomans, ensconced between milky-white, translucent screens. All manner of cocktails, designer beers and slammers are being consumed by those young enough not to be too dramatically affected by alcohol or a late night.

01:30

Wine Banc is almost empty. Before closing the bar, Sean shows Jimmy the electrician which bar lights are playing up. Apparently, Jimmy needs to remove a panel on the bar to fix the problem, that's why he's elected to work at night. He will soon be joined by a team of carpenters employed to replace some panelling at the far end of the room.

Most of the restaurant's maintenance work is done in the early hours of the morning so that customers and staff are not interrupted.

02:00

Sean and his team bid the maintenance workers good night. They are night owls and head off to *The Golden Century* in Chinatown for Peking Duck and a couple of beers before hitting the sack. After all, most of them won't be back on deck until tomorrow night.

On the way out, they run into the euphoric *Private Banc* diners who are about to be swept away in their private limousines.

02:30

Few customers at *The Mint Room* are still on their feet, but instead most of them are lounging on chairs, listening to the sultry sounds of the DJ's wind-down music.

The bar has a 24-hour licence. But it is doubtful that anyone will remain beyond 3am. After all, some have to work tomorrow.

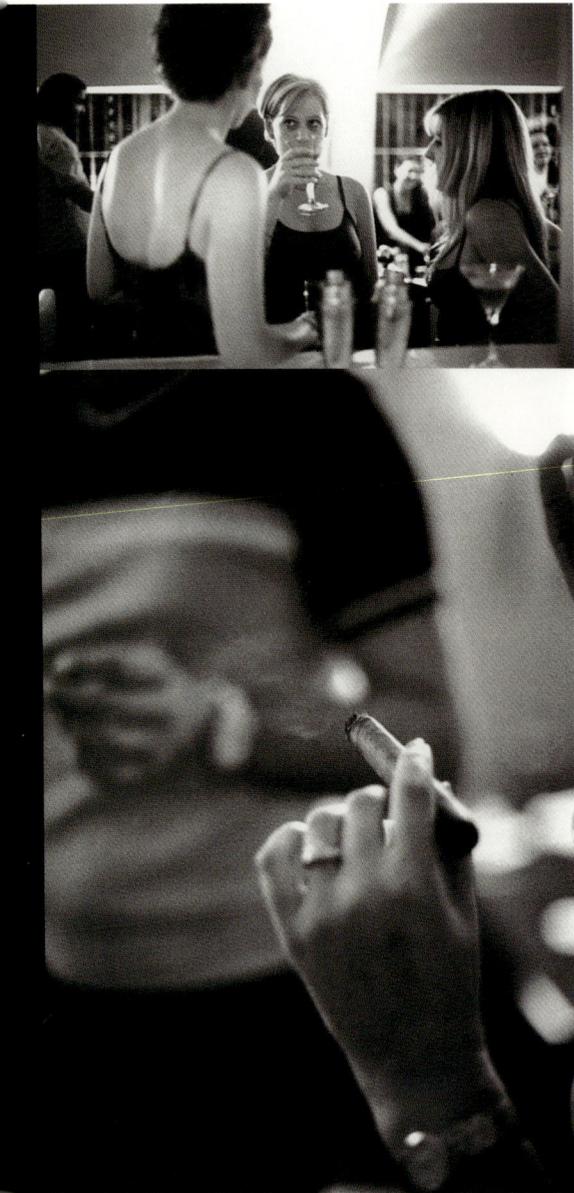

03:00

As the barmen in *The Mint Room* put the last batch of dirty glasses on to wash and clear the remaining ashtrays, the cleaners arrive. Thank God, the barmen think, they are the ones who will have to deal with the floor and the sticky ring marks left on the tables. The DJ is now playing the barmen's requests. It's music while you work!

A couple of gorgeous female customers hang back at the bar. They are sipping mineral waters and checking their make-up in their hand mirrors. They must be waiting for the barmen!

03:30

Jimmy the sparky and the carpenters are listening to Triple J on the radio as they screw, hammer and saw. Working through the early hours of the morning doesn't worry them one little bit. It has its positive upside — it means they can have the day off tomorrow for the beach, the movies, or whatever, and garner a healthy slice of *Banc*'s maintenance budget.

04:45

Stan is woken from deep slumber by the shrill sound of the telephone. Security is on the line. The alarm has gone off in the main dining room. In minutes, he is dressed and zooming back into town through the deserted streets. More than likely, the alarm is a false one, but he'll have to check it anyway, and he can always drop in to see how Jimmy and the boys are getting on.

05:00

Stan arrives at *Banc* just in time to see the back of the street sweepers and a single pigeon pecking away at the pavement for breakfast.

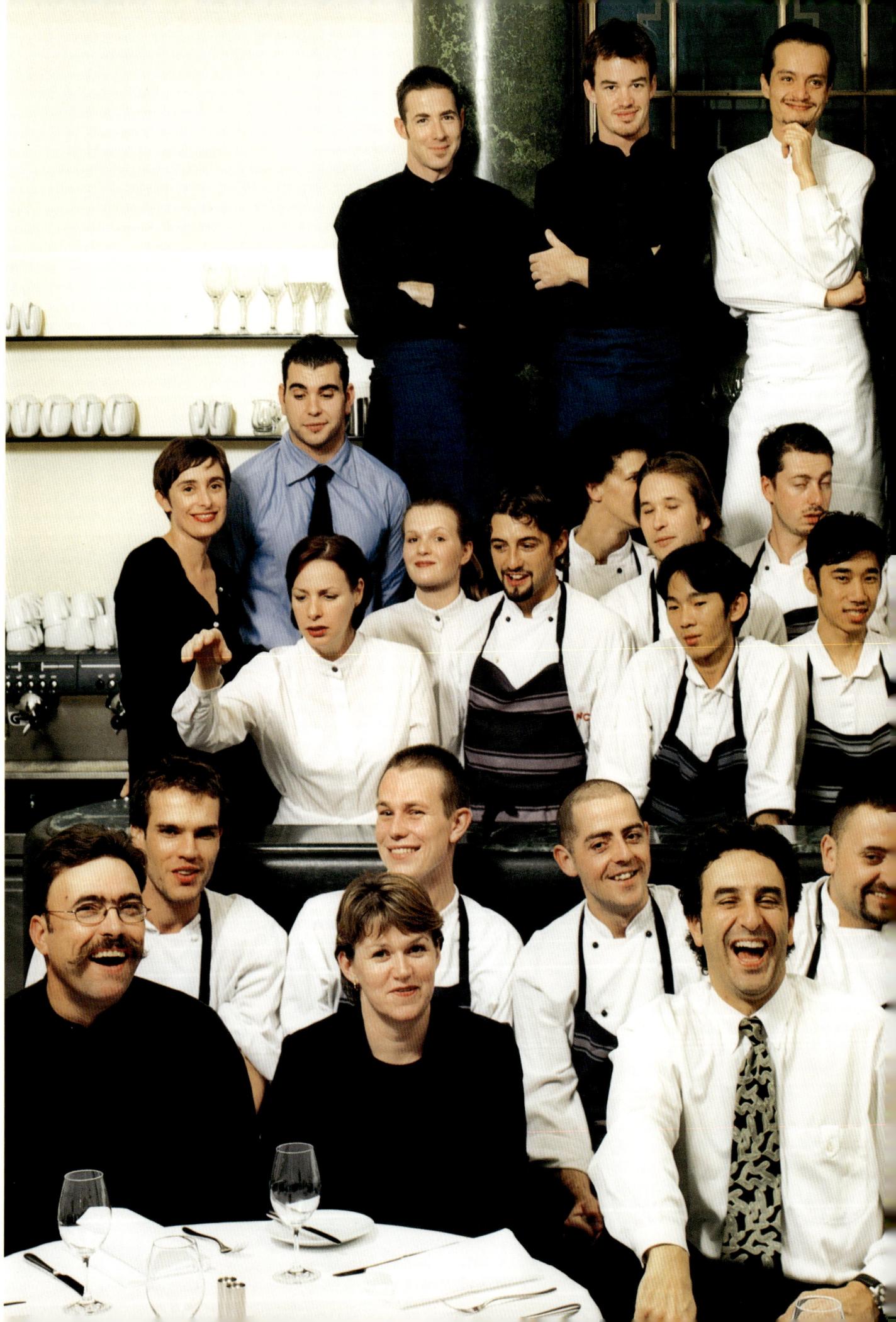

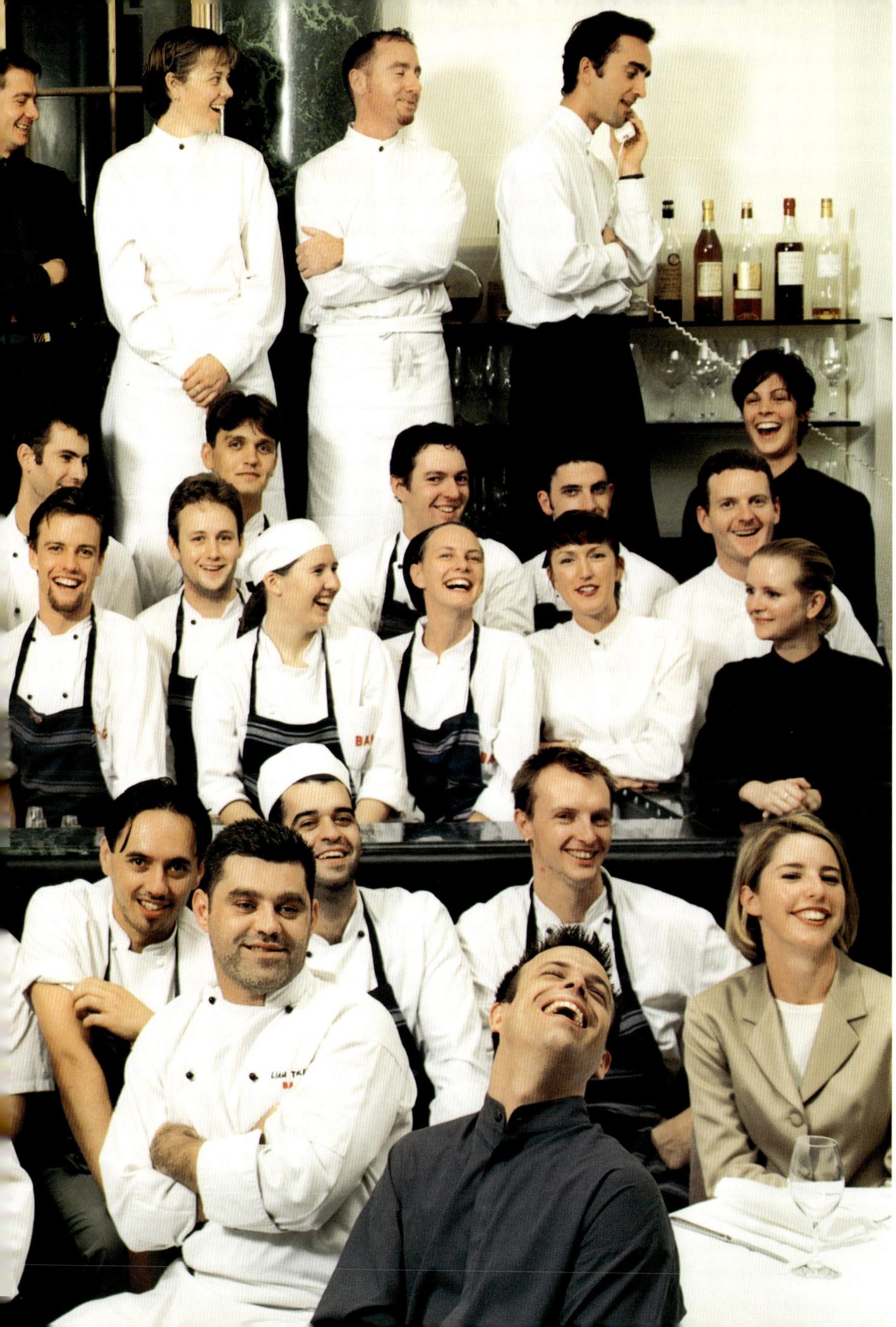

The wine business is full of coincidences. How else do you account for a meeting that led to the establishment of a rewarding business?

In 1995, I happened to meet a friend whom I hadn't seen for some time. He recommended that I meet, and talk with a guy who was interested in trying out some new ideas. This guy apparently wanted much more than the usual 'cosmetic' wine list for his CBD restaurant — he wanted to change the scene.

TIME FOR INNOVATION

The 'guy' was style-setter Stan Sarris, and his restaurant would later be called *Banc.* As it turned out, I had already met Stan back in the 1980s. Stan and I got together and talked about ways in which a restaurant could make wine a feature of the business; how to make it stand out from the rest of the pack.

However, like most innovative ideas these ones had their teething problems. They needed the support of a busy evening location and an inquisitive crowd. They also needed the support of a sympathetic licensing framework, instead of the archaic licensing laws in force at the time that forbade sales of glasses of wine without service of a substantial meal. The ensuing experiment proved that these ideas could work, they just needed the right location and a resourceful use of the existing laws.

FOOD AND WINE

The common thread among the world's top restaurants is the great food/wine package. The key to making a great dining experience is recognising the importance of this combination. Wine lists are not intended to serve as a catalogue to a museum, where bottles sit forever as window dressing. They are there to present bottles to be sold and enjoyed.

People don't seem to realise that wine can be such an important profit for restaurants. By this, I don't mean excessively high mark-ups. Today's diners are too savvy to pay highly inflated prices. The object of a wine list should be to provide diners with the opportunity of choosing wines that will suit their pockets, the occasion, and match the food that is served. It involves a matter of scale, and finding the level that the diner wants to, or can afford to, reach.

The successful matching of wine and food is best attained with the help of the restaurant sommelier. A great wine list may be a futile exercise, without the sommelier to sell the wine.

Time and time again I have witnessed the 'sommelier effect' on restaurants: the

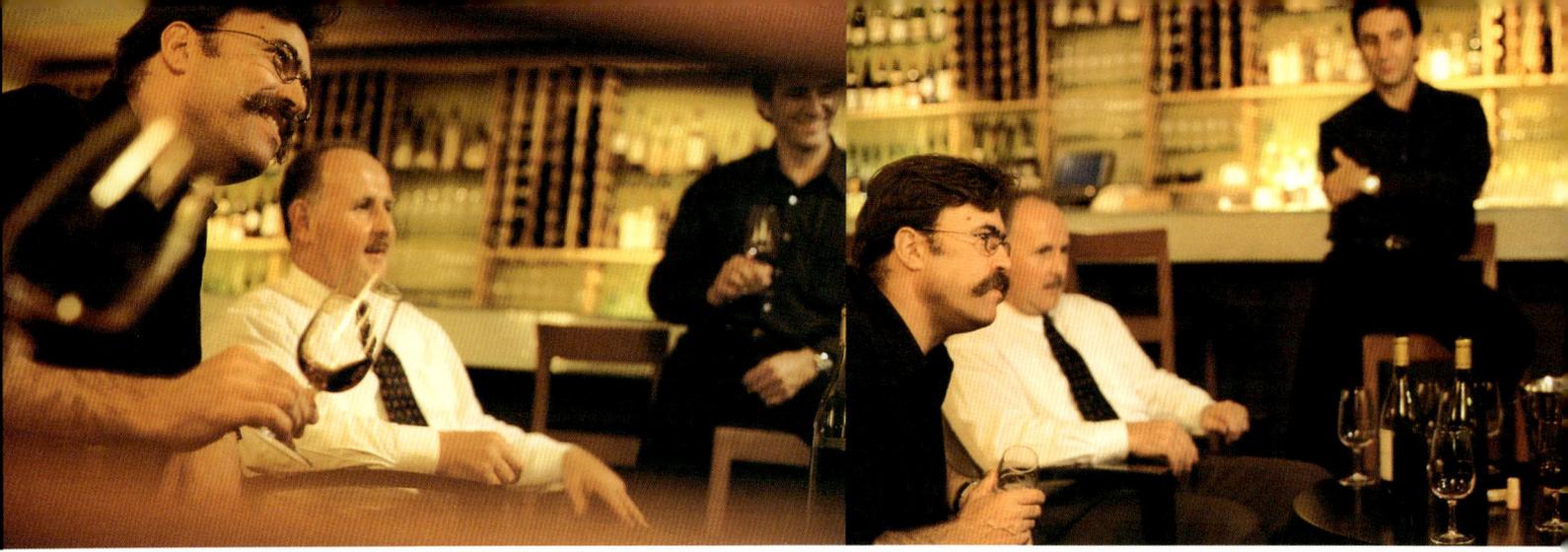

loss of a sommelier can completely change the dynamics of sales. While there is still a shortage of sommeliers in Australia, the situation is rapidly improving with many new faces now emerging in the industry.

BANC

Banc is innovative and successful. It offers the total dining experience at different levels. *Wine Banc*, for example, is a very high quality restaurant and bar, operating separately to *Banc* , but in total synergy with it.

To have a wine bar in New South Wales, it is necessary to have a hotel licence. *Banc* took the considerable investment decision to buy that licence.

Despite the competition for the location being fierce, Stan Sarris's presentations to secure the location won by stressing the total concept of wine and food. *Wine Banc* created a new standard for the concept of a wine bar in Sydney; a sophisticated, stylish place that offers a constantly changing range of high quality wines that match the terrific food.

WHY BANC WORKS

The thing that had always struck me in conversations with Stan was his understanding of the importance of wine in a great restaurant; it is an integral part of the package. It was also clear to me that Stan wanted a wine list that would be second-to-none.

From the earliest time at *Banc*, once Executive Chef Liam Tomlin was secured on board, the priority was to find someone special to be in charge of the wine programme. Luckily for *Banc*, Remi Bancal was available.

Remi brought with him a wealth of experience and an obvious professionalism. With his French background Remi well understood matching food and wine — wine as an adjunct to food not as a flavour competitor.

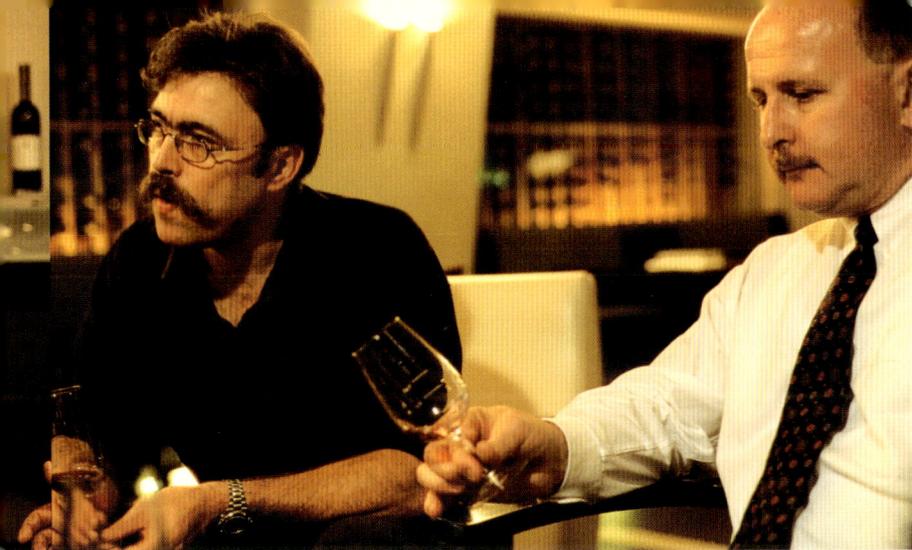

I am increasingly confused by the direction that some winemaking is taking in this country. We seem to be fixated to producing bigger, more alcoholic red wines, that are loaded with oak. They are wines that I think of as 'tasting wines', rather than 'drinking wines'. Their taste is impressive, but I don't enjoy drinking them over dinner. Bigger is not necessarily better. And I am yet to be convinced that this style of wine will age gracefully!

Some winemakers forget that the purpose of wine is to be drunk and enjoyed. Instead they seem to deliberately design their wines through sheer weight and size, to win tasting contests or wine shows.

Banc features a number of European wines, balanced by a very extensive Australian list. The wine list emphasises the food-compatibility of wine; the key features of the wine are balance and complexity, not just 'bigness'.

It is not easy to create an excellent wine list, particularly when a venture is new. It involves foresight and careful investment. It also takes time and effort to be constantly on the lookout for wines to lay down, for future addition to the list. The wine list must be seen as a continuum — it evolves over time and as the wines are bottle-aged and become ready to drink. This message is now being understood in Australia, with wine list awards like Tucker Seabrook, spurring restaurants on to create better and better lists.

A general criticism of Australian restaurants is of the youth of the wines on their lists. It is a problem that can be solved, but it requires significant prudent investment. *Banc* is committed to providing an excellent wine list, and the benefits of this commitment will continue in the future with the availability of superbly aged wines on the wine list.

Bravo *Banc*, and all who serve there! May it long continue to set the standard for the total wine and food experience.

—JON OSBEITSON

Wine Merchant

SUZIE WONG

30ml (1 fl oz) Citron Vodka
10ml (2 tsps) lime juice
fresh watermelon juice

Build over ice in an Old Fashioned glass. Pour in Citron Vodka and lime juice. Top up with fresh watermelon juice and stir. Garnish with lime segments.

SHEER GOLD

3 to 4 chunks of rockmelon
½ ripe mango
30ml (1 fl oz) coconut liqueur
30ml (1 fl oz) Crème de Peche
crushed ice

Blend all the ingredients with the ice in an electric blender. Serve in a double cocktail glass. Garnish with berry coulis and lime zest.

COSMOPOLITAN

30ml (1 fl oz) vodka
15ml (½ fl oz) Cointreau
dash of fresh lime juice
30ml (1 fl oz) cranberry juice
crushed ice

Pour ingredients into a cocktail shaker. Shake, and strain into a standard cocktail glass. Top up with cranberry juice. Garnish with a strip of lime zest.

SOSUMI

60ml (2 fl oz) ginger-flavoured vodka
salmon and pickled ginger, threaded on to a wasabi-encrusted skewer

Pour chilled ginger vodka into a cocktail glass and garnish with the skewer.

RED HOT MARTINI

60ml chilli-infused vodka
1 or 2 red, hot chillies

Pour chilled chilli vodka into a cocktail glass and garnish with a floating whole chilli.

VODKA INFUSIONS

CHILLI VODKA Lightly pan fry 10 small, red, hot chillies to allow the oils to surface. Place the chillies in a bottle of Vodka and infuse at room temperature for about 2 weeks. Test the vodka to ensure the heat level is to your liking. The longer you leave the chillies the hotter the vodka gets. Remove chillies and chill the vodka.

GINGER VODKA Place a knob of peeled fresh ginger root and a small knob of Japanese pickled ginger in a bottle of vodka. Allow to infuse at room temperature for about 2 weeks until the strength is to your liking. The ginger may be left in the bottle. Chill and serve.

CITRON VODKA Place a combination of zest from a lime and a lemon into the bottle of vodka and allow to infuse at room temperature for about a week. The zest may be left in the bottle. Chill and serve.

Vodka infusions can be made with almost anything, including coffee, vanilla, and strawberries.

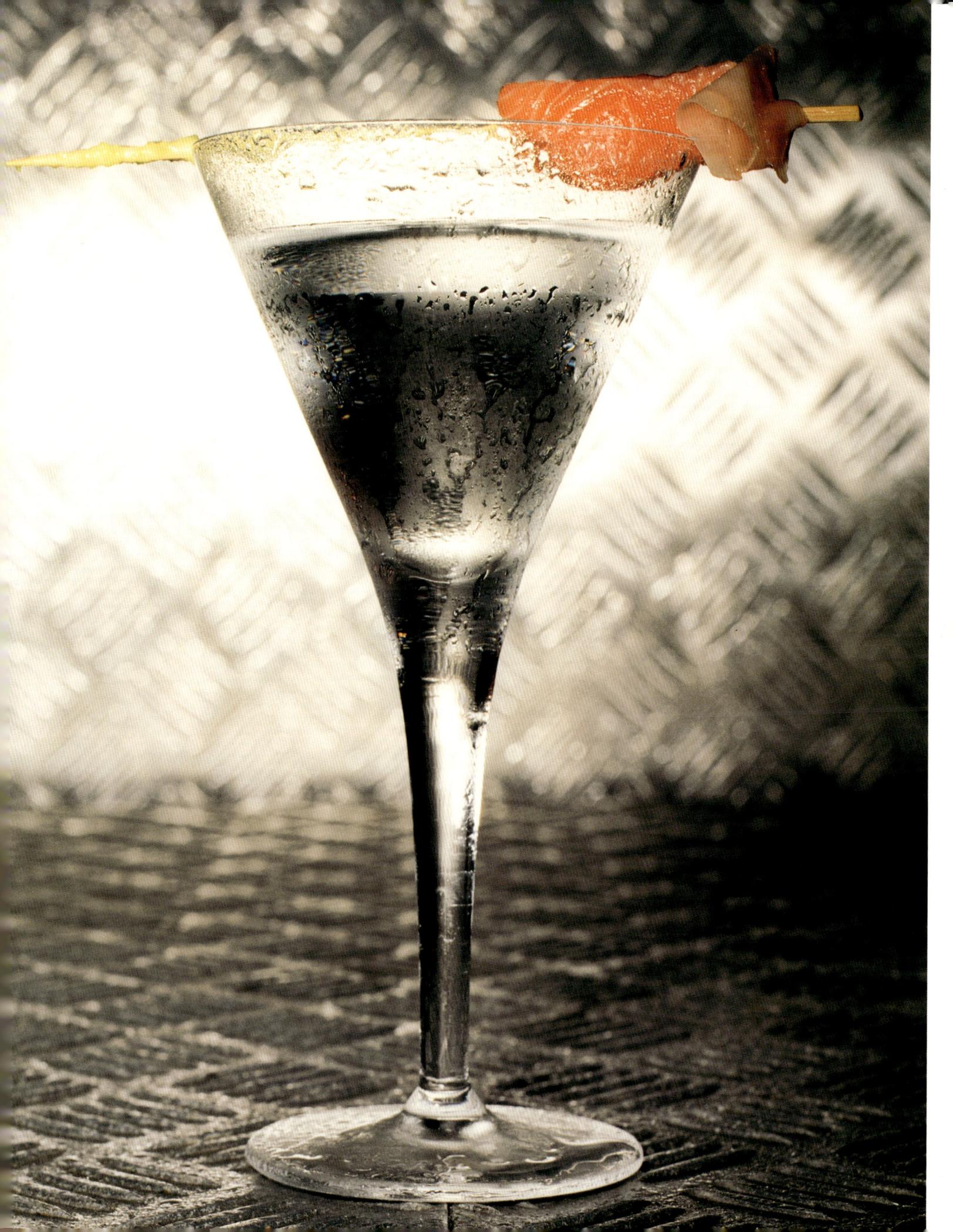

When I first embarked on translating a day in the life of the *Banc* kitchens, and the food we produce there, for the domestic kitchen it occurred to me how different the two environments actually are.

To begin with, I was fortunate enough to be able to design the *Banc* kitchens exactly to my requirements. This allowed me to create an ideal, functional, self-contained work space for each section of the kitchen — each with its own benches, stove tops, ovens and refrigeration.

Then there are the added luxuries that a professional kitchen enjoys such as plate warmers, hot lights, salamanders, slicing machines, blenders, electric mincers and mixing bowls, sorbet machines and a bank of ovens set at different temperatures and modes to accommodate all manner of dishes. All this allows us to offer a large menu with a variety of dishes prepared in different ways, using different techniques and cooking methods.

There is also a huge staff on hand. Working between the three kitchens at *Banc*, there are around 24 cooks, who each work anywhere from 60 to 70 hours a week. At a normal lunch or dinner sitting 16–18 of them will be rostered on to produce the food, while the four kitchen porters rush around cleaning up after them, as well as dispensing with customers' dirty dishes.

Obviously, another difference between a restaurant and a domestic kitchen is that we always have our basic ingredients *en place* or prepared. For example, we always have all our basic stocks such as chicken, veal, lamb, fish and so on, ready. Our meats and fish have been prepared in the morning and await use already boned-out and ready-portioned. We clarify butter in 25kg (55lb) blocks, make stocks in 50-litre (11-gallon) batches, and sauces in 5-litre (9-pint) lots. The larder will make vinaigrettes and dressings in 2-litre (3½-pint) amounts, slice 25 bunches of chives in one go to last the whole day, blanch and peel 20kg (44lb) of tomatoes at a time for dicing, and marinate four sides of salmon at a time. At the kitchen's vegetable section cooks will spend a morning picking, cutting, dicing and blanching produce for lunch service. The pastry section will always have 10 litres (2 gallons) of sugar syrup on hand,

anglaise waiting to be flavoured and turned into ice-creams, fruit coulis on call in 1-litre lots, and ready-to-roll sweet pastry is sitting waiting to be turned into tart cases and the like. They will churn 6 litres of different flavoured ice-cream, and the same quantities of sorbets, they will temper 5kg lots of chocolate ready to turn it into different flavoured chocolate truffles for the *petits fours*. Consequently, the kitchen ticks along smoothly as we rarely have to start a dish from scratch.

To make life easier in the home kitchen, when preparing recipes, increase the quantities of components that can be stored. For instance, if a recipe calls for 250ml (1 cup) of stock, make 2 litres (approx 8 cups) and freeze the remainder in 250ml (1 cup) lots for next time or for use in other dishes. When clarifying butter, make a kilogram and store the excess in the fridge, or make a litre of salad dressing for use throughout the week. If you always apply this rule, you will soon build up a good supply of basic essential ingredients.

Perhaps my biggest time saver, and a marked difference between domestic and professional kitchens, is that I have a whole network of food suppliers who, basically, do my shopping for me.

At the end of every day, each section of the kitchens makes a list of their requirements for the following morning. These are phoned through to the various suppliers by myself, Matt, my second in command, or a sous chef.

The suppliers we have chosen to work with are, like us, very passionate and proud of what they do, and are committed to bringing us the freshest and finest produce available.

To this end, they start work in the early hours of the morning, just about the time we in the kitchen are winding down and thinking about getting some sleep. For example, not long after midnight, Con the fishmonger starts phoning the trawlers and his other suppliers buying what he needs for the day. Vic, our butcher, is at the meat markets by 2am, hand-picking the best produce, and by 4am, Barry the greengrocer will be power walking around Sydney's Flemington Markets, scouring provedores' wares for the best and the freshest.

By between 7am and 9am the same day, the fruits of their

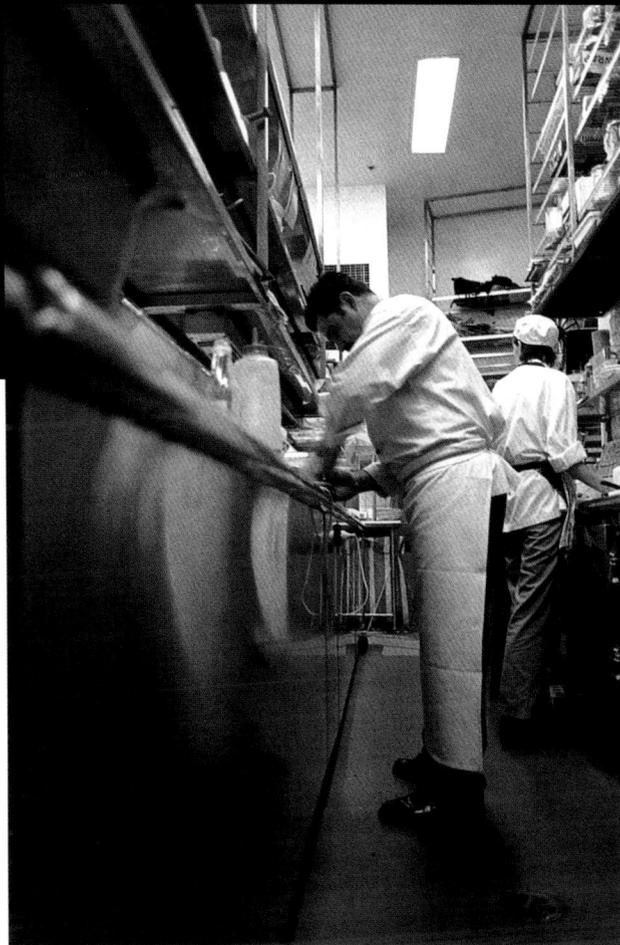

labour will appear at our kitchen door. Sometimes, I get calls from suppliers at odd hours about items that are unavailable or about something new or unusual they can lay their hands on. Every day, at about 2.30pm, we will be on the phone to Con, Vic and Barry again, requesting immediate top-ups on items that were especially popular at lunchtime, and are now required for dinner. I often wonder when they ever sleep! It is unlikely that you will be able to phone through your nightly food order as we do, but you can still access excellent suppliers. Search for a butcher who will bone out meat, chop bones for stocks and order specialities such as sweetbreads and *crépinette* for you. Find a greengrocer who carries fresh herbs and several varieties of potato and a large variety of fresh seasonal fruit and vegetables, and who will let you taste test his produce. Find a fishmonger who will fillet fish for you and cut it into the specific pieces a recipe requires. A good cheesemonger will also allow you to taste test and will advise you before you buy.

Some of the techniques and methods I use in the recipes may seem a little daunting, or your dish won't turn out picture perfect the first time. But please don't be put off. Bear in mind that professional chefs prepare these dishes all day every day, allowing 'practice to make perfect'. We also have the advantage of numerous pairs of hands to help assemble each dish. This allows more time to concentrate on presentation. When I mention 'season to taste' do exactly that. It is essential that you taste everything you prepare so that the flavour is to your liking. For this reason I do not stipulate specific quantities of seasoning such as pepper, salt and lemon juice.

Another important point to bear in mind is that the times given for cooking meats are to my own taste, and how I believe they should be served. Again these can vary depending on how you prefer your food cooked.

Last of all, don't be afraid to vary the dishes to suit yourself. You may decide to use salmon instead of tuna in the **Tuna Niçoise** or to just drizzle a good olive oil over the dish rather than make the **Tapenade Beurre Blanc**.

The food we create at *Banc*, and which I hope you will enjoy making too, is a mixture of old and new styles. The old being my interpretation and presentations of dishes I have learnt from one of the chefs I have worked under over the years. The new ideas have been inspired by many sources including my travels, eating out, reading cook books and magazines, or even conversations about produce. But perhaps my biggest influence is *Banc*'s senior kitchen staff, including head chef Matthew Kemp, Warren Turnbull, my sous chef, Darrell Felstead, head chef at our new operation, *The GPO* in Sydney's Martin Place, and Marcus Chant his senior sous chef. Between them, they have worked for and acquired skills from some of the world's best chefs, including Herbert Berger, Anton Mosimann, Phil Howard, Gary Rhodes, Shaun Hill, Roger Chant, Raymond Blanc, Gordon Ramsey, Brian Turner and Marco Pierre White to name a few.

On the following pages, I have chosen a selection of *Banc* dishes that have become customer favourites and for which we are often asked the recipes. Remember, nothing is set in concrete; you may only wish to use part of a recipe, or simply use it to inspire other ideas. Whatever you do, enjoy.

— LIAM TOMLIN
Executive Chef

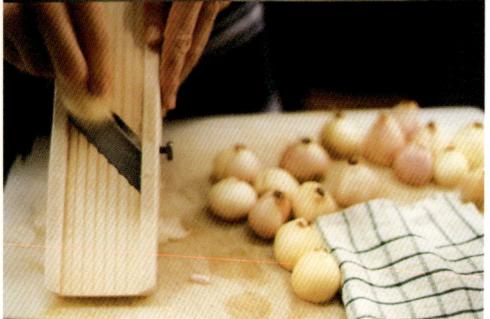

USEFUL KITCHEN EQUIPMENT

To help in the preparation of the following recipes, and as useful additions to your kitchen in general, I have put together a list of recommended equipment (see opposite page).

I would advise that you go for the best quality you can afford, collecting pieces over a period of time. If bought well, each piece should last a lifetime and soon become an indispensable, old favourite.

Nobody needs drawers filled with numerous, nifty gadgets and utensils that are rarely touched. Take knives, for instance. In my kitchen, the only types we would use on a normal day are a boning knife for dissecting meat, game and poultry; a fish filleting knife, with a good flexible blade; a large chopping knife and a paring knife for use on vegetables and fruit; a cleaver for chopping bones, and a good pair of kitchen scissors.

The other few implements we most commonly use, are an asparagus peeler, fish tweezers for removing bones from fillets, and a mandolin for slicing vegetables (for example, preparing the nice, even discs of potato required for the **Potato Galettes** described on page 185). When a recipe lists meats such as prosciutto and pancetta to be thinly sliced, don't try it yourself, call on your butcher — these meats need to be sliced on a proper slicing machine!

It's essential to have a decent-sized, solid, chopping board on which you can comfortably fillet a whole fish, bone-out a whole joint of meat, or dice and slice large amounts of vegetables. There's nothing worse than using a small board and losing half of what you are preparing to the bench or the floor — creating mess and waste.

My life would be a misery without my heavy-based, stainless steel pots. I suggest you invest in a few of varying size, including a 2-litre (3½-pint) pan for making beurre blanc, and for reducing or making sauces. They really do give much better results than the cheaper versions, which tend to wear out quickly, buckle, and distribute uneven heat to whatever you're making, causing it to be inconsistently coloured and cooked.

Stainless steel pots are also very versatile and can be used for all sorts of cooking methods. For example, we seal food in them, on the stove, then transfer them straight to the oven to finish off the dish.

Cast-iron frying pans are my preference, and again we use a variety of sizes for jobs such as sealing meat, browning bones, pan-frying fish, as well as for

sautéeing and glazing vegetables. Again, after sealing food on the stove, these pans can be transferred straight to a hot oven. The great advantage in this is that the cooking temperature can be maintained at all times, preventing food from spoiling. For smaller or individual dishes such as the **Bacon and Onion Roesti** or **Potato Galette** mentioned on pages 184 and 185 respectively, it's best to use cast-iron blini pans. One last tip, when you've finished using a cast-iron pan, wipe it out with a damp cloth rather than wash it with soapy water, as this prevents food from sticking to the pan the next time you use it.

An electric mixer with a dough hook and a mincing attachment is a bonus for making pastries, mousses and terrines, and it's useful to have an electric blender or food processor for breaking down foods before passing them through a fine sieve when creating soups and purées.

Speaking of sieves, we keep various sizes. Some for achieving smooth purées, others for clear sauces. We use a large drum sieve for passing mousses and vegetable purées. However, when making a sauce or stock from scratch, it's best to use a coarse, stainless-steel sieve first to trap the bones. You can then pass the sauce or stock through a finer, less-hardy version and avoid damaging the sieve. At the other end of the spectrum, for exceptionally fine straining, it's wise to have a good supply of muslin.

After passing raw ingredients, such as duck livers or chicken for terrines, through a sieve, always wash it first with cold water. Hot water can cook the remains of the food to the sieve and clog it.

Between *Banc* and *Wine Banc*, there are usually four different terrines on the menus, so we keep a supply of various sized and shaped moulds. The most frequently used are the 1.2-litre (approx 2-pint) Le Creuset terrine for Duck Liver Parfait, and a rounded 750ml (1⅓ pint) version we use for the tomato terrine.

When making desserts you should reserve separate pastry brushes, wooden spoons and spatulas for pastry-making, as they absorb the flavours and aromas of other foods you may be preparing. Last of all, an electric, domestic ice-cream machine may not be an essential, but I'm sure you'll derive a lot of pleasure from churning out your own sorbets and ice-creams.

— LIAM TOMLIN
Executive Chef

BASIC RANGE OF PANS

roasting tray
stockpot
selection of smaller saucepans
frying pan
blini pan
cast-iron baking tray for pastry

OTHER ESSENTIALS

spatulas
slotted spoon
skimmer
asparagus peeler
palette knife
serrated-edge knife
pastry brushes
ladle
funnels
plain and fluted pastry cutters
tongs
scales
wire rack
rolling pin
grater
measuring jugs
whisk
stainless-steel mixing bowls
ice-cream scoop
dariole moulds for jelly
various size flan rings
sugar dredger
blow torch
pestle and mortar

This is a very simple and refreshing soup which can be served either warm or chilled. At *Banc*, it is presented to all dinner guests as an *amuse gueule*, and quite often, we will be asked for 'seconds' or an entrée-size portion. Like most soups and sauces made in *Banc*'s kitchen, this recipe begins with creating the appropriate stock. For this particular soup we make a stock from the cobs after they have been stripped of all their corn.

Above, top: Corn cobs simmering to make stock.

Above, centre: Infusing the finished corn soup with basil.

Above: Serving the soup as an amuse gueule.

Serves: 4 (makes 1 litre or 1¾ pints)
4 fresh corn cobs
200g (8oz) diced onions
50ml (3½ tbsps) cream
50g (2oz) diced butter
1 small bunch fresh basil
salt and freshly ground pepper

THE STOCK Peel and remove all the outer leaves and stalk from the cobs. Using a knife, remove all the corn kernels from the cobs and reserve, and then cut the cobs in half.
In a heavy-based pan melt half the butter and add half of the diced onion. Sweat the onion for 5 minutes on a medium heat without allowing it to colour. Add the cobs and a good pinch of salt and cook for a further 5 minutes without browning. Add 1.5 litres (2½ pints) of water and bring to the boil. Reduce heat and simmer for 30 minutes. Remove from the heat and allow the stock to infuse for a further 30 minutes before passing it through a fine sieve, discarding the cobs and the onions.

THE SOUP In a heavy-based pan melt the remaining butter and add the remaining diced onion. Sweat the onion for 5 minutes on a medium heat without allowing it to colour. Add the corn kernels and a good pinch of salt and continue to cook for a further 5 minutes. Add the corn stock and simmer for 20–25 minutes until the corn kernels are tender. Pour in the cream and continue to cook for 5 more minutes.
Remove from heat and blend the soup in a blender until smooth. Add roughly chopped basil, and season with salt and freshly ground pepper. Leave the soup for an hour, or even over night to allow the flavours to infuse, before passing the soup through a fine sieve, pressing hard on the corn to extract as much flavour as possible. Taste-check the seasoning once again. Serve either hot or chilled.

CHEF'S NOTE At cocktail parties, we frequently serve chilled **Sweet Corn & Basil Soup** in shot glasses, with a small drop of pesto oil floating on top. Another favourite is to slowly roast corn kernels in butter with a clove of cracked garlic and a sprig of thyme until golden brown. Drain off and add to the soup that has already been thinned with corn stock to a sauce consistency. Serve with plain roasted chicken and potato purée.

VICHYSSOISE OF OYSTERS

Vichyssoise is a classic soup made of purée of leeks and potatoes, finished with cream and normally served chilled.

At *Banc*, we make it in the traditional manner, but finish it by blending in freshly opened oysters and their juices. This gives the vichyssoise a completely different flavour. We serve it hot with oyster *beignets* — oysters which are coated in batter and fried golden brown and crisp, but which are left moist and just slightly warmed through on the inside.

It is important to use fresh oysters, and to save all their beautiful juices. Perhaps the most difficult part of this recipe is opening (or shucking) the oysters, if you haven't attempted it before.

The simplest way is to take a tea towel, soaked in water and squeezed out. Place the rounded part of the oyster shell, which holds the oyster and its juices, on the tea towel. Then, using an oyster knife place its tip between the two shells making sure you have a good grip. Put some pressure on the knife and twist the blade until you can feel the two shells coming apart. Gently pull the lid off the oyster and using the knife separate the oyster from the muscle which attaches it to the shell. You won't have to open too many before becoming an expert.

Below: Shucking oysters.

Serves: 4 (makes 1 litre or 1¾ pints)
VICHYSSOISE
25g (1oz) butter
300g (10½oz) white of leek, finely sliced
150g (5¼oz) finely sliced onion
175g (6oz) potatoes, peeled and cut into small, even-sized pieces
750ml (3 cups) chicken stock (see page 203)
125ml (½ cup) single cream
6 freshly shucked oysters and their juices
25ml (5 tsps) Noilly Prat
OYSTER BEIGNETS
(ingredients for 12 oysters)
1 doz freshly shucked oysters and their juices
250g (9oz) plain flour
60ml (4 tbsps) water
220ml (1 cup) warm beer
60ml (4 tbsps) olive oil
2 egg yolks
4 egg whites
plain flour for dusting
salt and freshly ground pepper
sprigs of chervil to garnish

Shuck all 18 oysters, saving the juices for the soup. Sterilise the shells by boiling in water for 3 minutes and save for decorating the dish later. Place 12 oysters on a dry towel; keep the other 6 in the juice.

Prepare the first stage of the batter by whisking the flour, water, warm beer, olive oil and egg yolk together to form a smooth batter. Clean down the inside of the bowl with a spatula, then cover the bowl with cling wrap to prevent a skin from forming. Allow it to stand for 1 hour.

To prepare the vichyssoise, melt butter in a heavy-based pan. Allow the butter to foam before adding the potatoes, onions and leeks. Cook for 6 minutes without browning over a medium heat. Add the Noilly Prat and continue to cook for about 2–3 minutes until it has evaporated. Pour in the chicken stock and bring to the boil. Reduce the heat and simmer for a further 20 minutes until the potato pieces are tender. Add the cream and bring the soup back to the boil and continue to cook for another 5 minutes. Remove from heat and blend the soup in an electric blender until smooth. Pass the soup though a fine sieve pressing hard on the vegetables to extract as much flavour as possible.

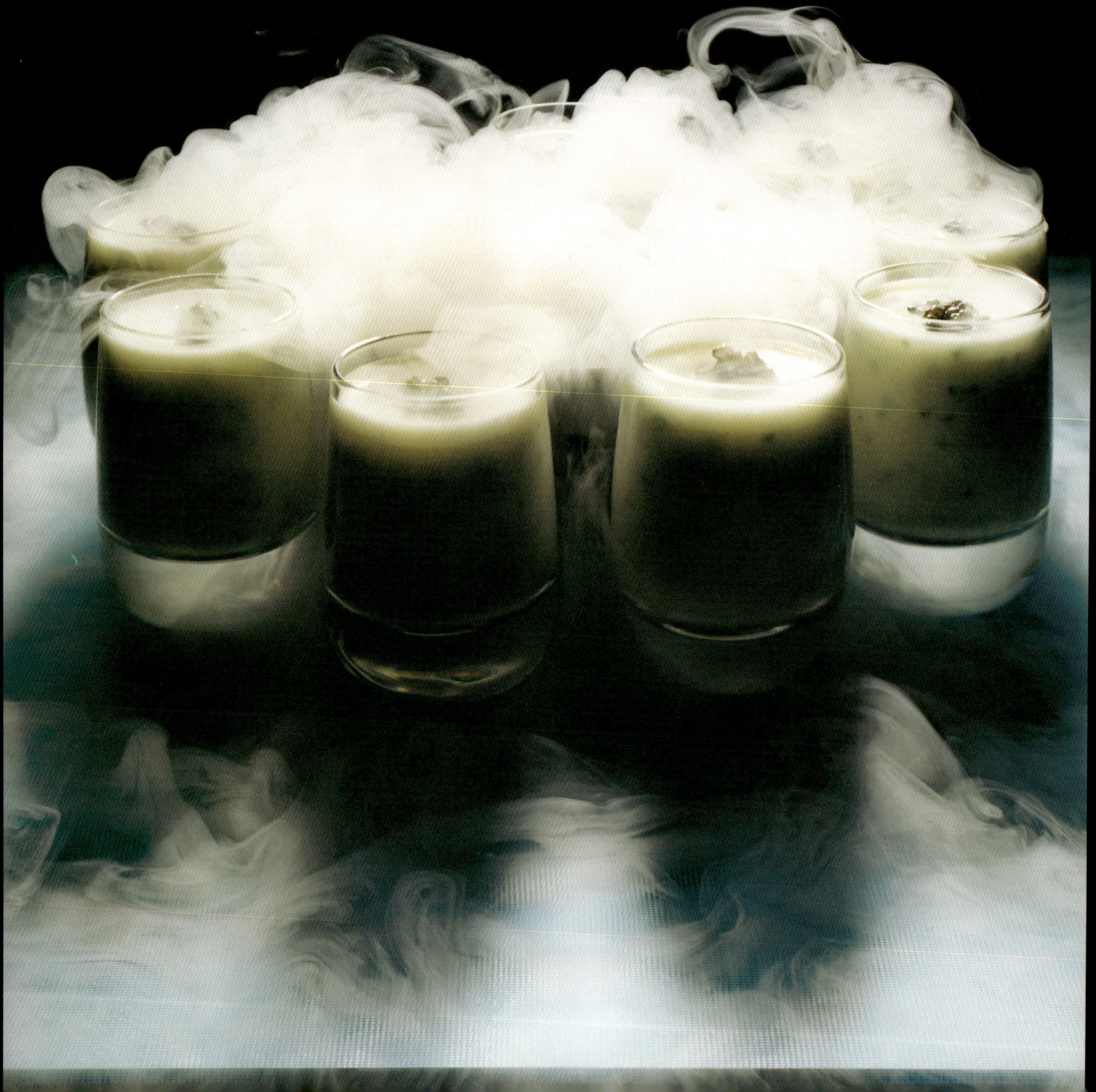

VICHYSSOISE OF OYSTERS

...continued

Using a hand blender, add the oyster juice and the other 6 oysters, one at a time, to the vichyssoise. Taste as you go, as you may prefer to use fewer oysters and less juice than shown in the recipe. When the oysters have been blended, taste the vichyssoise and season with salt and freshly ground pepper. Once again, pass the mixture through a fine sieve into a clean pan. Keep the mixture warm over a gentle heat while you finish the oyster *beignets*.

Heat oil in a deep pan to 180°C (360°F).

Whisk the egg whites until they form firm peaks, and fold through the batter mixture.

Lightly dust the remaining oysters in flour. Dip the oysters in the batter, and gently work with your finger tips until each is evenly coated. Remove from the mixture and gently place them in the oil and cook until they are golden brown and crisp. You may need to fry the oysters in two separate batches.

Lift the *beignets* from the oil with a slotted spoon on to kitchen paper to absorb excess oil. Season with salt, freshly ground pepper and lemon juice.

Pour a little rock salt onto each of the serving plates and press an oyster shell into each pile. Place a *beignet* into each shell and place another two on each plate. Pour a serving of vichyssoise into a cup or bowl and place beside the oysters on the serving plate, and garnish with sprigs of fresh chervil.

CHEF'S NOTE The vichyssoise, like the sweet corn soup, has several different uses. Both the soup and the *beignets* can be served as canapés. The soup is served chilled in a shot glass with a little caviar and sliced chives folded through it.

The *beignets* are served in oyster shells into which a little tartare sauce has been spooned. The shells should be served packed firmly on trays covered with rock salt to prevent them slipping.

Another version of the vichyssoise is served with the fresh oysters gently warmed through it with some sliced chives. This is then poured over a pile of warmed cucumber spaghetti which has been cut on a mandolin, and which has been arranged in the centre of the soup plate. At *Banc*, we spoon some caviar on top of the cucumber (see photo, bottom left).

Instead of finishing the vichyssoise with fresh oysters, a cheaper and quicker version utilises a hand blender to add some Chinese oyster sauce to taste. This will make the soup a little darker in colour. Due to its high salt content the oyster sauce should be added a little at a time, and taste tested after each addition. Although the soup won't have the same explosive flavour as that achieved with fresh oysters, it will still taste great.

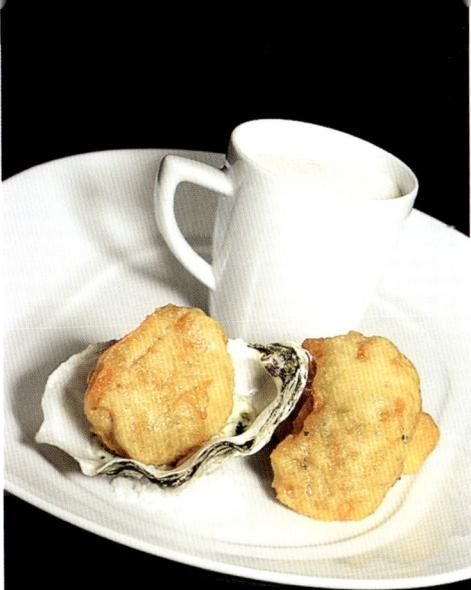

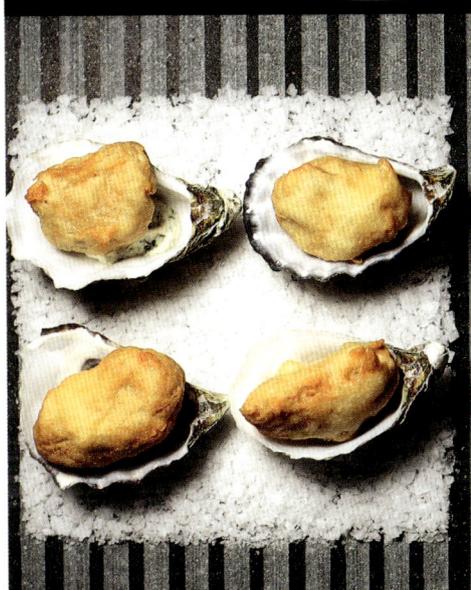

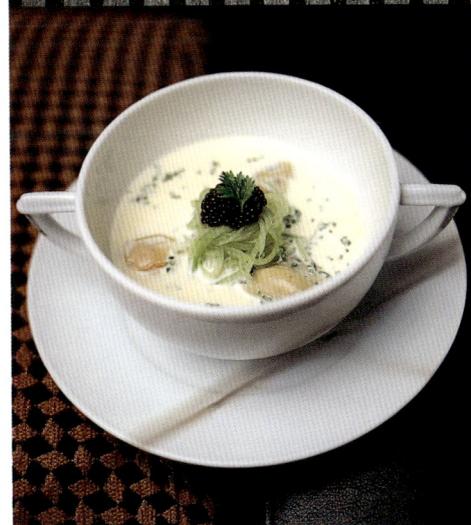

Above, top: The vichyssoise served as entrée with oyster *beignets*.

Above, centre: Oyster *beignets* served on rock salt for cocktail parties.

Above: Vichyssoise served with cucumber and Sevruga caviar.

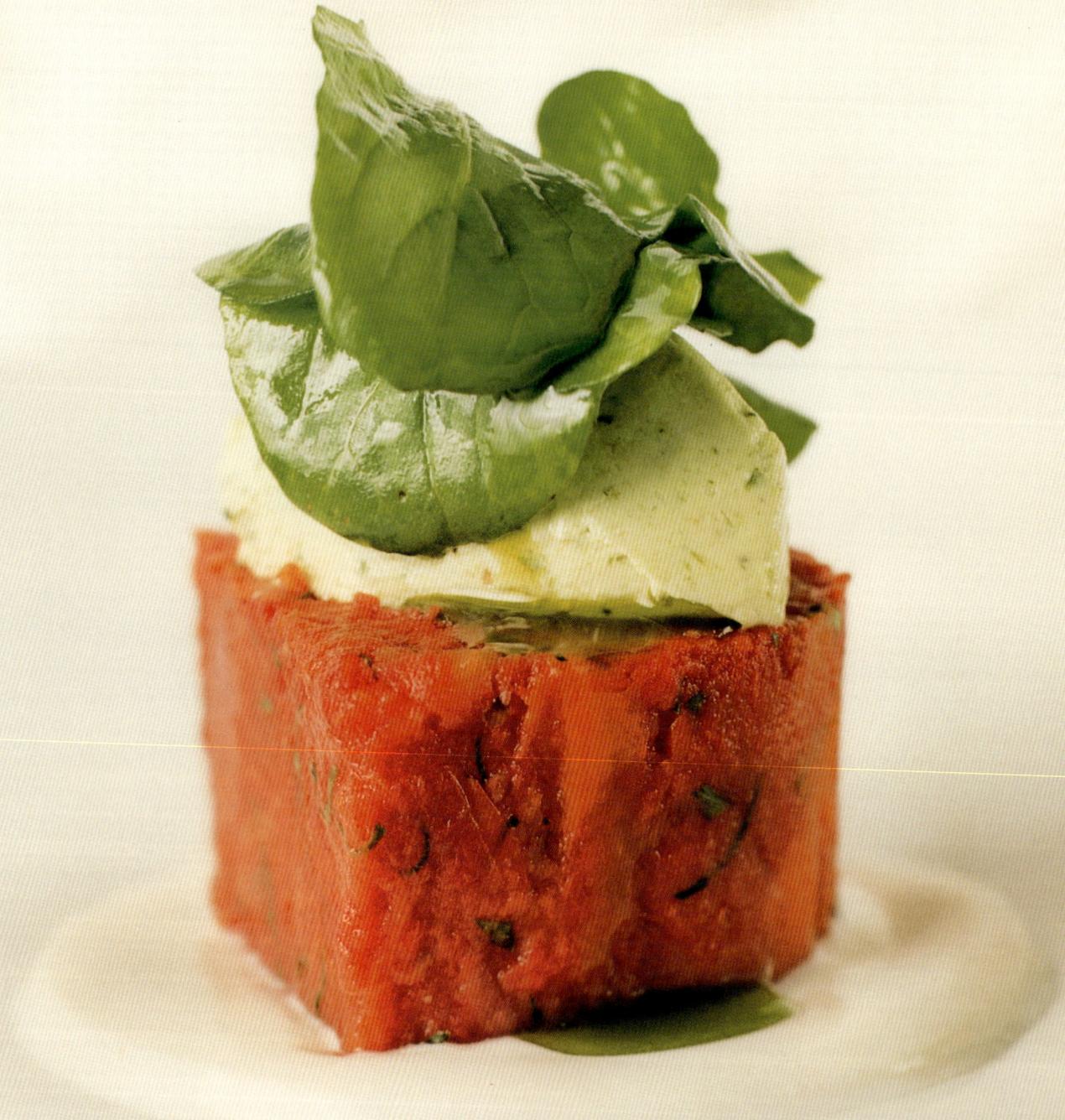

TERRINE OF TOMATO CONFIT WITH PESTO-FLAVOURED GOAT'S CHEESE

We use tomatoes for so many different dishes and garnishes at *Banc*. Several types of tomato are prepared, cooked and presented in various ways, each with its own particular flavour and texture. In any given week, we go through 180–200kg (400–440lb) of tomatoes, including cherry tomatoes that are semi-dried for lamb sauce, Roma or egg tomatoes for tomato fondue or for confit for the tomato terrine. Nothing is wasted, even the water released from the confit is used as the stock for a tomato risotto we sometimes make, while over-ripe tomatoes are made into the simplest and most refreshing tomato consommé (inspired by Paul Heathcote's book *Rhubarb and Black Pudding*) I have ever tasted. This we serve with Rock Lobster Tail, French Tarragon and Baby Basil or with Pesto Goat's Cheese Ravioli, a favourite vegetarian dish. Vine-ripened tomatoes are used for tomato tart, for a cod dish, and for tomato dice which is used to garnish the Prawn and Scallop Ravioli, or they are sliced and served simply dressed with good olive oil, balsamic vinegar, Ligurian olives and sliced shallots as Tomato Salad.

Makes: 750ml (1⅓ pint) terrine mould; serves: 12 slices

TOMATO CONFIT To make this size terrine you will need 650g (1½lb) of tomato confit for which you will need approx 8kg (18lb) of Roma tomatoes. By the time you core, remove the seeds, confit, skin, hang and squeeze them, they will have reduced to about 85–90 per cent of their original weight.

8kg (18lb) Roma tomatoes cored, halved and de-seeded

200g (7oz) rock salt

4 cloves of garlic, peeled and sliced thinly

50ml (3½ tbsps) extra virgin olive oil

freshly ground pepper

10 sprigs fresh tarragon with stalks

12 sprigs fresh continental parsley with stalks

12 sprigs fresh basil with stalks

6 sprigs fresh thyme

5g (1 tsp) julienne of fresh basil

5g (1 tsp) julienne of fresh parsley

5ml (1 tsp) garlic oil

10ml (2 tsps) balsamic vinegar

10ml (2 tsps) pesto (see page 209)

16 blanched tomato petals (see page 206)

GAZPACHO

250g (9oz) tomatoes, cored, halved and de-seeded

¼ cucumber, halved and de-seeded

½ red capsicum, halved and de-seeded

1 small clove of garlic, peeled

½ small Spanish onion, peeled

6 sprigs fresh basil

15ml (3 tsps) sherry vinegar

Tabasco sauce to taste

25ml (5 tsps) extra virgin olive oil

50ml (3½ tbsps) tomato water released from the confit

4 gelatine leaves

salt and freshly ground pepper

PESTO-FLAVOURED GOAT'S CHEESE (Serves: 4)

60–80ml (4–5½ tbsps) pesto (see page 209)

120g (4oz) plain goat's cheese log

salt and freshly ground pepper

GOAT'S CHEESE CURD

50ml (3½ tbsps) goat's cheese curd

4 sprigs fresh basil

lemon juice

salt and freshly ground pepper

Garnish, 1 small bunch of baby rocket leaves

TERRINE OF TOMATO CONFIT WITH PESTO-FLAVOURED GOAT'S CHEESE

...continued

CHEF'S NOTE The tomato confit, gazpacho and pesto can all be made 24 hours in advance. Once the terrine is made, you must allow at least 6 hours for it to set before turning out and slicing.

TOMATO CONFIT Pre-heat oven to 140°C (280°F). Sprinkle the rock salt over a tray. Roughly chop the herbs and scatter them over the salt. Lay the tomato halves, packed closely together, flesh side down on the herbs. Drizzle 25ml (5 tsps) olive oil and scatter garlic over the tomatoes. Season with freshly ground pepper. Cover tomatoes with greaseproof paper and then wrap the entire tray in aluminium foil. Bake in the oven for 25–35 minutes, depending on the size of the tomatoes. They are ready when the flesh becomes soft and the skin comes away easily.

Remove from the oven and allow to slightly cool. Brush off any herbs, garlic or salt stuck to the tomatoes. Remove and discard the skins. Place the tomatoes in a piece of muslin cloth and tie it up from the corners tightly. Place this in a sieve, over a bowl to catch the tomato water that will be released. Set to one side. You will need some of the tomato water for melting down the gelatine.

GAZPACHO Roughly chop the tomatoes, cucumber, capsicum, garlic, Spanish onion and basil. Place in a food processor and blend until you have a smooth purée. Pass this through a fine sieve, pressing hard on the vegetables to extract as much flavour as possible. Add the sherry vinegar and Tabasco to taste, but don't make it too hot as the dish should be very delicate in flavour. Season to taste. Keep stored in the fridge until you are ready to use.

GOATS CHEESE CURD Roughly chop the basil and mix it into the curd. Season to taste. Leave the mixture to infuse for 1 hour before passing it through a fine sieve. Keep stored in the fridge until ready for use.

PESTO-FLAVOURED GOAT'S CHEESE Use your fingertips to crumble the cheese. Then, using a wooden spoon, work the cheese to a smooth paste and add the pesto. The cheese will take on a nice, pale green, pesto colour. Season with a little freshly ground pepper. Keep stored in the fridge until you are ready to use. If the cheese has lumps in it, pass it through a fine drum sieve.

Remove the tomato confit from the muslin cloth. It should be quite dry by now. If it still feels wet, squeeze it out with your hands, before undoing the muslin. Place in a bowl and add the olive and garlic oils, stir in the pesto and julienne of basil and parsley. Season with salt and freshly ground pepper.

Left, from top: Tomatoes about to be turned into confit; the baked tomatoes, ready for peeling; squeezing out excess tomato water from the muslin wrapped tomato pulp; building the terrine, layer by layer.

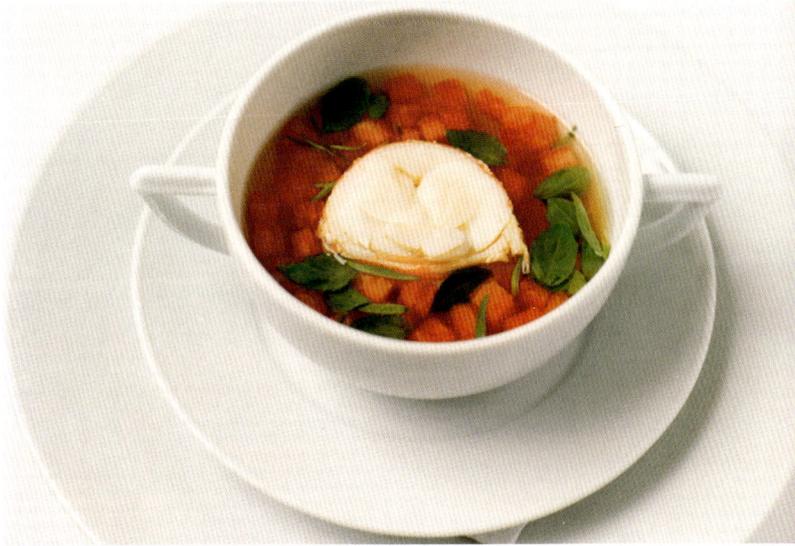

TOMATO CONSOMMÉ

Yields: 1 litre

1.6kg (3½lb) over-ripe Roma tomatoes

2 shallots, sliced thinly

1 small bunch of fresh tarragon, chopped

1 small bunch fresh basil, chopped

10ml (2 tsps) white wine

1 tbsp Maldon sea salt

1 tsp sugar

160g (6oz) tomato dice (see page 206)

20 picked basil leaves

20 picked tarragon leaves

4 x 40g (1½oz) medallions of cooked lobster tail

freshly ground pepper, salt

Core tomatoes and roughly chop. Place in a bowl with shallots, chopped herbs, wine, sugar, salt and a twist of freshly ground pepper. Mix all ingredients together and cover with cling wrap. Place in the fridge for 4 hours to allow the flavours to infuse. After 4 hours transfer the tomato mixture into a muslin cloth or clean tea towel and tie tightly. Place this parcel in a sieve over a deep bowl to catch all the juices released by the tomatoes, and store in the fridge overnight. Using a coffee filter paper, decant the tomato consommé into another bowl to remove any sediment. Cover with cling wrap and keep in the fridge ready for use.

TO SERVE Warm 100ml (about 7 tbsps) of the consommé in a saucepan, add the medallions of lobster and tomato dice, and warm through gently. Lift the medallions of lobster and tomato out of the consommé and lightly season with salt and freshly ground pepper. Gently warm the remaining consommé. Divide the medallions of lobster, tomato dice and picked herbs between four soup bowls and pour consommé over. Serve immediately.

Place the gelatine in a little cold water for 30 seconds to soften. Lift out and squeeze dry. Bring 50ml (3½ tbsps) of the tomato water to the boil in a pan, and add the gelatine. Stir until dissolved. Stir this mixture into the gazpacho. Trim the sides of the tomato petals so that they are squared off. Brush with a little olive oil and season with salt and freshly ground pepper.

Line the terrine mould with cling wrap, ensuring there are no air pockets, and allowing enough overhang to cover the top of the terrine when built.

BUILDING THE TERRINE Pour a thin layer of gazpacho to cover the base of the terrine mould. Add a layer of tomato confit and smooth out with a small palette knife. Pour another thin layer of the gazpacho to cover the tomato confit. Press the tomato petals gently into this layer of gazpacho and cover with another layer of tomato confit. Continue building the terrine until the mould is full. The last layer should be tomato confit. Fold the cling wrap over the top of the terrine.

NB: If the gazpacho begins to set while you are building the terrine, just place it on the stove on a low heat to melt it down again.

The terrine should now be pressed lightly so that the various layers hold together. Cut a piece of cardboard the same size as the terrine and cover with aluminium foil followed by cling wrap. Place on top of the terrine and place a 250g (9oz) weight each end of the terrine. Place in the fridge for at least 6 hours, and overnight if possible.

Remove the weights from the terrine. Remove the cardboard and un-wrap the cling film from the top of the terrine. Run a sharp knife around the sides of the mould. Invert the mould onto the cut out cardboard. Slice the terrine, and allow slices to stand for 10–15 minutes to reach room temperature.

To serve, pour a small pool of goat's cheese curd in the centre of each plate. Work it into a nice round with a spoon. Place a slice of terrine in the centre of the curd. Using two tablespoons, make quenelles (see Glossary, page 212) from the goat's cheese pesto and place on top of the terrine. Dress the baby rocket leaves with a little olive oil, and arrange on top of the quenelles.

TERRINE OF SALMON WITH YABBY TAILS WITH SALAD OF FENNEL

There is much preparation to be done before assembling this terrine. I recommend you prepare the tomato consommé and tomatoes the day before you plan to serve the dish, while the salmon, yabbies, leeks and herbs should be prepared on the day.

Makes 14 portions

1 x 1.5-litre (approx 2-pint) terrine mould

1 litre (1¾ pints) Tomato Consommé (see page 153)

8 leaves of gelatine

1 x 700g (1½lb) piece of de-boned salmon, with skin removed

1.5kg (3⅓lb) yabby tails

8 medium size leeks

large tomato petals (see page 206)

10g (2 tsps) chives, sliced

10g (2 tsps) chervil, chopped

10g (2 tsps) tarragon, chopped

1 litre (1¾ pints) water

50ml (3½ tbsps) Pernod

50ml (3½ tbsps) Noilly Prat

200g (7oz) fennel trimmings

100g (3½oz) shallots, sliced

pinch saffron threads

stalks reserved from chervil and tarragon

salt and freshly ground pepper

THE DRESSING

100ml (7 tbsps) reduced salmon poaching liquid

20ml (4 tsps) champagne vinegar

20ml (4 tsps) Pernod

200ml (7 fl oz) citrus olive oil

300ml (10 fl oz) extra virgin olive oil

pinch saffron threads

lemon juice, to taste

GARNISH

(30g [1oz] per serve)

bulb of fennel, thinly sliced

5ml (1 tsp) extra virgin olive oil for every 120g (4oz) of fennel used

lemon juice

salt, freshly ground pepper

20g (¾oz) per serve tomato dice (see page 206)

sprigs or fresh chervil

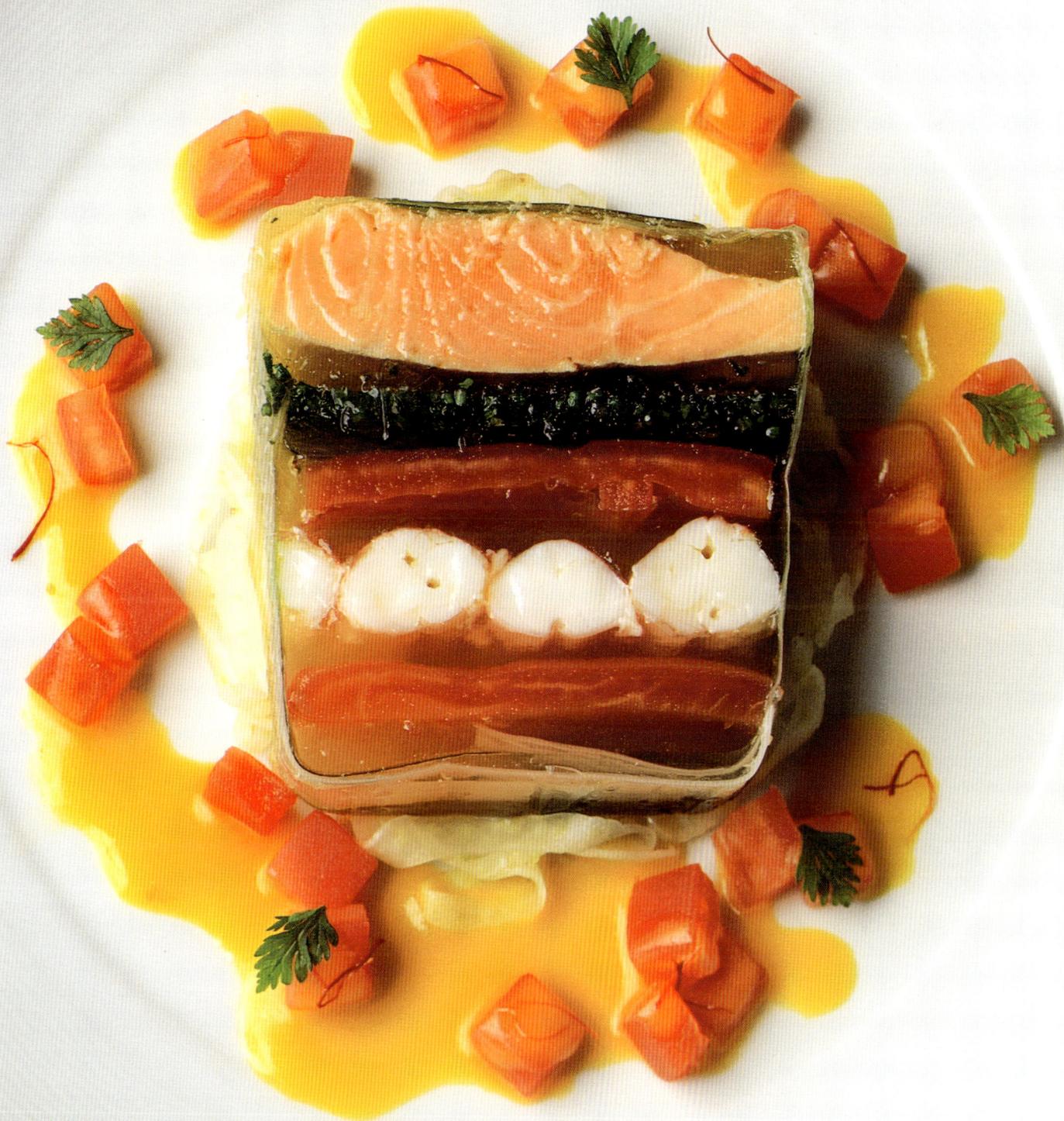

Prepare the tomato consommé, tomato petals and tomato dice in advance. Soften gelatine in cold water and squeeze dry. Heat the tomato consommé and whisk in the gelatine until dissolved. Take off heat and keep aside ready for use.

Remove the heads from the yabbies and put the tails on skewers to prevent them curling during cooking. Cook in salted, boiling water for 1½ minutes. Lift out and refresh in iced water. Remove the yabbies from skewers, shell and de-vein and lay out on a tray covered with a clean tea towel. Cover with cling wrap and refrigerate until required.

POACHING LIQUID In a large saucepan, add the water, Pernod, Noilly Prat, herb stalks, fennel, shallot and saffron. Lightly season with salt and freshly ground pepper. Bring to the boil, reduce the heat and simmer for 15 minutes.

THE SALMON Prepare the salmon by cutting it into a piece 8.5cm (about 3½in) wide and 26cm (about 10in) long to fit into a terrine mould. Any trimming can be reserved for another dish such as salmon fish cakes. Remove the poaching liquid from the stove. Place the salmon gently into it. Allow the salmon to sit in the liquid as it cools down, poaching slowly so that the centre remains pink. When cool, gently lift the salmon out and place on the tea towel with the yabbies. Cover until required.

Pass the poaching liquid through a fine sieve into a clean saucepan, return to the heat and reduce to 100ml (about 7 tbsps) and allow to cool. This will later be used to make the dressing for the terrine.

THE LEEKS Slit the white of the leeks lengthways, peeling back each layer. Wash in plenty of cold water to remove any grit and sand. Blanch in boiling salted water for 4 minutes and refresh in iced water. Drain well. Using a knife, scrape away the fibrous membranes from the inside of the leeks. So you are left with a very thin layer of almost transparent leek. Trim each leek to 22cm (about 8½in) in length and lay on a clean tea towel until required. Scrape any bloodline from the underside of the salmon and trim any rough edges.

ASSEMBLING THE TERRINE Line the terrine mould with a double layer of cling wrap, pressing into the corners. Line this with a layer of leeks, overlapping each other and pressed well into the corners of terrine. The leek should overhang the sides of the terrine by about 6cm (2½in) each side. Square the sides of the tomato petals and lightly season with salt and

freshly ground pepper. Pour 160ml (5½ fl oz) tomato jelly into terrine and allow to set slightly before covering with a layer of tomato petals, presentation side down.

Lightly season yabby tails with salt and freshly ground pepper. Pour another 160ml (5½ fl oz) of tomato jelly over the tomato petals and allow to set slightly before adding a layer of yabby tails closely packed together to cover the entire surface.

Pour another 160ml (5½ fl oz) of tomato jelly into the terrine to cover the yabbies, and allow it to slightly set before adding another layer of tomato petals. Measure out another 160ml (5½ fl oz) of tomato jelly and add the chives, chervil, tarragon. Pour over the second layer of tomato petals. Allow to slightly set.

Lightly season the salmon with salt and freshly ground pepper, and gently place it into the terrine and cover it with the last of the tomato jelly. Allow to set slightly before covering with leek so that the terrine is completely sealed. Place the terrine in the fridge for at least 5 hours to completely set before turning out and cutting.

THE DRESSING Place the reduced poaching liquid in a bowl, add the champagne vinegar, Pernod and saffron threads. Stand in a warm area for 15 minutes to allow saffron to infuse. Whisk in citrus oil and extra virgin olive oil. Season to taste with sugar, salt, freshly ground pepper and lemon juice. If the dressing is too thick, add a little water.

THE FENNEL Slice fennel as thinly as possible, we use an electric slicing machine for the best results. Place in a bowl and add 5ml (1 tsp) of oil to every 120g (4oz) of fennel used. Season to taste with salt, freshly ground pepper and lemon juice.

Invert the terrine on to a board. If it doesn't slide out easily, run a tea towel under hot water, squeeze out and place on to the terrine to help loosen it.

TO SERVE Measure out 15ml (3 tsps) dressing per portion. Use 20g (¾oz) tomato dice per portion, lightly season with salt and freshly ground pepper and add to the dressing.

Place a 10cm-wide (4in-wide) pastry ring in the centre of plate and spread a thin layer of fennel inside it. Repeat for each plate. Using a very sharp knife, cut the terrine into 1½cm (½in) slices. Lightly season each slice with salt and freshly ground pepper. Place slice of terrine on the fennel salad. Spoon the dressing and tomato around the terrine. Garnish with sprigs of fresh chervil.

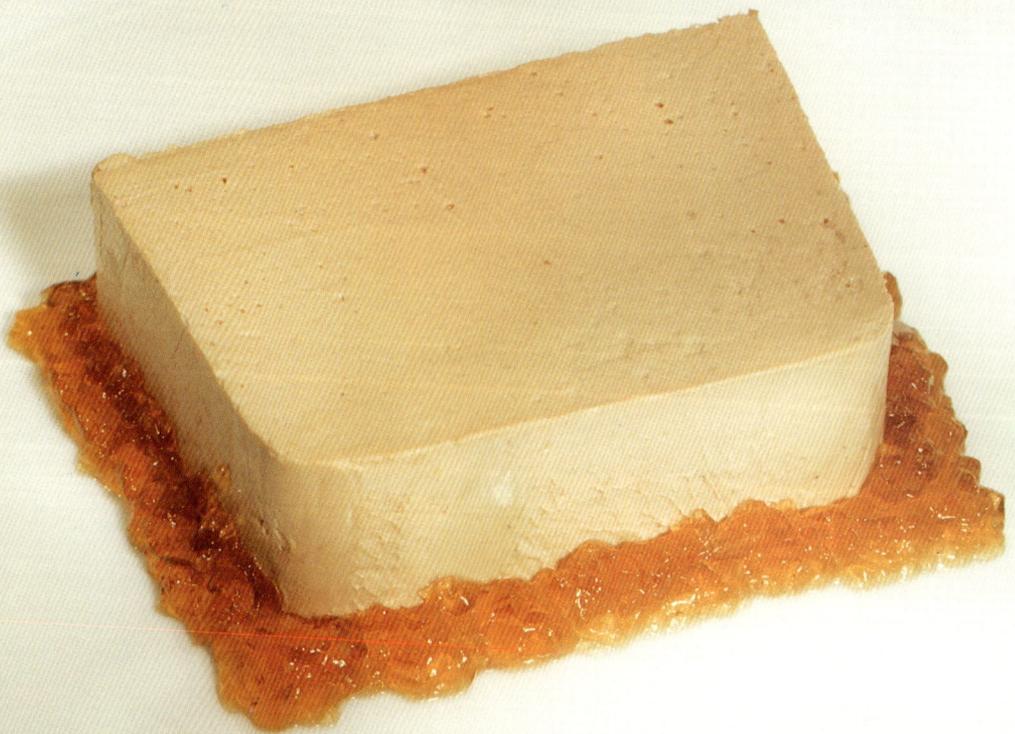

This is a very smooth, rich parfait which is always on the menu at *Banc* or *Wine Banc* in one form or another. It is beautiful served with the **Sauternes Jelly** (see page 208) or simply spread on a piece of toasted sour dough bread or brioche as a quick snack. If you don't have time to make the jelly, serve the parfait with a good quality chutney or Cornichons and cocktail onions. I sometimes serve an assiette of duck with a small slice of parfait, rillette of duck, and some crisped duck confit with potato salad.

You can replace the duck livers with chicken livers if you wish.

Above: A selection of terrines. Left to right: Veal and Bacon; Duck Liver Parfait; Terrine of Tomato Confit; and Duck Confit with Foie Gras.

Makes: 1.2-litre (approx 2-pint) terrine or enough for 16 slices

660g (1½ lb) duck livers

85ml (6 tbsps) madeira

85ml (6 tbsps) port

85ml (6 tbsps) cognac

425g (1lb) softened unsalted butter

3 large eggs

salt, freshly ground pepper

10g (½ oz) chopped sauternes jelly per portion (see page 208)

Thoroughly clean the livers, removing any sinew or green parts left from the gall bladder, as these will turn the livers bitter.

Place the livers in a bowl and cover with madeira, port and cognac. Marinate for 2 hours in the fridge.

Pour the livers into a sieve over a bowl and catch all the alcohol. Put the alcohol in a small saucepan and reduce its volume by half. Pass through a fine sieve and allow to cool.

Blend the livers to a purée in an electric blender or food processor. Add the eggs one by one until fully incorporated and the mixture is smooth. Add the reduced alcohol. Pass the mixture through a very fine sieve.

In a clean blender or food processor, place half the liver purée and blend with half the butter until smooth. This process works best if the butter is very soft but not melted (hard butter will create lumps). Pour into a bowl and repeat with the remainder of the liver purée and butter. Add to the bowl and gently whisk together. Season to taste with salt and freshly ground pepper, and add a little more cognac to taste.

Line a 1.2-litre (2-pint) terrine mould with cling film, making sure that you press it right into the corners to ensure you achieve a nice even surface when turning out, and leave enough overhang to cover the top of terrine mould during the cooking of the parfait.

Pour the duck liver parfait into the terrine and fill to about 2cm (¾in) from the top. Gently tap the terrine on the benchtop to expel any air bubbles through the parfait. Cover with the over-hanging cling wrap, and place the lid on top. Pre-heat the oven to 90°C (195°F).

Place a tray deep enough to hold the terrine on the stove and half fill with water. Place the terrine into it. Pour in more water so that it reaches four-fifths of the way up the side of the terrine mould. Leave it on the stove until the water begins to simmer, and then very carefully transfer into the oven. Cook for 50 minutes and test with a skewer. If the livers are still soft and runny give it a few more minutes before testing again (when the skewer is removed, it should be clean and barely warm to touch).

Remove from the oven and take the terrine out of the pan. Allow the duck liver parfait to set over night in the fridge before turning out.

To turn out, run a sharp knife around the sides of the terrine mould to loosen the parfait. Invert the mould onto a board or plate. If it doesn't slide out easily, run a tea towel under hot water, squeeze out and place on the terrine. The heat from the tea towel will loosen the parfait.

Heat a sharp knife under hot water, wipe dry and cut the terrine into 1½cm (½in) slices. Place each one on the centre of a plate and either spoon on or pipe the sauternes jelly around the parfait.

Serve with hot toast or slices of toasted brioche.

If you don't want to make a whole parfait, reduce the quantities and cooking time, and make individual portions in ramekins.

CHEF'S NOTE It is very important that the oven is kept at a low temperature and the water bath just 'trembles'. If it is too hot, the parfait will cook too quickly and end up being very coarse and dry.

TRUFFLED POLENTA AND POACHED EGG WITH ASPARAGUS SPEARS

Although I have lived and worked in Australia for more than 10 years, there are still many ingredients from Europe I really miss. From time to time, some of these hard-to-find ingredients may be flown in, but usually at enormous expense.

Take for instance the European selection of wild mushrooms such as chanterelles, morels, trompette, cepes — the list goes on. Then there are certain fish such as monkfish, Dover sole, turbot, brill and sea bass, and I've yet to come across scallops like those we have in London.

One thing we do get here during our summer, are fresh truffles from France. You can always tell when a shipment has arrived because, all at once, truffles begin to appear on the menus of the better restaurants. Being such an expensive item, around $1400 per kilogram, we try to stretch them out as far as possible. One method is to store them in parfait jars filled with polenta, arborio rice or eggs. The flavour of the truffle infuses into each product, allowing us to create such delicacies as truffled polenta, risotto or poached and creamed truffled eggs. We also cook the truffles in madeira, port and veal stock to form the base for our Périgueux sauce.

You *can* make this dish without fresh truffles. Simply drizzle a little truffle dressing or vinaigrette (see page 210) over and around the dish or make the basic beurre blanc (see page 205) and add a tablespoon of chopped chervil to it, and just use the recipe that follows.

Serves: 4

1 tbsp white wine vinegar

4 truffled or plain eggs

150g (5oz) truffled or plain polenta

375ml (1½ cups) milk

190ml (6½ fl oz) cream

190ml (6½ fl oz) chicken or vegetable stock

1 clove or garlic, peeled and crushed

2 sprigs of fresh thyme

24 spears of asparagus, blanched and refreshed

8 long strips of reggiano parmigiano

sprigs of fresh chervil

16 slices fresh truffles

salt, freshly ground pepper

120ml (4 fl oz) basic beurre blanc (see page 205)

Bring a large deep pan of water to the boil. Add vinegar and a pinch of salt. Reduce the heat so it is just trembling.

Crack the eggs into separate cups and then gently pour them into the water and poach for 3–4 minutes until the whites have set. Remove the eggs from the pan and place into a bowl of iced water.

Bring the milk, cream, stock, garlic and thyme to a simmer, remove from the heat and allow the thyme to infuse for 10 minutes. Remove the garlic and thyme, and return the liquid to heat. Bring back to the boil and simmer.

Whisk in the polenta and cook over a low heat for 5–7 minutes, whisking continuously until the polenta thickens. Season to taste with salt and freshly ground pepper.

Re-heat the eggs and asparagus spears in simmering water. Lift out of the water with a slotted spoon and drain on a tea towel. Season lightly with salt and freshly ground pepper.

Spoon the polenta onto a warmed plate. Place 6 asparagus spears alongside the polenta, and place a poached egg on top. Drizzle a little beurre blanc over the egg and asparagus.

Wrap 2 strips of reggiano parmigiano around each egg. Garnish with sliced truffle and sprigs of chervil.

Far left: Preparing the asparagus spears for blanching.

Left, centre: Assembling the dish.

Left: The finished dish, beautifully presented — Truffled Polenta and Poached Egg with Asparagus Spears.

Main photo, opposite page: Fresh truffles, worth $1400 per kilogram.

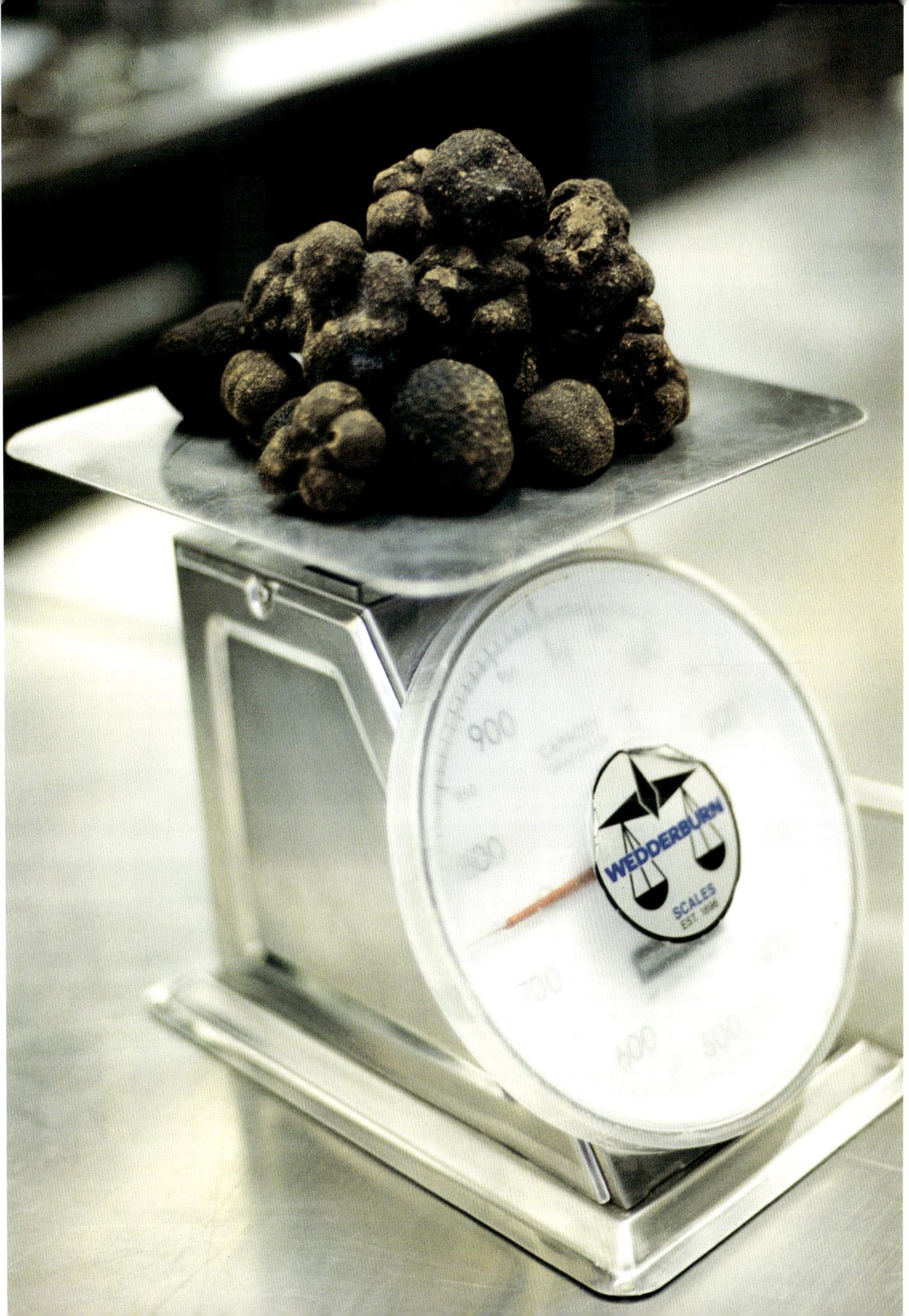

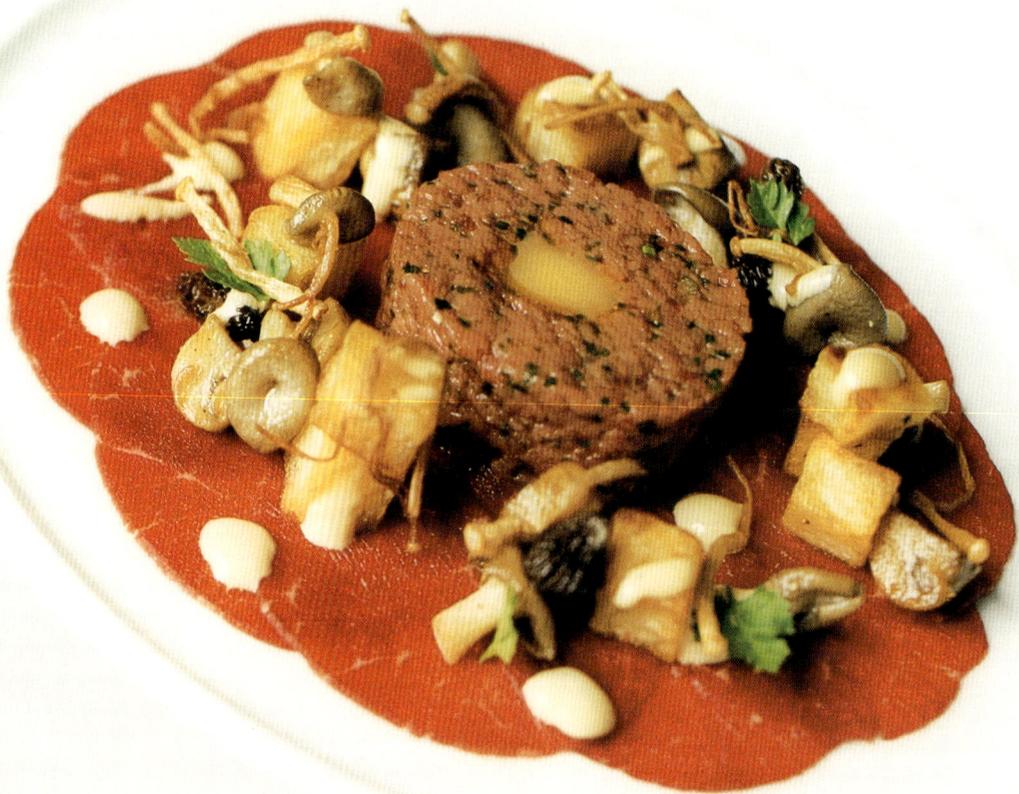

TARTARE OF BEEF

If you have made the **Fillet of Beef Rossini** on (page 174), and have some trimming left over, why not turn them into tartare? This is one of my favourite snacks, served spread on a piece of toasted brioche or sourdough bread, or with chips and green salad. If you're feeling very extravagant top the tartare with a spoonful of caviar.

When making the tartare, it's important that you taste as you go. The ingredient measures I have suggested are just a guide, as some people don't like capers, while others prefer a spicier tartare and add more Tabasco. To each his own.

Instead of cognac, calvados can be used to flavour the tartare.

Whatever ingredients you use, it is important that the meat is very fresh with a nice red colour. Tartare should always be served as soon as it is mixed.

Serves: 4 (60g or 2½oz portions)
200g (8oz) fillet or rump of beef
15g (½oz) gherkins or Cornichons, finely chopped
15g (½oz) cocktail onions, finely chopped
2g (½ tsp) capers, finely chopped
2g (½ tsp) chives, sliced
2g (½ tsp) parsley, chopped
1 small egg yolk
5–10g (1–2 tsps) Dijon mustard to taste
dash Tabasco to taste
dash Worcestershire sauce to taste
dash cognac to taste
20g (4 tsps) tomato ketchup
salt, freshly ground pepper

Trim meat of any fat or sinew and, using a large, sharp chopping knife, chop the meat very finely.
Place the meat in a bowl and stir in the gherkin, cocktail onions, capers, chives, parsley and egg yolk.
Add the tomato ketchup, Tabasco, Worcestershire sauce and Dijon mustard to taste, depending on how hot you like your tartare.
Add the cognac to taste and season with salt and freshly ground pepper.
The tartare can be served as above, or you could try the presentation we do at *Banc* (see picture, opposite). We start by brushing some truffle dressing (see page 210) on to a plate. We then overlap thin slices of beef carpaccio in a neat circle around the plate. We mould a round of tartare in the centre of the carpaccio before spooning a garnish of sautéed potatoes and mushrooms around the tartare and over the carpaccio.

Left: Carpaccio and Tartare of Beef with sautéed potatoes and mushrooms and truffle dressing.

ROAST FILLET OF BLUE EYE COD WITH PRAWN COLCANNON & RED WINE SAUCE

When cooking this fish dish — and in fact any fish dish — I wouldn't be without my cast-iron pans. They allow me to first seal the fish on the stove and then transfer the fillets straight to the oven for further cooking without causing damage to the pan.

Always pre-heat your oven well in advance to avoid a drop in temperature when the pan is moved from the stove to the oven. If the heat is reduced at this stage, the fish releases its beautiful juices, which causes it to poach in these juices.

When selecting your fish, ask the fishmonger for pieces of even size and thickness. This not only means they will all require the same cooking time, but they will look uniform when you plate them.

Salmon is an equally good choice of fish for this dish, and should be prepared the same way, but slightly reducing the cooking time to keep the fish a touch undercooked and pink on the inside.

Serves: 4

4 x 180g (6oz) fillets of blue eye cod, skin removed

1 basic recipe of colcannon (see page 184)

150g (5oz) cooked tiger prawns

24 thin slices of pancetta

120ml (4 fl oz) red wine sauce (see page 204)

25ml (5 tsps) vegetable oil

50g (2oz) butter

lemon juice

salt, freshly ground pepper

Pre-heat oven to 160°C (320°F). Lay the sliced pancetta on a baking tray and cook in the oven for 8–10 minutes until crisp. Remove pancetta and place on kitchen towels to soak up any fat. Increase oven temperature to 220°C (430°F) for cooking the cod later.

Shell and de-vein the prawns. Split them down the centre into two, and cut each half into two again. They should remain quite chunky so you can see them through the colcannon.

Prepare the red wine sauce (see page 204) and keep warm in a small jug standing in a pot of simmering water. Prepare the potato purée and all the garnish for the colcannon as described on pages 182 and 184, and place in a bowl and cover with cling wrap. Keep the bowl warm until ready to serve by placing it over a pot of simmering water.

Season the blue eye cod with salt and freshly ground pepper. Heat a little oil in a heavy-based pan and cook the fillet, skin side up for 4–5 minutes until golden brown. Transfer the pan to the oven and continue to cook for about another 4 minutes, depending on the thickness of the fish. Remove from the oven. Add the butter and a squeeze of lemon juice. Use to baste the fish, and lightly season again. Allow the fish to rest in a warm area.

Fold the prawn meat through the colcannon.

Spoon a large tablespoon of prawn colcannon on the centre of each plate. Drizzle the red wine sauce over and around the colcannon. Place the roast blue eye cod on top of the colcannon, and garnish the top of the fish with pieces of the crisp pancetta.

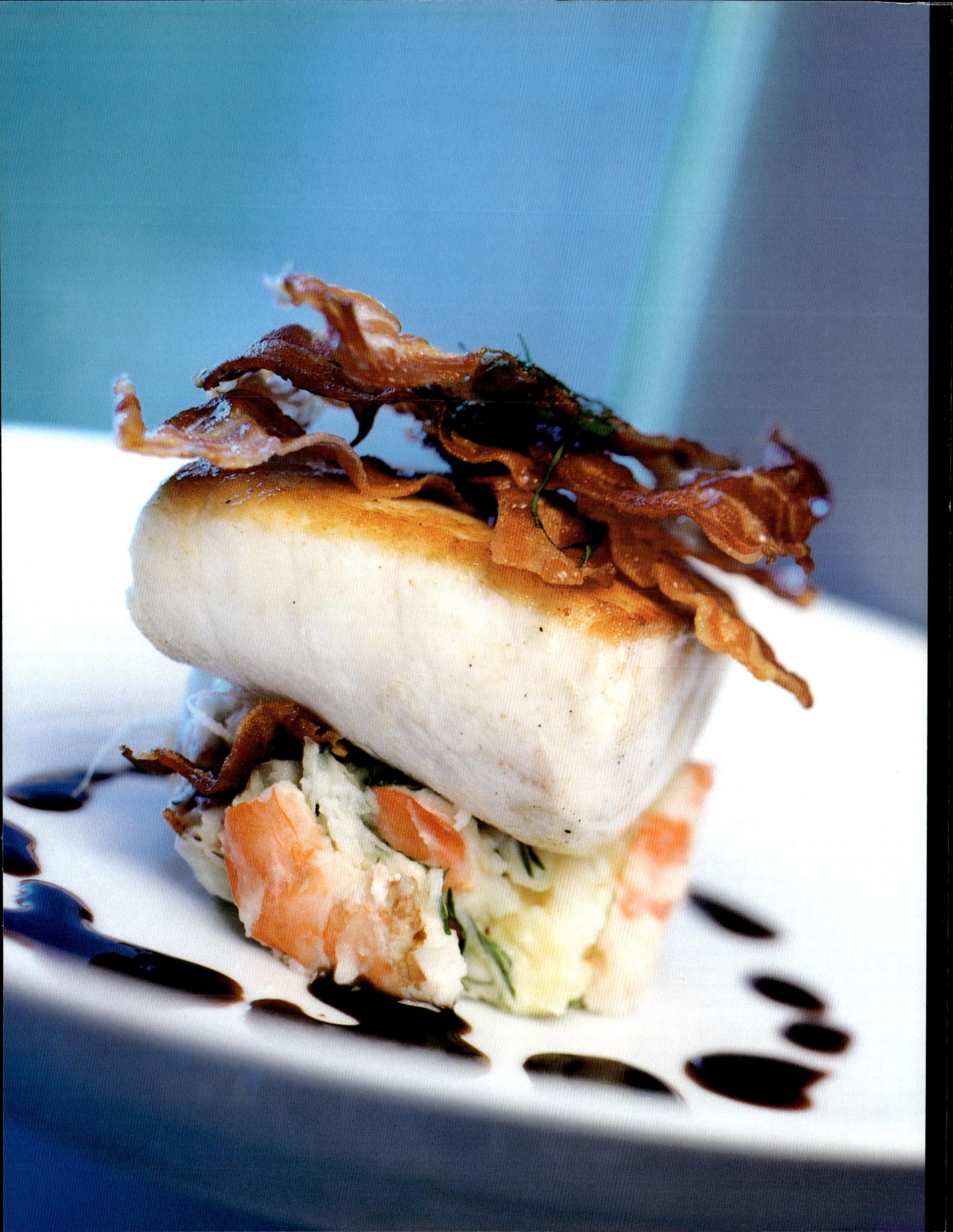

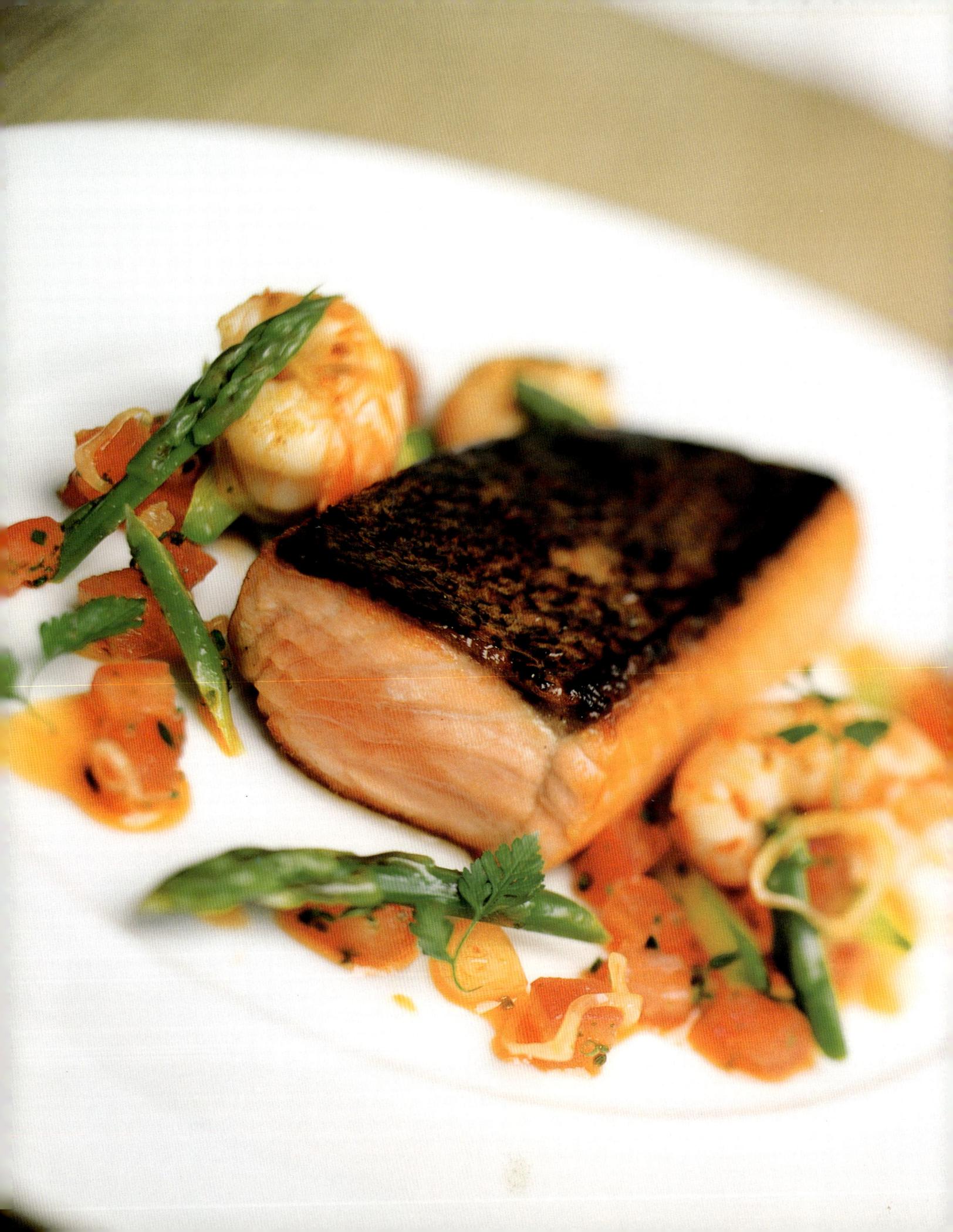

PAN FRIED FILLET OF SALMON WITH YABBY TAILS AND CRUSTACEAN OIL

Preparing the crustacean oil is the most time-consuming part of this recipe but, once you have made it, it will keep in the fridge for several weeks. The yabby tails, shallots, asparagus, diced tomato and herbs can all be prepared in advance. At *Banc*, we use the middle piece of the salmon for this dish, the head and tail are used for Salmon Fish Cakes or Brandade of Salmon.

Serves: 4

4 x 160g (5½oz) fillets of salmon with skin on

12 fresh yabbies

6 blanched asparagus spears

2 sliced shallots

200g (8oz) tomato dice (see page 206)

1 tsp chopped parsley

1 tsp sliced chives

½ tsp pickled thyme leaves

25ml (5 tsps) vegetable oil

50g (2oz) butter

lemon juice

salt, freshly ground pepper

150ml (⅔ cup) crustacean oil (see page 208)

3–4 sprigs fresh chervil

Cook the yabbies in boiling, salted water for 1 minute. Lift out and refresh in iced water. Remove the shells and de-vein, leaving just the tails.

Peel the asparagus spears and cook in boiling, salted water for 2 minutes. Lift out and refresh in iced water. Drain and cut into 3cm (1in) pieces.

Pre-heat oven to 200°C (400°F).

In a large frying pan, heat the vegetable oil. Place the salmon in the pan, skin side down. Cook for 2 minutes over a gentle heat. Transfer the salmon in the pan to the oven and cook for a further 5–6 minutes. The salmon should remain pink on the inside. Remove the salmon from the oven, add the butter to the pan, and baste the salmon. Season with salt, freshly ground pepper and a squeeze of lemon juice.

Remove the fish from the pan and place on a plate, cover with another plate, and keep warm by the side of the stove while you prepare the garnish.

In a frying pan, heat 100ml (about 7 tbsps) of the crustacean oil. Add the yabby tails and sauté until golden brown. Add the shallots, asparagus and thyme. Reduce the heat and cook until the shallots have softened. Add the remaining crustacean oil, diced tomato, parsley and chives. Season to taste with salt, freshly ground pepper and lemon juice.

Place the salmon in the centre of a warm plate and spoon the yabby and asparagus mix in neat piles around the salmon. Garnish with sprigs of chervil. Spoon the crustacean oil from the pan over and around the salmon.

SEARED TUNA NIÇOISE WITH A TAPENADE BEURRE BLANC

Tuna is a fish that I didn't encounter much when working in European kitchens, except out of a can in a sandwich with sliced onion and mayonnaise. Now, it seems, I'm making up for lost time as tuna features on almost every menu we write at *Banc* and *Wine Banc*. In fact, one of the most popular dishes we've ever made is **Tuna Niçoise**. This we serve with a **Tapenade Beurre Blanc and Pesto Potatoes**. Ask your fishmonger for the mid-cut of tuna as there is less sinew and waste than in the tail.

Below: Delicious variations include Pepper Tuna (left) and Herb-crusted Tuna (right). If you'd rather eat your Niçoise cold as a salad, prepare the tuna as described in the main recipe, but keep it as a whole piece. Evenly sear it in a very hot pan, making sure it remains rare on the inside. Allow it to cool slightly before brushing it with a grain mustard. Spread chopped parsley, chervil, tarragon and sliced chives on a tray and roll the tuna in them so that the entire piece is coated in a herb crust. Roll it tightly several times in cling wrap and allow it to stand in the fridge for a few hours before slicing it into medallions. Season lightly and brush with olive oil before serving.

For a different taste, replace the herb crust with a pepper crust by blending, in a food processor, equal quantities of white, black and green peppercorns with olive oil to form a smooth pepper paste. Spread over the raw tuna and wrap in cling wrap. Slice a medallion and pan fry it rare.

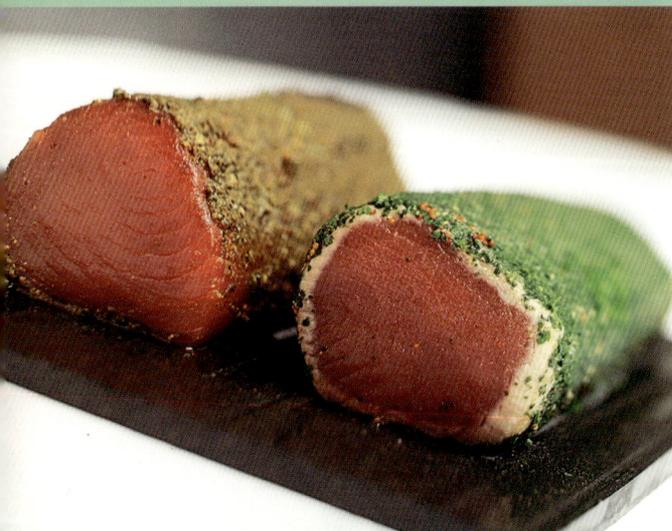

Serves: 4

720g (1½lb) piece of mid-cut tuna

SALAD NIÇOISE

30g (1oz) olive petals (see page 206)

8 anchovy fillets

80g (3oz) French beans, trimmed and blanched

2 vine-ripened tomatoes, cored, blanched and skinned

6 quail eggs, boiled for 2 minutes and peeled

25ml (5 tsps) olive oil

PESTO POTATOES

12 small kipfler potatoes

80–100ml (5–7 tbsps) pesto (see page 209)

salt, freshly ground pepper

TAPENADE OF BEURRE BLANC

200ml (7 fl oz) beurre blanc (see page 205)

tapenade (see page 206) to taste

Pre-heat the oven to 140°C (280°F). Prepare the tuna by removing the skin and any blood line. Trim the tuna into a nice cylinder shape. Wrap very tightly in several layers of cling wrap. Store in the fridge until you are ready to use. Scrub the skins of the kipfler potatoes and cook in salted water for about 20 minutes until tender. Peel them while still hot, place in a bowl and, using a fork, crush the potatoes. Mix in the pesto to taste; the potatoes will soak it up and take on a nice green colour. Season to taste with salt and freshly ground pepper. Cover the bowl with cling wrap and keep warm by placing it over a pot of simmering water until ready to serve.

Make the beurre blanc as explained on page 205. Add the tapenade to taste. The sauce will take on a charcoal colour. Season to taste. Keep the sauce warm until ready for use. (Cover it with cling wrap and keep it by the side of the stove. The sauce must not be re-boiled or it will separate.)

Cut the tomatoes into 8 wedges, place in a large bowl. Trim the French beans so that they are all of even size, and add to the tomato wedges along with the anchovies and olive petals. Drizzle olive oil over the ingredients and gently mix together. Season to taste with salt and freshly ground pepper.

To achieve a uniform shape on each plate, stack the salad neatly inside a large pastry cutter. Place plates in a warm oven for 3 or 4 minutes.

Using a teaspoon, make 3 small quenelles of pesto potato for each plate, and place them around the edge with half a quail egg between each.

Slice the tuna into 4 even pieces and season. Either pan fry or grill for 2–3 minutes on each side until medium-rare.

Drizzle a little beurre blanc over the tomato and bean salad and around the plate. Brush the tuna with a little olive oil and a squeeze of lemon juice. Place tuna on top of the salad.

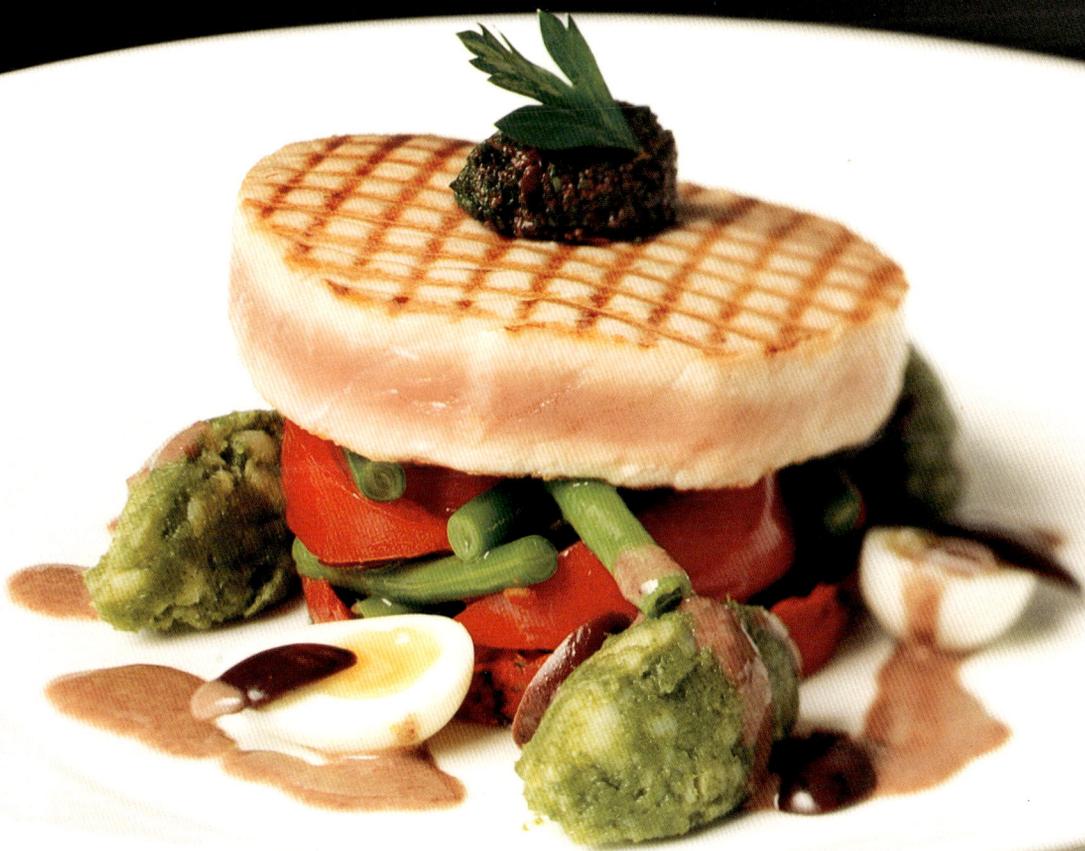

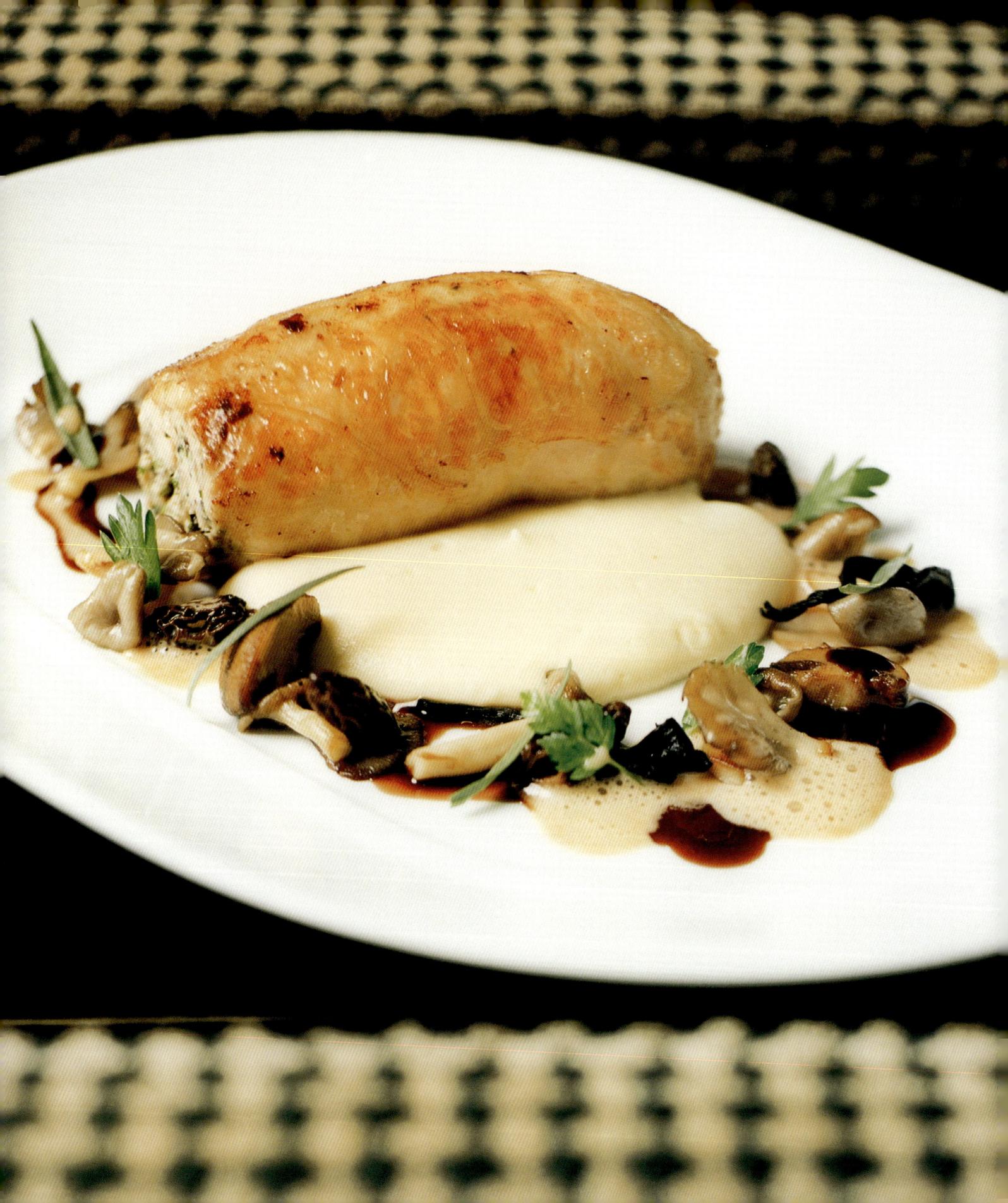

ROAST STUFFED LEG OF CHICKEN WITH GARLIC POTATO PUREE & MUSHROOMS

At *Banc*, we often buy ingredients that will be used in several different dishes. Take, for example, ducks. Their breasts are roasted for terrine and their legs are salted and turned into confit. Veal fillets are used for **Veal Zurichoise** while the heads of the fillet are flattened out and used for the **Veal and Bacon Terrine** served in *Wine Banc*. As you will see on the following pages, our beef fillets are also broken down into 3 or 4 different dishes, and our salmon trimmings are used for **Salmon Brandade** and **Fish Cakes**.

Once we cut up our chickens, we always have a lot of legs left over, so we turn them into a lunch time dish served in both *Banc* and *Wine Banc*. This is a time-consuming recipe, but really worth the effort. It can be served hot with fresh noodles, or it is equally as good sliced and served cold with salad and a nut-oil dressing.

To save time, you could ask your butcher to bone out the legs, but remember, it is essential the skin is not punctured.

Serves: 4

4 x 180g (6oz) chicken legs

400g (14oz) button mushrooms, finely chopped

50g (2oz) unsalted butter

1 onion, finely chopped

1 clove of garlic, finely chopped

40g (1½oz) bacon, rind removed and finely diced

60g (2½oz) minced chicken meat

1 egg

5g (1 tsp) parsley, chopped

½ tsp fresh thyme leaves

100g (3½oz) crépinette soaked in cold water

salt, freshly ground pepper

400g (14oz) selection of mixed mushrooms

1 basic recipe of potato purée (see page 182), prepared and kept hot

200ml (7 fl oz) morel cream sauce (see page 205), prepared and kept hot

75ml (5 tbsps) vegetable oil

Bone out the chicken legs using a sharp boning knife, taking care not to puncture the skin. The easiest way to do this is to lay a leg, skin side down, and cut around the thigh bone. Scrape the tip of the knife down the bone toward the joint which holds the thigh and drum bones together, freeing the meat from the thigh bone. Keeping the knife close to the joint, cut around it carefully. Remove the joint and the thigh bone. The drumstick bone will now be exposed. With the tip of your knife start to free the meat from the drumstick bone until you can grip the bone. Pull the bone hard, holding on to the meat. This will turn the drumstick inside out and make removing the bone and any sinew much easier. Slice across the skin which is attached to the bone. Keep the bones for chicken stock. Repeat process for other legs. Lightly season the insides of the chicken legs with salt and freshly ground pepper. Reverse them so that the skin is on the outside again.

To make the stuffing for the chicken legs, melt half of the butter in a heavy-based saucepan. Add the finely chopped button mushrooms and cook until they have released their juices.

Continue to cook over a low heat, stirring frequently until all the juices have evaporated and the mushrooms are dry. Remove from the heat and allow to cool down.

ROAST STUFFED LEG OF CHICKEN WITH GARLIC POTATO PUREE & MUSHROOMS

...continued

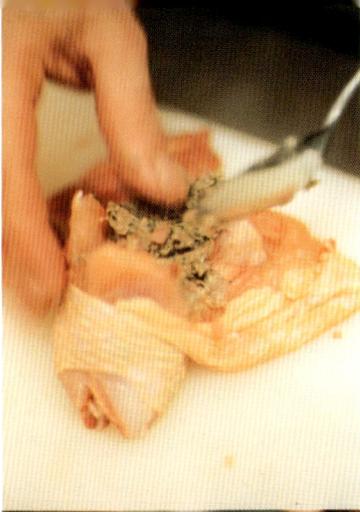

Heat the remaining butter in a frying pan and, without browning, sweat the onion, garlic and bacon until softened. Drain into a sieve and allow to cool. Place the minced chicken in a bowl. Add the mushroom, onion, garlic and bacon and stir well. Add the egg, parsley and thyme. Season with salt and freshly ground pepper. At this stage, it is a good idea to pan fry a teaspoon of the stuffing until cooked through. Taste test the seasoning, and adjust if required — once the stuffing is inside the leg, you won't be able to season! Spoon the stuffing between the four legs, packing it in tightly. Reshape the legs to their original form. Season with salt and freshly ground pepper. Squeeze the crépinette dry and spread out in a thin layer on a clean work surface. Place a chicken leg on the crépinette and wrap it twice, tightly. Be careful to keep the original shape of the chicken leg. Repeat with the remaining legs. Place the chicken legs in the fridge for an hour to firm them up before cooking.

Pre-heat the oven to 200°C (400°F).

Heat 25ml (5 tsps) oil in a frying pan large enough to hold the four legs, and seal them until golden brown all over. Transfer to the oven and continue to cook for a further 20–25 minutes. Test that the legs are cooked through by inserting a skewer — if the juices are clear, they are ready. If there is any trace of blood cook for a little longer.

While the chicken legs are cooking, heat 50ml (3½ tbsps) of oil in a heavy-based frying pan and sauté the mixed mushrooms until just soft and nicely coloured. Season with salt and freshly ground pepper (see Chef's Note, below). Drain well.

To serve, spoon the potato purée into the centre of the plate. Spoon the mushrooms around it. Place the chicken leg on the potato purée, and spoon the morel cream sauce around the chicken. This is also nice served on a crisp **Potato Galette** (see page 185) with the same garnish and sauce.

CHEF'S NOTE It is always good practice whenever making fillings, stuffings or mousses, to regularly test them before proceeding to the next stage. A stuffing may need more seasoning, flavouring or even more egg to hold it together. The flavour of a mousse may need adjusting or more cream added to it. You cannot tell by looking, you must taste the mixture. Taking time to make the test could mean the difference between a wonderful, tasty dish or a bland one.

Left, from top: To prepare the chicken leg, first remove the thigh and drum bones; pack stuffing in tightly; place the chicken into the crépinette; wrap twice, maintaining the shape of the leg.

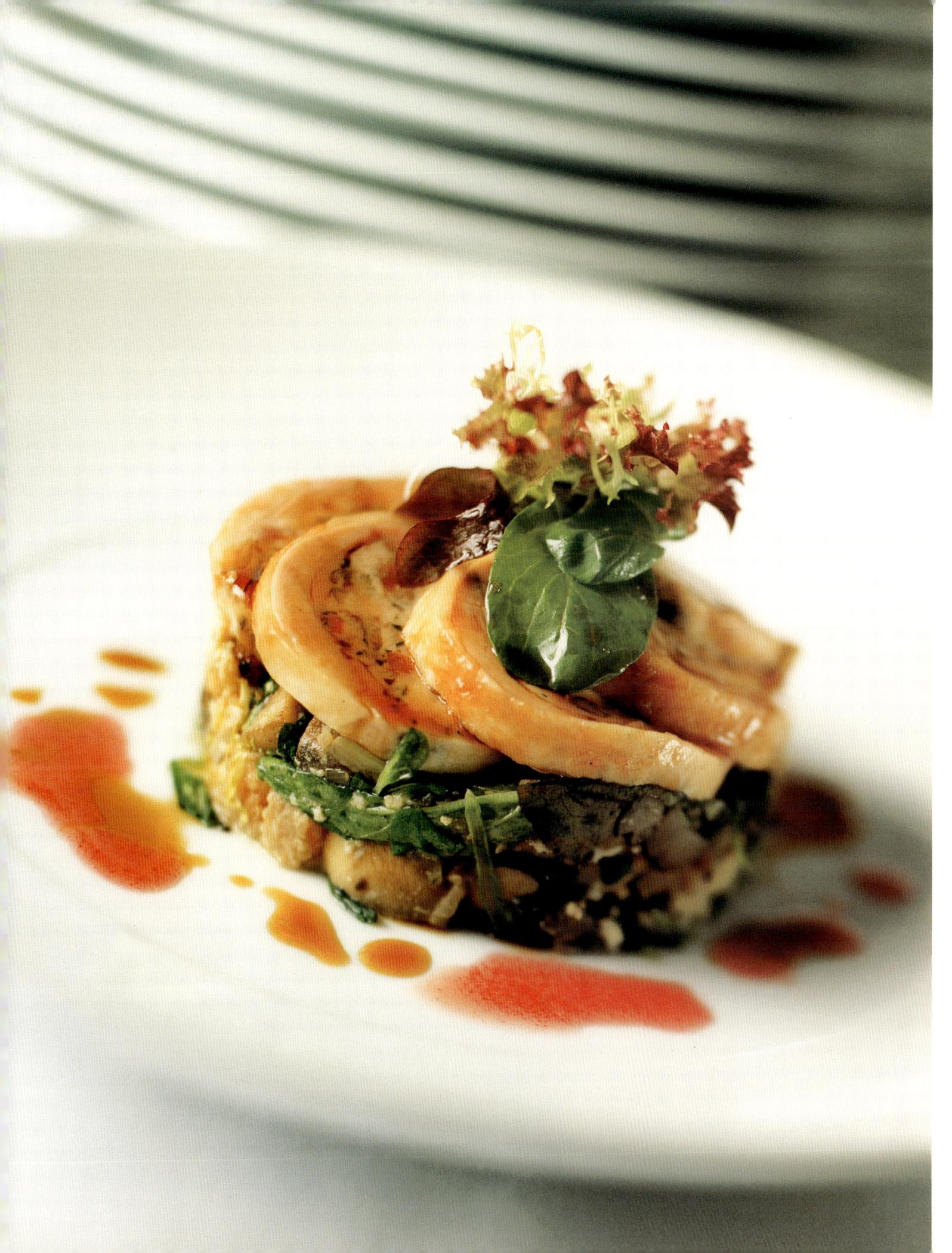

FILLET OF BEEF ROSSINI

Beef Rossini is one of those dishes we just cannot take off the menu. Again, it's a classic dish, and one that is quite expensive to put together but worth every cent. We buy in whole fillets of beef weighing 2½–3kg (5½–6½lb). The fillet is then cut into three pieces and used in three different ways. The tail of the fillet, weighing roughly 200g (7oz), is rolled tightly in cling wrap and placed in the freezer for use as **Beef Carpaccio** or canapés at a later date. The heads of the fillet which weigh around 400g (1lb) are either cut in three and used as **Mini Beef Rossini** for the menu degustation (a six-course tasting menu of dishes on the main *Banc* menu, served in smaller portions and matched with wines), or chopped finely, along with any other trimming from the beef, for **Tartare of Beef** (see pages 162–163). The remainder of the beef fillet is cut into 180g (6oz) pieces for the **Beef Rossini.**

Serves: 4

4 x 180g (6oz) fillets of beef

4 thin slices of prosciutto, large enough to wrap around the beef fillet

4 x 15g (½oz) slices of foie gras

20g (¾oz) foie gras trimming

½ tsp chopped truffle

25ml (5 tsps) vegetable oil

4 potato galettes (see page 185)

160g (5–6oz) creamed spinach (see page 207)

100ml (7 tbsps) Périgueux sauce (see page 204)

4 slices of truffle

salt, freshly ground pepper

Begin by preparing the Périgueux sauce, as explained on page 204.

Prepare the beef. Using a sharp knife make an incision in the centre of each piece of meat to form a pocket.

Mix the foie gras trimmings and chopped truffle together and divide between the four pockets. Wrap each piece of beef in a slice of prosciutto to hold the foie gras and truffle in place during cooking, and tie with a piece of butcher's twine.

Pre-heat the oven to 200°C (400°F).

Prepare the potato galettes as explained on page 185. These can be made in advance and heated in the oven before serving.

Prepare the creamed spinach as explained on page 207. This can also be prepared in advance and re-heated on the stove before serving.

In a heavy-based frying pan, heat the vegetable oil. Season the beef all over with salt and freshly ground pepper and seal all over in the pan, until evenly browned. Transfer to the oven, and cook to your taste. Don't cook the beef any more than medium-rare to medium. If you cook the beef past medium, the foie gras will render down and seep out. Remove the beef from the oven and allow it to rest in a warm place while you finish preparing the dish. Warm the potato galettes in the oven. Reheat the creamed spinach and check the seasoning. Gently warm the sauce over a low heat.

Heat a non-stick pan on the stove. Season the slices of foie gras lightly with salt and freshly ground pepper, and quickly sear the foie gras for 45 seconds on both sides. When both sides are golden, remove from the pan with a spatula. Place a slice of foie gras on top of each piece of beef, and a slice of truffle on the foie gras.

To serve, spoon the creamed spinach in the centre of each plate. Place a potato galette on top of the spinach, and place the beef on to the galette. Spoon the **Périgueux sauce** over and around the beef.

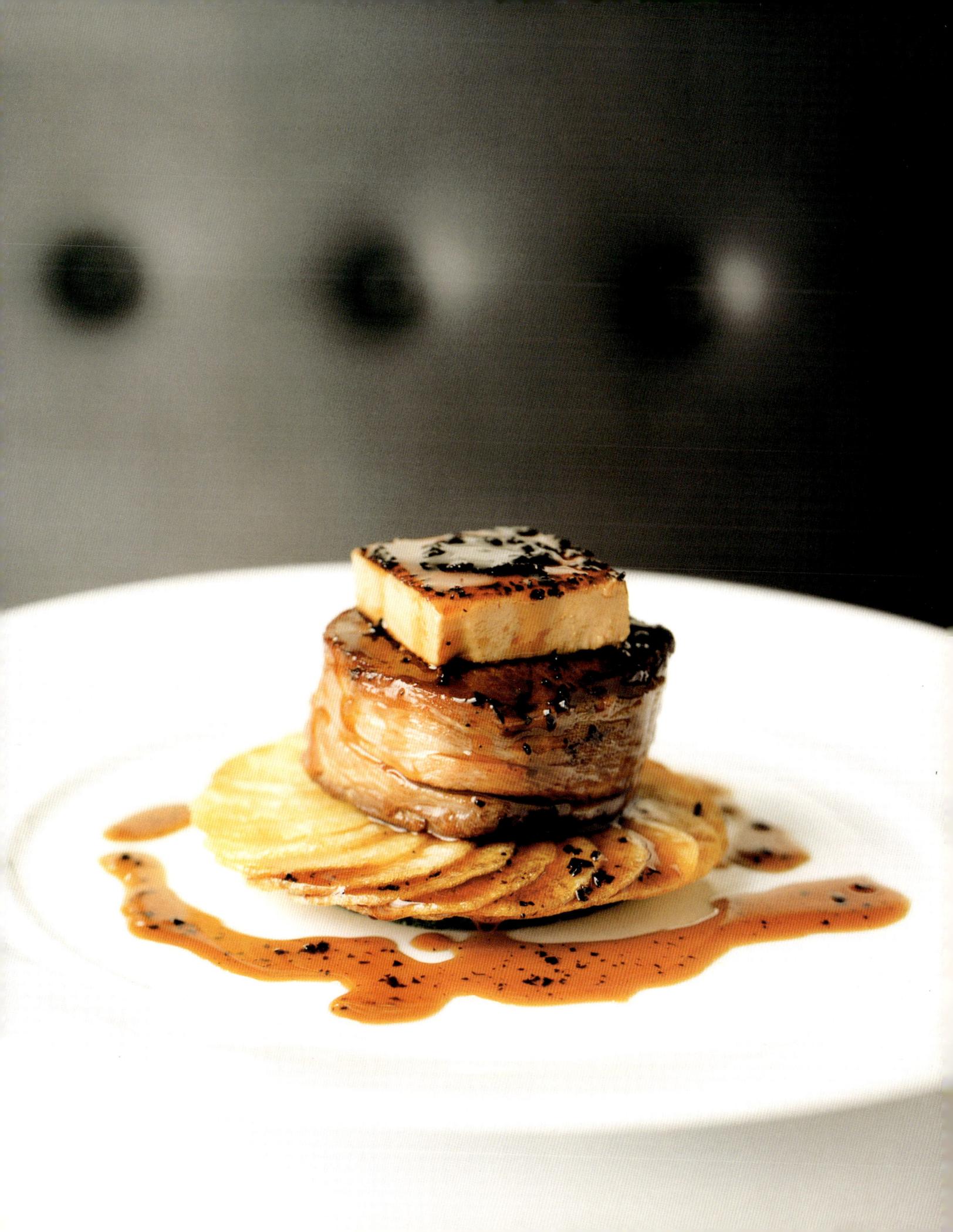

VEAL ZURICHOISE

This is one of my all-time favourite dishes. I first learnt how to make it while working in Hotel Central in Zurich, Switzerland.

The Swiss slice thin strips of veal, sauté them and then make the sauce in the same pan.
Traditionally it is served with a wedge of Potato Roesti. At *Banc*, I prepare it differently, using dried cepes for the sauce.

Firstly, I grind dried cepes to a powder in the food processor, then mix with salt and ground pepper to make the seasoning for the meat. I also roast a fillet of veal whole, and carve it into nice, even-sized slices. This is served on individual **Bacon and Onion Roestis** (see page 184), accompanied by the sauce and a mixed selection of sautéed mushrooms. Mine is not quite as rustic as the Swiss version but, as I remember it, it tastes just as good.

Serves: 4

2 x 400g (14oz) fillets of veal
140ml (½ cup) cepe cream sauce (see page 295)
4 Bacon and Onion Roestis (see page 184)
32 very small button mushrooms
24 very small dried morel mushrooms, soaked in warm water for 30 minutes
50ml (3½ tbsps) cream
2 shallots, deep fried (see page 207)
10g (½oz) sliced chives
salt, freshly ground pepper
50ml (3½ tbsps) vegetable oil

Make **Bacon and Onion Roestis** as explained on page 184. These should be made in advance and reheated in the oven when the rest of the dish is ready to serve.
The cepe cream sauce (see page 205) can also be made in advance and kept warm or can be reheated when ready to use.
Pre-heat the oven at 200°C (400°F).
Trim the fillet of veal of all the fat and sinew, and season with salt and freshly ground pepper or the cepe seasoning described above if you decide to make it. Heat half the vegetable oil in a heavy-based pan and seal the veal all over until evenly browned. Transfer to the oven and cook for 6–8 minutes until medium-rare. Allow the meat to rest for 10–15 minutes in a warm area before carving. Reduce the oven temperature to 140°C (280°F).
Meanwhile, whip the cream to ribbon stage, until it's just beginning to thicken. Drain the morel mushrooms and dry on a cloth.
Heat the remaining vegetable oil in a heavy-based pan. Add the button mushrooms and sauté until golden brown. Add the morels and warm through. Season with salt and freshly ground pepper. Drain well.
Reheat the bacon and onion roesti in the oven.
Add the mushrooms to the cepe sauce and slowly bring back to the boil. Carve the veal into six even slices per portion and lightly season with salt and freshly ground pepper. Reheat very gently in the oven for 1–3 minutes. To serve, place roesti in the centre of each plate. Arrange the six slices of veal on top of each roesti, overlapping each other. Spoon the mushrooms and sauce over and around the veal and roesti. Spoon a little whipped cream in the centre, and sprinkle with deep-fried shallots and sliced chives. Roast chicken breast or guinea fowl are also wonderful served this way.

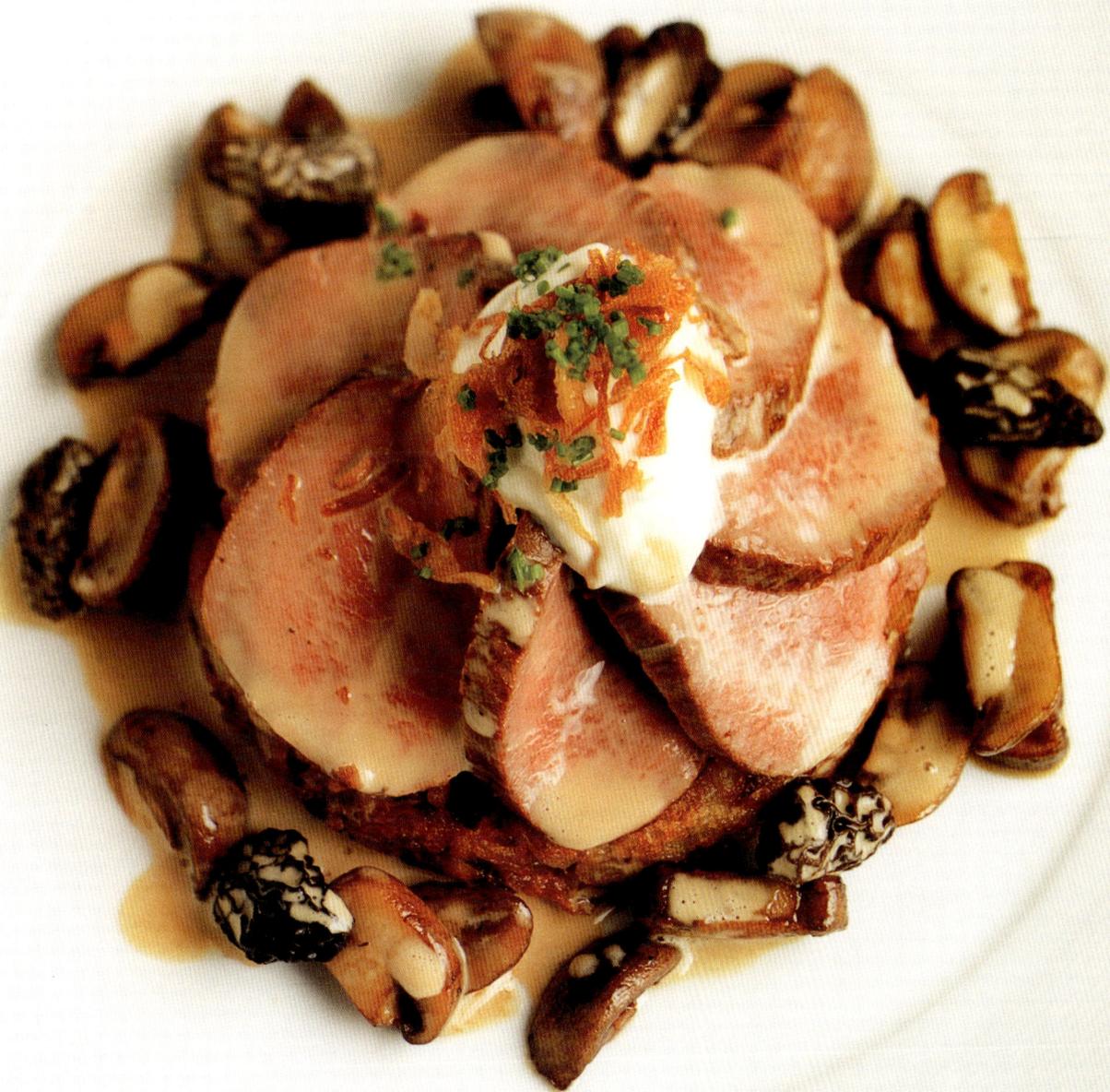

DUCK CONFIT

The word confit means to preserve or conserve. The process of making confit involves cooking meat very slowly in its own fat, until it literally falls from the bone.

At *Banc* we make confit using 120 duck legs at a time, and the confit goes through many different stages before being served to the customer.

The first stage involves trimming the duck legs of some of the fat, rendering it down, and flavouring it with herbs and garlic. Then we salt the duck legs and leave them for 24 hours, before cooking them for a further four hours.

When cooked the confit is taken from the oven and allowed to stand in its own fat, for two hours before being lifted out and placed into scrupulously clean stainless-steel buckets. The fat is then used to cover and seal the confit which is left in the fridge for at least four weeks, and up to 12 weeks, before serving.

The confit can be served in many different ways, my favourite being on **Warm Potato and Shallot Salad** (see pages 180–181). At *Wine Banc*, we serve it on Crisp, Pan-fried Mushroom Risotto with a little duck jus. Sometimes, the confit is shredded and bound in its own fat with herbs and seasoning, and turned into a terrine consisting of layers of confit, rare duck breast, foie gras and sauternes jelly. This we serve with toasted brioche.

The whole process is time-consuming, but there is nothing like the flavour of a good confit.

Makes: 20 legs

20 x 220g (8oz) duck legs
8kg (18lb) of raw duck fat
2 sprigs of rosemary
1 whole head of garlic
5g (1 tsp) coriander seeds
5g (1 tsp) white peppercorns
SALT MIX
175g (6oz) rock salt
2g (½ tsp) star anise
2g (½ tsp) coriander seeds
2g (½ tsp) white peppercorns
1 bay leaf
2 sprigs fresh thyme
6 cloves garlic
the zest from ½ an orange
½ a cinnamon quill

TO MAKE DUCK FAT To cook 20 legs of confit you will require 4 litres of rendered duck fat. To achieve this quantity, you will need to start with approximately 8kg (about 18lb) of raw duck fat which is available from good butchers. It is also possible to buy excellent tinned, rendered duck or goose fat, but I prefer to make my own. Besides, it's cheaper than buying the ready-made version.

Crush the white peppercorns and coriander seeds together, using a pestle and mortar. Place this mixture, along with the duck fat, 2 sprigs of rosemary and an unskinned head of garlic, split in half, in a heavy-based saucepan. Add 1 cup of water, to prevent the duck skin or fat sticking to the bottom of the pan (the water will evaporate during cooking). Leave the saucepan on a very low heat for 6–8 hours.

When the fat is crystal clear, pass it through a very fine sieve, ready for use. Once the confit has been made, the same fat can be used for two further batches providing it is boiled, skimmed, and passed through a fine sieve, discarding any solids. In my kitchen, when we've used the fat three times for confit, we then use it for sealing other meats such as squab or chicken.

Far left: Leave the duck legs on a very low heat for 6 to 8 hours.

Left, centre: Cook until the fat is crystal clear.

Left: Duck Confit, after 3 hours of cooking.

TO SALT THE DUCK LEGS Using a pestle and mortar, grind the salt, star anise, coriander seeds, peppercorns and cinnamon quill. Transfer to a bowl and add thyme, orange zest, and the bay leaf.

Rub the salt mix into the duck legs and place on a clean perforated tray. In turn place this in a second tray to collect any moisture released, but be sure that the legs are not standing in any liquid. Tuck the garlic between the legs, and cover tightly with cling wrap. Allow to stand in the fridge for 24 hours.

COOKING THE DUCK LEGS Pre-heat the oven to 140°C (280°F).

Melt the duck fat. After rubbing the salt mix off the legs with a tea towel, place them in a heavy-based saucepan, and pour the duck fat over them. Bring to simmering point. Cover with a lid, and transfer the pan to the oven. NB: it is important that the contents of the saucepan only reaches as far as ¾ of the way up the saucepan, to prevent any fat spilling out into the oven. Cook the confit slowly for 3½–4 hours. It's a good idea to take one leg out after 3 hours, to check progress. When ready, the meat will just fall off the thigh bone. It is also essential, during the cooking process, to check that the temperature of the fat doesn't creep up too high, resulting in fried, stringy duck. When cooked, remove from the oven, and allow to stand at room temperature for 2–3 hours in the fat.

TO STORE THE CONFIT Using a perforated spoon, carefully lift the confit, piece by piece, out of the pan. Take care at this stage, as the duck is very fragile and will break easily. Place the duck in a stainless steel or earthenware dish, gently layering the pieces on top of each other.

Pour the fat over the duck, first passing it through a very fine sieve. The duck confit must be totally covered in fat to make a perfect seal to store it until ready for use.

Place in the fridge for up to three months.

Right, from the top: Mixing the seasoning; the seasoned ducks' legs; crisped duck confit legs; Terrine of Duck Confit Foie Gras.

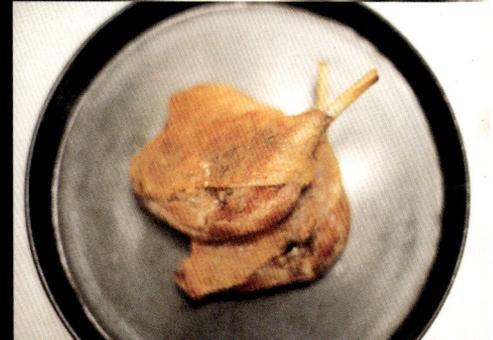

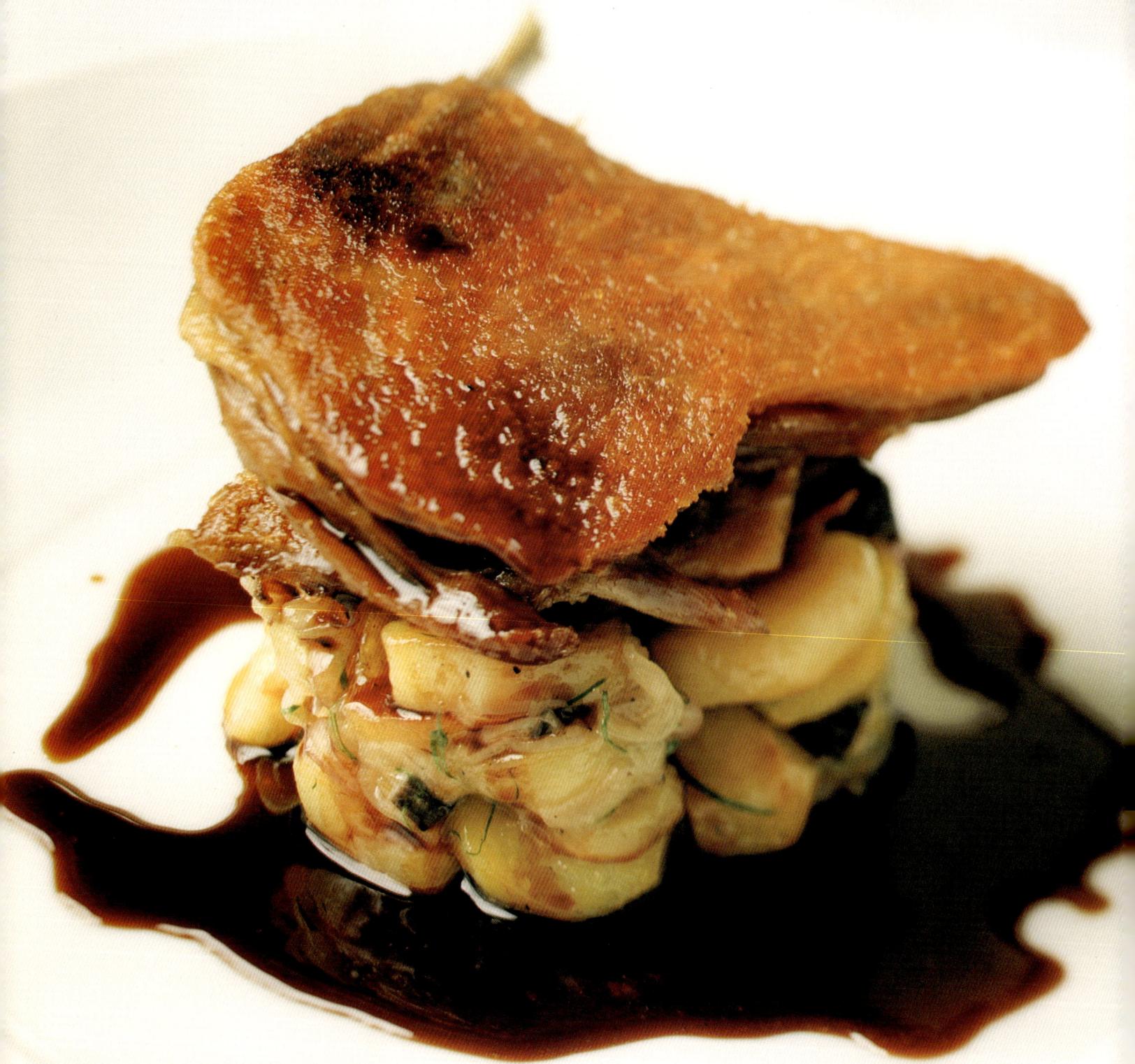

CRISP DUCK CONFIT WITH WARM POTATO & SHALLOT SALAD

Serves: 4

4 legs of prepared duck confit

720g (1½lb) kipfler potatoes, with skins scrubbed

60ml (4 tbsps) truffle dressing (see page 210)

5ml (1 tsp) truffle oil

65ml (4½ tbsps) rendered duck fat, that confit was cooked in

100g (3½oz) finely sliced shallot

60g (2oz) lardons of bacon

½ tsp chopped parsley

½ tsp sliced chives

salt, freshly ground pepper

100ml (7 tbsps) red wine sauce (see page 204) or Périgueux sauce (see page 204)

Gently cook the potatoes in salted water until tender. Drain and allow to cool before peeling. Cut into 1cm (½ in) slices. This is best done a few hours before you serve the dish, so that the potatoes have time to firm up.
Pre-heat oven to 200°C (400°F).

Heat 10ml (2 tsps) of duck fat in a pan, and sauté the lardons of bacon until they take on a little colour and begin to crisp. Strain the lardons in a sieve over a bowl, and allow the fat to drain off.

Melt 20ml (4 tsps) of duck fat in a pan large enough to hold the 4 duck legs. Place the legs skin side down in the pan, and transfer pan to oven to warm through and to allow the skin to crisp and turn golden. This will take about 8 minutes. Baste from time to time.

In another pan, melt the remaining duck fat and that drained off from the lardons. Add the potato and sliced shallot and sauté carefully without breaking the slices, until the potatoes have lightly browned. Add the truffle oil and truffle dressing and continue to cook for another 1½ minutes, so that they are absorbed by the potato. Turn off the heat and add the herbs, and season to taste with salt and freshly ground pepper.

Remove the duck confit from the oven, and drain off any excess fat.
Re-heat the red wine or Périgueux sauce.

Using a round pastry cutter, divide the potato salad into nice rounds, between the four plates. Place a crisp leg of duck confit on top, and drizzle a little sauce over and around each one.

Above: Warm Potato and Shallot Salad.

POTATOES

Like the tomato, the potato plays a big role at *Banc*. It is prepared and served in many different ways. On any one menu, there can be more than a dozen different garnishes made with potato, including sautéed for the **Warm Potato and Shallot Salad** served with **Crisp Duck Confit** (see page 180–181); turned and boiled for the John Dory dish; baked and puréed for **Twice-cooked Potato** (see page 186, boiled and grated for the **Veal Zurichoise** (pages 176–177) or simply cut into wedges and fried for the staff meal.

The potatoes we most commonly use are désirée, sebago or pontiac. These can all successfully be baked, turned into purée, boiled in the skin and grated for roesti, and fried for galettes and wedges.

For salads, for the **Pesto Potatoes** used for **Tuna Niçoise** (pages 168–169), or for the turned potatoes, we use a waxy-fleshed variety such as the kipfler, nicola, patrone, pink fir apple, or bintje, as they absorb dressings and have a nice, firm texture. Small chats are ideal for hollowing out, deep frying and filling with various ingredients for cocktail parties.

Find a good fruit and vegetable provedore and, depending on the time of the year, you will be assured of at least some of the varieties I have mentioned.

POTATO PURÉE

For potato purée, I suggest you bake the potatoes rather than peel and boil them. Though baking will take longer, the finished result is better because the potato hasn't absorbed any moisture, allowing you to incorporate a lot more butter, cream and milk. This not only makes the potatoes smoother and creamier, but when adding to brandades or fish cakes, the potato remains firmer allowing more stock or flavoured reduction to mix with it.

Serves: 4
600g (1⅓lb) large potatoes
50g (2oz) diced soft butter
70ml (5 tbsps) cream
70ml (5 tbsps) milk
salt, freshly ground pepper

If you intend to save the potato skins for **Twice-cooked Potato with Ragout of Mushrooms** (pages 186–187), set the oven at 140°C (280°F) so that the skins don't take on too much colour. If you are just making Potato Purée, set the oven at 180°C (360°F) to speed up cooking time.
Scrub the potatoes. Place on a baking tray, and place in the oven for 75–90 minutes, depending on their size. Check with a skewer to make sure the potato is cooked through.
Remove from the oven and cut the potatoes in half; scoop out the flesh and pass it through a drum sieve.
Bring the milk and cream to the boil, and work into the potato. Add the butter, piece by piece, and stir into the purée until fully incorporated.
Season to taste with freshly ground pepper.

CHEF'S NOTE It is important that everything is kept hot while you are making the potato purée, otherwise small lumps will form through it. If lumps do form, pass it through the fine sieve one more time.
For garlic potato purée, crack 2 cloves of garlic with the back of a knife, and add them to the milk and cream as you bring them to the boil. Allow the garlic to infuse for 2 to 3 minutes before lifting out. Alternatively, purchase a good quality garlic oil and add it to the finished potato purée to taste.

Main photo, opposite: Potato pulp is used for the purée, while the skins are used for the Twice-cooked Potato.

Left: Preparing the potato purée.

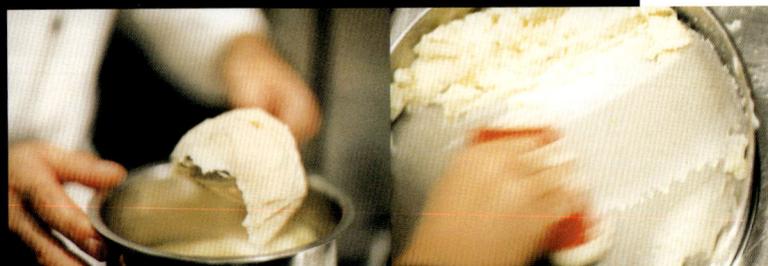

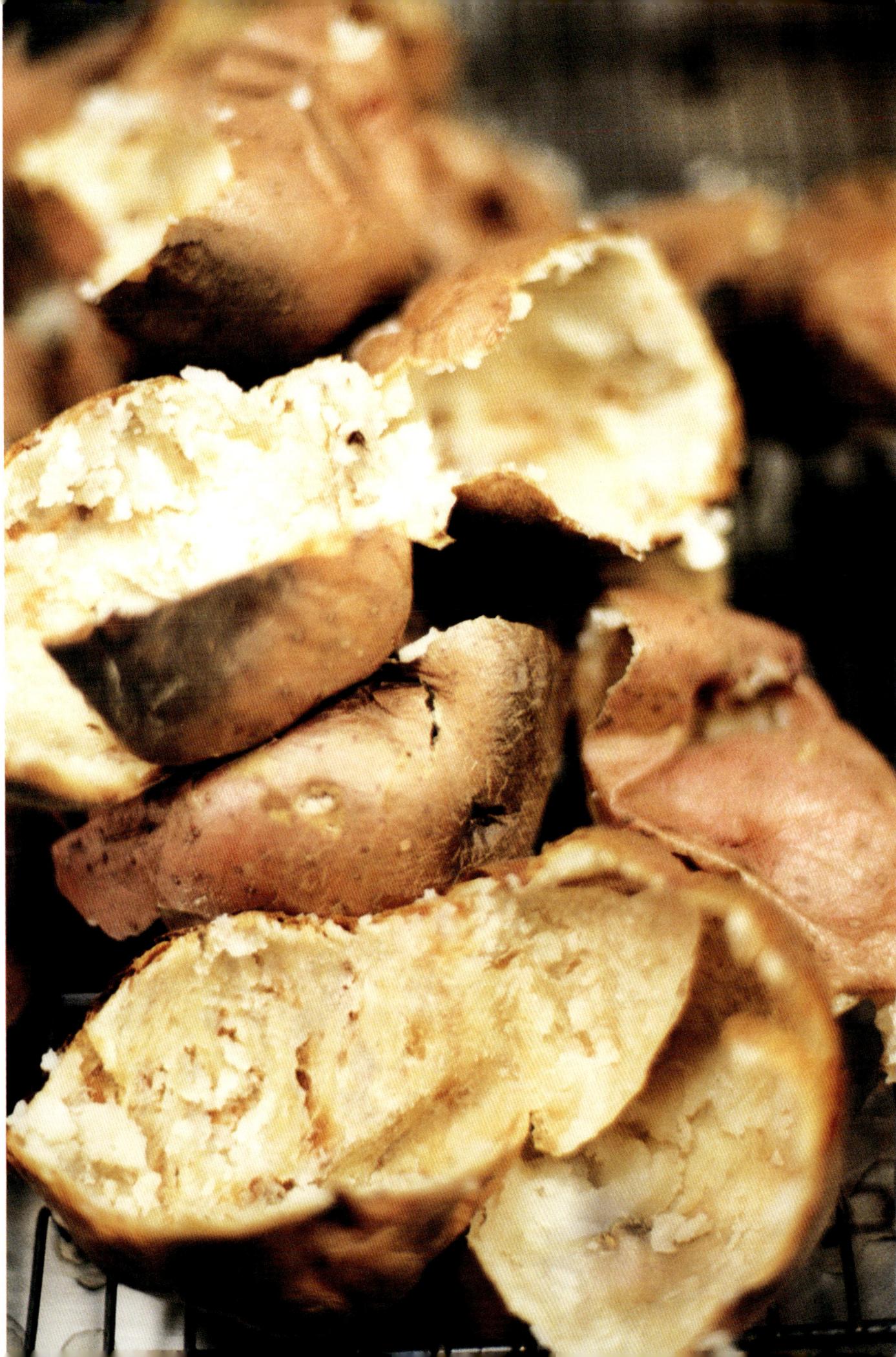

COLCANNON

Colcannon would be one of my favourite potato dishes and is always on the menu in one form or another. It goes equally well with meat or fish.

Serves: 4

400g (14oz) potato purée as explained in the previous recipe
140g (5oz) savoy cabbage, cut into large pieces and blanched
60g (2oz) spring onion, sliced
20g (1oz) shallot, sliced
12 slices crisp pancetta
1 tsp julienne of continental parsley
salt, freshly ground pepper

Make the potato purée as explained on page 182.
Add the cabbage, spring onion, shallots, crisp pancetta and parsley. Fold all the ingredients through the potato and warm Season to taste with salt and freshly ground pepper.
As a variation, some cooked, diced prawns could also be added to the colcannon to make prawn colcannon — this is delicious served with freshly fried or roasted fish.

BACON AND ONION ROESTI

When cooking the potatoes for the roesti it is important they are not completely cooked, as they are going to be grated and re-cooked a second time in the pan. It's also important to lift them out of the water to cool down so they don't absorb the water and become mushy during the subsequent cooking.

Serves: 4

1kg (2.2lb) large potatoes
25g (1oz) sliced onion
100g (3½oz) bacon
140g (5oz) clarified butter
salt, freshly ground pepper

Cook the potatoes in their skins in salted water until they are cooked three-quarters of the way through, and remain slightly firm. Remove the potatoes from the water and allow to cool.
Heat 20g (about 1 oz) of clarified butter in a pan, and sauté the onion and bacon without browning. Allow to cool.
Peel the potatoes and grate on the largest blade of your grater, so you create nice long strips of potato.

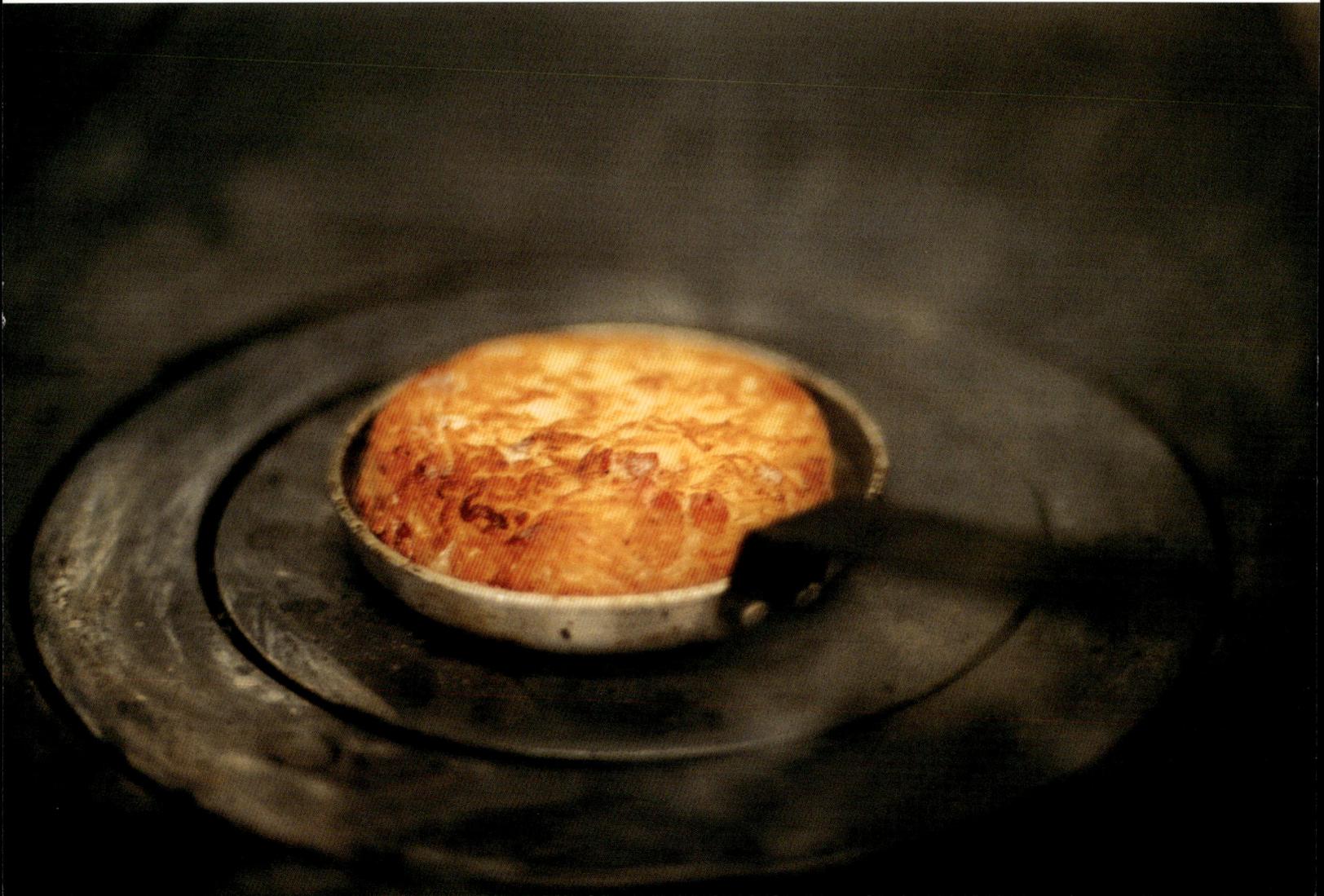

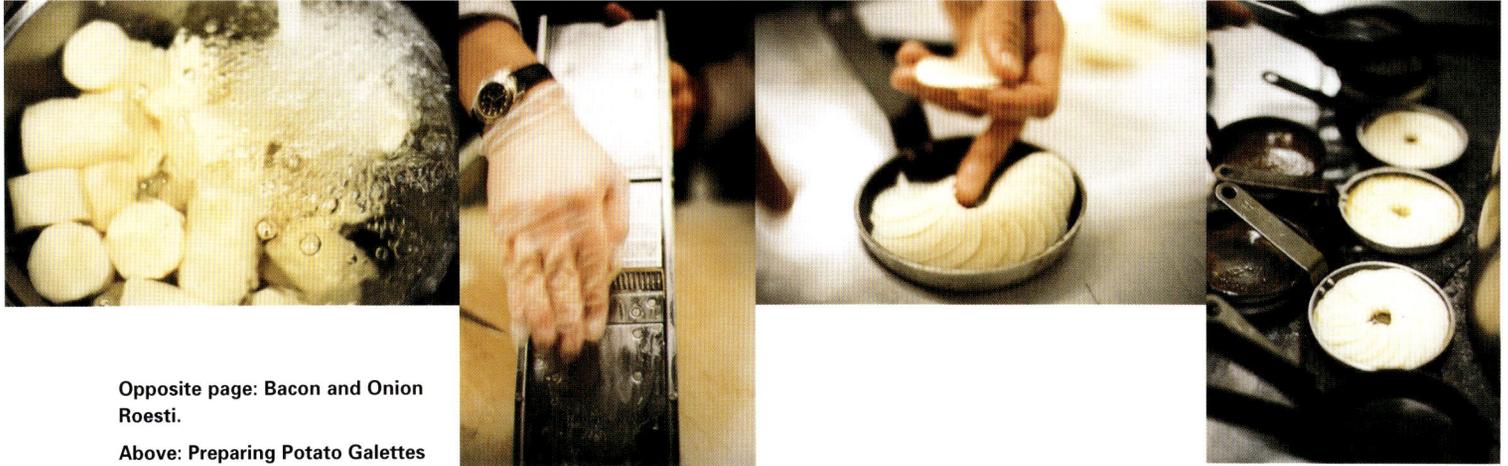

Opposite page: Bacon and Onion Roesti.

Above: Preparing Potato Galettes — potatoes are 'topped and tailed' and a steel tool used to stamp out perfect cylinders of flesh; the prepared potatoes are then sliced thinly and arranged in a circle in the pan; the individual galettes are cooked on both sides until golden brown.

Pre-heat oven to 180°C (260°F).

Gently mix the bacon and onion through the potato and season with salt and freshly ground pepper. Using your hands, form the mixture into balls, weighing about 220g (8oz) each. Heat 15g (½oz) of clarified butter in a blini pan, and add a potato ball. Using a palette knife, press the potato down so it has a flat surface. Go around the side of the pan with the knife to ensure the potato forms even sides and doesn't stick.

Over a gentle heat cook the potato for about 6–7 minutes until it is crisp and golden brown in colour. Turn the potato out on to a plate. Wipe the pan out with some kitchen paper. Again, heat the same amount of clarified butter in the pan and cook the other side of the roesti until crisp and brown. Repeat for other roestis.

Place in the oven at 180°C (360°F) for a further 5 minutes to make sure the roestis are heated through.

CHEF'S NOTE You can make one large roesti in a large, non-stick pan and extend the cooking time in the oven by 10 minutes. Serve cut into wedges.

Roestis can be made well in advance of a meal, and re-heated in the oven before serving.

POTATO GALETTES

To make potato galettes, take large potatoes and slice the top and bottom ends off them so that they stand upright on a chopping board. Take a 5cm (2in) diameter steel tube which has a sharp end on it, and press it through each potato to create a perfect cylinder. The potato trimmings are used for potato wedges. If you don't have the correct implement for stamping the potatoes out, use a sharp knife to peel the potato and form it into a neat shape without wasting too much flesh.

Serves 4
3 large potatoes, cut into cylinder shape
120g (4oz) clarified butter
salt, freshly ground pepper

Using a mandolin or a sharp knife, cut the prepared potatoes into 3mm (1/10in) slices. You will need 18 thin slices for each of the galettes.

Place the potato slices on to a tea towel and pat dry. Season with salt and freshly ground pepper.

Each galette is prepared separately. For each one, heat 30g (about 1oz) of clarified butter in a blini pan. Arrange one portion of potato slices in a circle, allowing the slices to overlap each other.

Cook the potatoes over a gentle heat for 5–6 minutes until slices are crisp and golden brown. Using a palette knife flip the potato over and cook for a further 5–6 minutes until crisp and golden brown.

Lift the galette out of the pan and drain on paper towel. Lightly season one more time. Repeat for the other 3 galettes.

CHEF'S NOTE It is a lot quicker and easier to prepare the potato galettes for a number of people if you use more than one pan at a time. However, the potato galettes can be made in advance and re-heated in the oven before serving.

TWICE COOKED POTATO
WITH RAGOUT OF MUSHROOMS

Try to get your hands on some fresh chanterelle, cepe, trompette or girolle mushrooms. We are sometimes lucky enough to have them imported into Australia from Europe. This is a great dish in which to use them. If imported mushrooms are not available, use whatever selection you can find. You could even add some dried morels.

Serves: 4

4 large potatoes

560g (20oz) mixed mushrooms

10g (2 tsps) julienne of continental parsley

220ml (1 cup) cepe cream sauce (see page 205)

40ml (3 tbsps) vegetable oil

1 litre vegetable oil for deep frying

2 shallots, sliced and deep fried

1 tsp chives, sliced

8 leaves of fresh continental parsley

Pre-heat oven to 140°C (280°F). Wash and dry the potatoes. Place on a baking tray and cook for 1½ –2 hours depending on the size of the potatoes. Test with a knife to make sure they are cooked through.

Take the potatoes from the oven and cut the tops off about two-thirds of the way up the potato. Using a spoon scoop the flesh from both pieces, taking care not to break the skin and leaving a thin layer of potato inside. This helps the potato to keep its shape. Turn the scooped potato into purée as explained on page 182, and keep warm.

Heat the vegetable oil in a heavy-based pan and sauté the mushrooms until just soft and nicely coloured. Season with salt and freshly ground pepper. Drain well and mix the julienne of parsley through the mushrooms.

Re-heat the cepe sauce over a low heat.

Heat the litre of oil in a deep pan to 180°C (360°F) and deep fry the potato skins until crisp and golden brown. Drain well on paper towel and season the insides with salt and freshly ground pepper.

To serve, put a small amount of potato purée in the centre of the plate. Place the fried potato skins on this to prevent it sliding around. Spoon the potato purée into the skins, and, using the back of a spoon, spread it up the sides of the potato. Spoon the mushrooms into and around the potato. Pour the sauce over and around the potato.

Garnish with deep-fried shallot, sliced chives and fresh parsley.

CHEF'S NOTE Sometimes I select smaller potatoes, prepare them in the same way, and serve them as a garnish to a piece of roast beef, rack of lamb or a roast chicken breast. When sautéing the mushrooms, it is important the temperature of the pan doesn't drop too much as the mushrooms are added, otherwise they may release their juices. If this happens, they will boil in the juice. If you ever cook large quantities of mushrooms, do them in two pans, or in separate batches. Some varieties may need a longer cooking time than others.

To serve this as a vegetarian dish, simply replace the veal stock with mushroom stock when you are making the Cepe Cream Sauce.

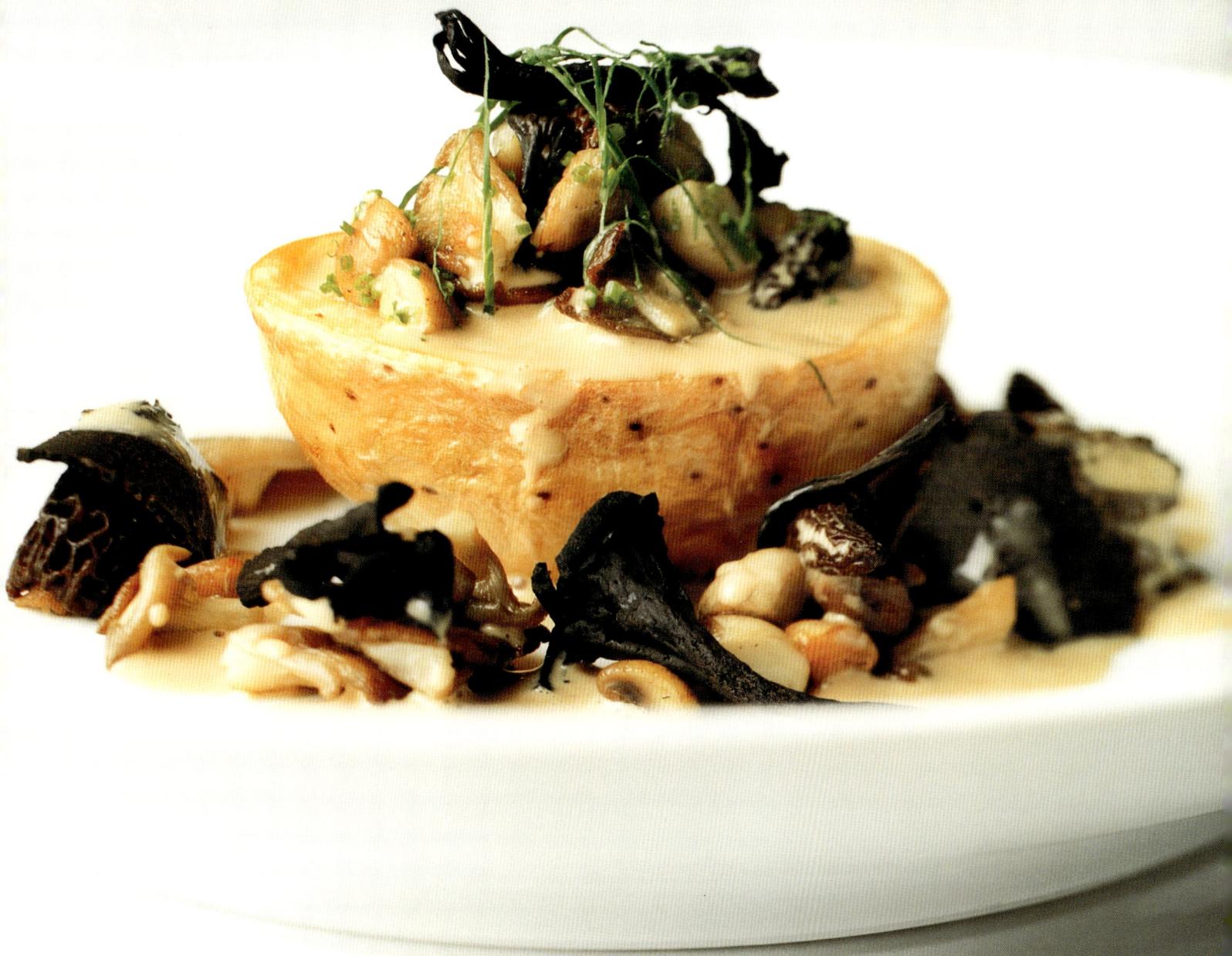

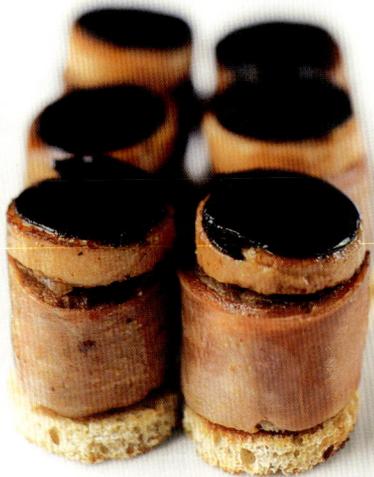

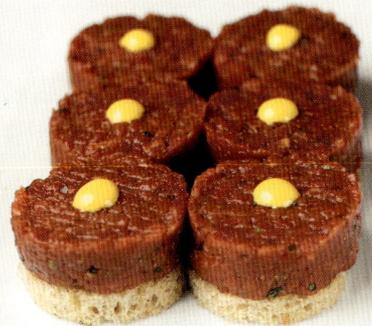

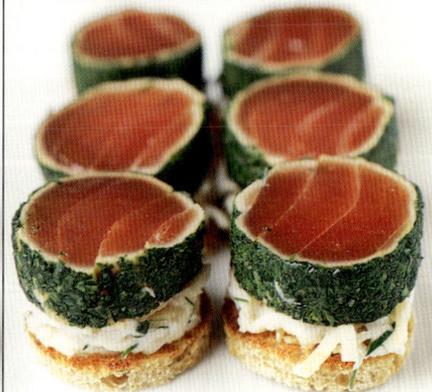

CANAPÉS

At *Banc* and *Wine Banc* we frequently get requests to hold cocktail parties for both businesses and private clients. The cocktail party menus are normally devised by adapting the dishes we have on the menu at the time into canapés. Here are some examples.

BEEF For a mini **Beef Rossini** we use the tail ends of the beef fillets and prepare them as described on pages 174–175. They are cut into 25g (about 1oz) slices and then cooked rare and served on a crouton topped with *foie gras* and truffle and brushed with **Périgueux Sauce** (see page 204). **Tartare of Beef** (see pages 162–163) is moulded into small rounds using pastry cutters, and served on a crouton cut out in the same manner. A small spoon of caviar is placed on top.

PARFAIT Duck Liver Parfait (see pages 158–159) is cut into small blocks and served on small squares of toasted brioche with a little **Sauternes Jelly** (see page 208) piped on top, and garnished with a sprig of chervil.

SOUP Chilled **Sweet Corn and Basil Soup** (see pages 144–145), **Vichyssoise** (pages 146–147) and **Gazpacho** (pages 151–152) without the gelatine can all be served in shot glasses arranged on large trays.

TOMATOES The **Terrine of Tomato** (pages 151–152) can be cut out with pastry cutters and served on toasted olive bread. If short of time, simply remove the tops from cherry tomatoes and fill with the **Pesto-flavoured Goat's Cheese** (pages 151–152) and garnish with a small leaf of basil.

OYSTERS Oysters served natural are another very simple canapé. At *Banc* we sometimes make a **beurre blanc** (page 205) to which we add chopped iceberg lettuce and oysters. The mixture is warmed through before being spooned back into the oyster shells and garnished with a little caviar.

POTATOES Salmon Roestis are always very popular. Make the **Roesti** as described on page 184 without the bacon and onion, but instead with equal amounts of minced fresh salmon and smoked salmon, gently folding the fish through the potato and moulding into small rounds using pastry cutters. Pan fry them on both sides in a little clarified butter until golden brown, and then finish cooking through in the oven for about 5 minutes. Serve with a dipping sauce of soured cream and chives or with some apple purée.

Bake some chat potatoes in the oven on a bed of sea salt. Allow to cool before slicing the tops off with a knife. Scoop the inside out with a Parisienne cutter and deep fry the skins just like the **Twice-cooked Potato** on pages 186–187. Fill them with creamed leeks or sour cream and chives. For another great filling, pick a hard cheese such as raclette, cheddar or Gruyère. Cut it into pieces large enough to fill the hollow of the potato and bake through in the oven at 160°C (320°F) until melted. Dust with some paprika as soon as they come out of the oven.

Opposite page, top row, from left: Roulade of Quail; Duck Liver Parfait with Sauternes Jelly; Salmon Roesti with Apple Purée.

Centre row, from left: Fillet of Beef Rossini; Cherry Tomatoes Filled with Pesto-flavoured Goat's Cheese; Tartare of Beef.

Bottom row, from left: Tomato Terrine; Crisp Chat Potatoes with Gruyère Cheese; Herb-crusted Tuna with Crab and Celeriac.

Banc is renowned for its outstanding cheese trolley, and, on finishing main course, 40 per cent of guests choose to have cheese before or instead of a dessert.

During any service, the trolley will be stocked with between 25 and 30 different cheeses from which to choose. The majority of the cheese on offer is imported from France, Italy, Spain or England, but the best from around Australia is also included.

The various cheeses are supplied to *Banc* by people who are knowledgeable and passionate about the product. They ensure that the cool room is always stocked with a range of cheeses, so that the trolley may be changed daily. They also make sure seasonal cheeses are available when they are at their peak. There are simple tips to follow to obtain optimum pleasure from a course of cheese with a meal.

When buying cheese, avoid supermarket fridges crammed with every cheese under the sun. They have usually been pre-cut and *creavaced* meaning they've lost flavour. Instead, find a cheese shop or counter with a good range, a high turnover, and one where you are allowed to inspect, smell and taste the produce before buying. You should also be able to get advice on the characteristics of particular cheese.

When choosing cheese for a meal, rather than buying a large range, select three or four made from different milks and with different textures.

At *Banc*, we unwrap and cut our cheeses into 250–300g (9–10½oz) pieces an hour before service, and arrange them on the trolley. This gives the cheeses time to come to room temperature, and to release their full aromas and flavours. We keep the cheeses covered with damp muslin cloth to prevent them from drying out and replenish the trolley whenever necessary during service.

After service, the remaining cheese will be individually wrapped in cling wrap or wax paper, and stored in a polystyrene box which is punched with holes to allow air to circulate around the cheese. This, in turn, is placed on a rack in the cool room.

When arranging cheese on a platter, allow a fair space between each piece, so that they don't run into each other. It is also a good idea to have a separate knife for each type, so as not to mix the flavours.

When eating cheese, start with the mildest flavours and work through to the stronger ones. The cheese should be accompanied only by the simplest of items such as hot bread, toasted fruit and nut bread or plain cheese biscuits. Dried and fresh fruits such as figs, apples or grapes also marry well with some cheeses, while others, such as the harder cheddars, are delicious with a mild fruit chutney.

If you ever have small bits of cheese left over after a meal, don't waste them. Remove the rinds, and add them to some polenta (see pages 160–161), or spread them on some toast and lightly melt under the grill. We do this at *Banc* for the staff elevenses. My favourite way of using leftover cheddar is to turn it into Welsh rarebit. Whatever you do, always cook cheese over or under a very gentle heat to ensure it doesn't become stringy or leathery. By the way, if a recipe calls for grated cheese, always buy a piece of cheese and grate it yourself. The flavour is much better!

Listed are some of the most popular cheeses we frequently include on our trolley.

GOAT'S MILK Pouligny-Saint-Pierre, Sainte-Maure de Touraine (ashed), Sainte-Maure Soignon (plain), Chabichou du Poitou, Woodside, Edith Ash, Strzelecki Goat Blue, Kervella, Rondolet.

WHITE RIND SURFACE Brie de Meaux, Camembert St Mere, St Andre Coup, Bucue D'Affinois, Charleston.

WASHED RIND Tourre L'Abier, Pont L'Eveque, Rouy, Taleggio, Heidi Reblochon, Mungabareena.

BLUES Fourme d'Ambert, Stilton, Piccante Gorgonzola, Milawa Blue.

SEMI-HARD Cantal, Morbier.

HARD-COOKED Parmigiano-Reggiano, Beaufort, Heidi Gruyère.

CHEDDAR Quickes Farm Cheddar, Chewton Cheddar, Woodside Cheddar, Pyengana Cloth Cheddar, Mount Emu Cloth Matured Cheddar.

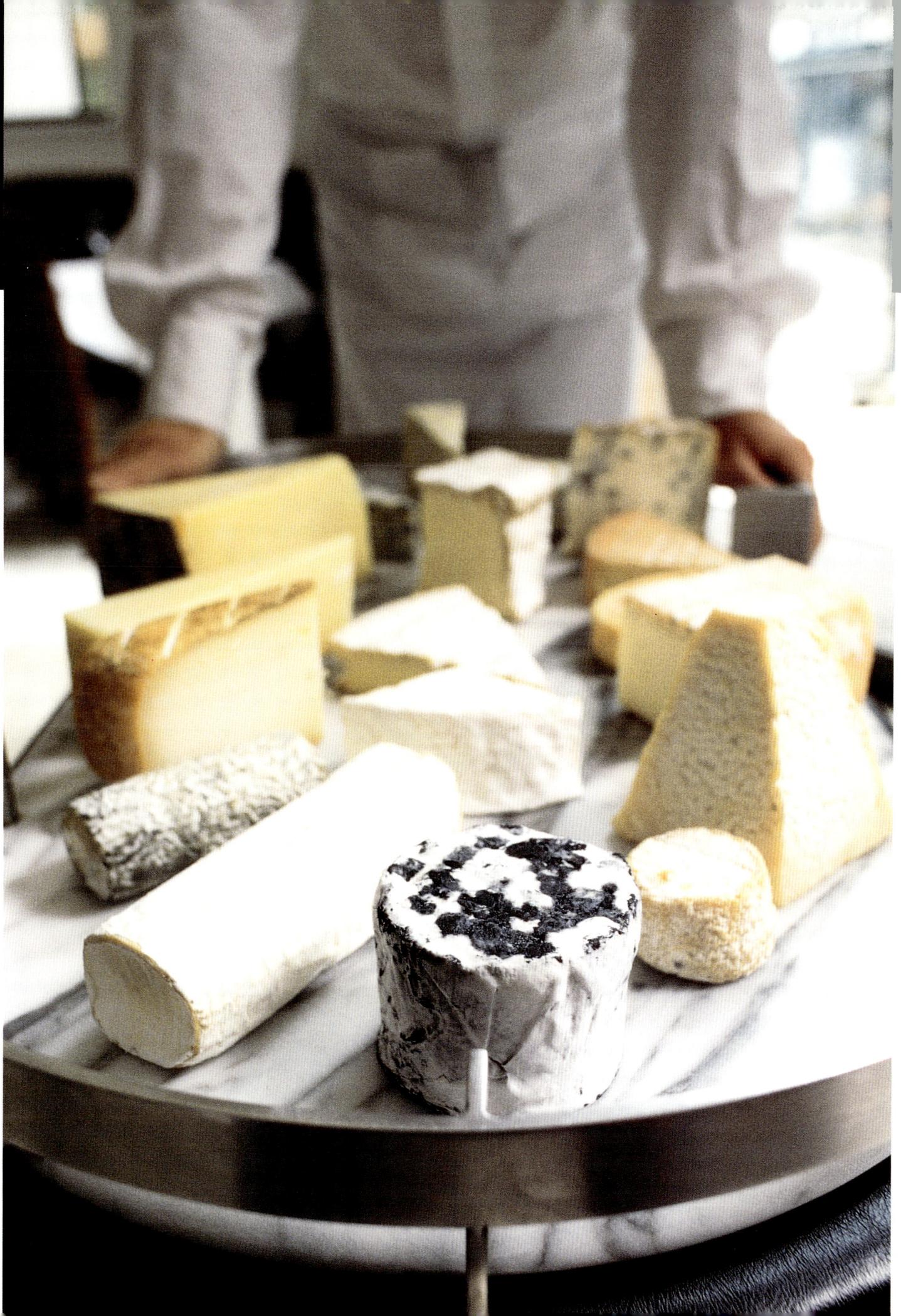

The chocolate mousses in this recipe are wonderful served on their own or with other types of fruit — the white chocolate mousse with a selection of berries, or the dark chocolate mousse with caramelised oranges or bananas. You could also add alcohol; to the dark chocolate mousse add Tia Maria or brandy, and to the white chocolate mousse add Poire William (it goes especially well with the poached pears).

Serves: 4

TO POACH PEARS

4 firm pears

400ml (¾ pt) sugar syrup (see page 210)

1 vanilla bean, split

1 lemon

WHITE CHOCOLATE MOUSSE

170g (6oz) white chocolate, broken into small pieces

65g (2½oz) fresh egg whites

40g (1½oz) icing sugar, sieved

2 leaves of gelatine

400ml (¾ pt) single cream

100ml (7 tbsps) double cream

75ml (5 tbsps) sugar syrup

DARK CHOCOLATE MOUSSE

170g (6oz) dark chocolate, broken into small pieces

65g (2oz) fresh egg whites

40g (1½oz) icing sugar, sieved

2 leaves of gelatine

400ml (¾ pt) single cream

100ml (7 tbsps) double cream

75ml (5 tbsps) sugar syrup

MINT-FLAVOURED ANGLAISE

200ml (7 fl oz) crème anglaise (see page 210)

1 small bunch fresh mint

POACHED PEARS Peel the pears and rub them with lemon to prevent discolouration. Place them in a heavy-based saucepan, and cover with sugar syrup. Add the split vanilla bean. Place the pan over a low heat and cook for 15–20 minutes. Check pears with the tip of a knife. They should remain a little firm. Remove the pan from the heat, and allow the pears to cool in the sugar syrup. At this stage, they will continue to cook a little further, so they become soft but still retain their shape.

CHOCOLATE MOUSSES (both are made the same way) Melt chocolate using a bain-marie (a saucepan inside another filled with boiling water). Do not expose chocolate to direct heat.

Soak the gelatine in cold water until softened, then squeeze out.

Heat the sugar syrup in a small saucepan. Add the gelatine and dissolve.

Whisk the single and double cream together to ribbon stage.

In an electric mixer, whisk the egg whites until they form peaks. Reduce the speed, and add the icing sugar. Continue to beat until the mixture becomes very shiny.

Pour in the melted chocolate, and mix into egg whites. Pour in the sugar syrup and gelatine, and continue to mix until completely incorporated.

Remove the bowl from the mixer and wipe down its sides with a spatula.

Fold a quarter of the cream through the chocolate mix. Then transfer this mixture into the remaining cream, and fold through. Pour into a bowl, and set in the fridge for up to 4 hours.

Clean the mixer and make the second mousse.

MINT-FLAVOURED ANGLAISE Chop the mint roughly, and add to the anglaise. Allow it to infuse in the fridge for 2 hours.

Pass through a very fine sieve, pressing the mint to extract all the flavour.

TO SERVE Drain pears from the syrup. Cut each in half lengthways, removing the stalk and core. Using a small pastry cutter, cut each pear into a round. Place each of the mousses into a piping bag, and fill 4 of the pear halves with white chocolate mousse, and the other four with dark chocolate mousse. Arrange one of each on four plates.

Pour the Mint-flavoured Anglaise over the mousses, so that it runs down on to the plate.

At *Banc*, we decorate the top of each mousse with chocolate shavings.

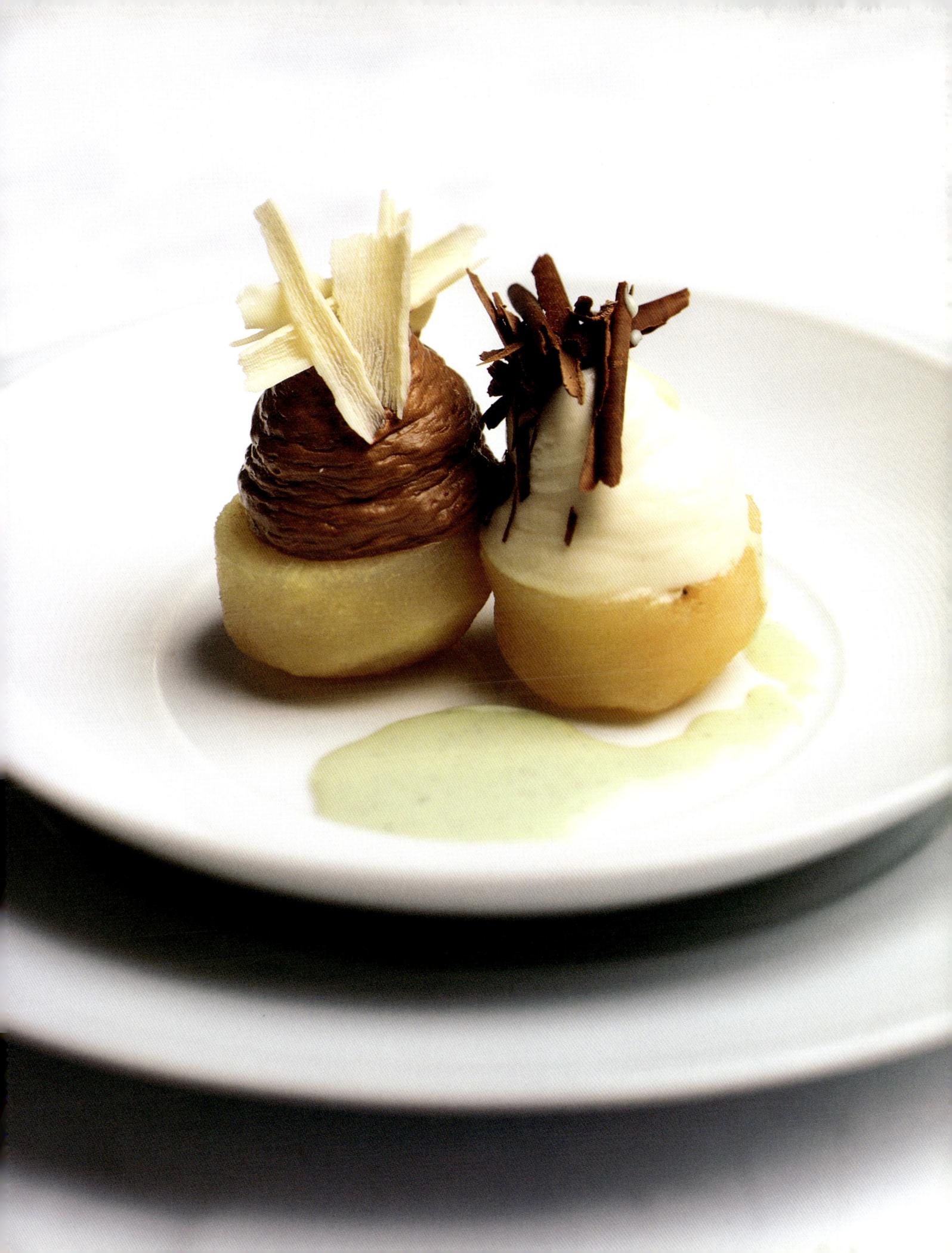

PASSIONFRUIT JELLY & PASSIONFRUIT ICE-CREAM

You needn't be limited to passionfruit. Other fruits can be used for the jelly. As a pre-dessert at *Banc*, we serve an apple jelly in a shot glass, topped with apple sorbet and a calvados sabayon (see photo, below).

Serves: 6 as individual portions

JELLY

100ml (7 tbsps) freshly squeezed orange juice

350ml (12 fl oz) passionfruit pulp

250ml (8 fl oz) sugar syrup (see page 210)

4½ leaves of gelatine

Cointreau to taste

ICE-CREAM

350ml (12 fl oz) milk

3 egg yolks

135g (4¾oz) caster sugar

75ml (5 tbsps) strained passionfruit juice

pulp from 2 passionfruit

PASSIONFRUIT SAUCE

(Makes 250ml or 1 cup)

125ml (½ cup) milk

125ml (½ cup) cream

50g (2 oz) caster sugar

3 egg yolks

½ split vanilla pod

juice and pulp of 2 passionfruit

TO MAKE JELLY Place the passionfruit pulp in a blender and blend for 45 seconds. Pass the pulp through a fine sieve over a bowl to catch the juice. Discard the extracted seeds. Into a measuring jug pour 300ml (10 fl oz) of the collected passionfruit juice and add the orange juice.

Soften the gelatine in cold water. Bring the sugar syrup to the boil. Squeeze the gelatine dry and add to the sugar syrup. Whisk until gelatine has dissolved and remove from the heat. Whisk in the juice mixture and add Cointreau to taste. Divide between 6 dariole moulds and allow to set in the fridge for at least 8 hours.

TO MAKE ICE-CREAM Whisk the egg yolks and half of the sugar together until they become pale in colour, and reach a ribbon-like consistency.

In a pan, bring the milk and the remaining sugar to the boil. Once boiled, whisk into the egg yolks. Transfer mixture into a clean saucepan and return to the stove over a low heat. Cook until the custard thickens to the stage where it coats the back of a spoon. It is important to stir continuously, and be sure that the custard does not overcook or go back to the boil, or you will be left with some very sweet scrambled eggs.

Pour the custard through a fine sieve into a bowl. Set over ice to cool the custard down, stirring from time to time to prevent a skin forming.

When cool, add the passionfruit pulp and churn in an ice-cream machine until it becomes smooth and creamy. Transfer to a clean container and store in a freezer until ready to use.

PASSIONFRUIT SAUCE Follow the same steps as for making the ice-cream. The vanilla pod is added to the milk and cream when being heated, and removed as you pass the custard through the sieve. Allow to cool before adding the passionfruit pulp. This sauce will keep in the fridge for up to three days, but it is important to keep it covered tightly to prevent it absorbing the smells or flavours from other items.

To serve, dip the dariole moulds in hot water for five seconds. This is just long enough to loosen the jelly from the sides of the mould. Turn the jelly out onto a plate and place a scoop of the passionfruit ice-cream beside it. Then drizzle a little of the passionfruit sauce over and around the ice-cream.

CHEF'S NOTE In summer, instead of serving the jelly with ice-cream, at *Banc*, we serve it with a selection of summer fruits and berries with a syrup flavoured with passionfruit and Cointreau.

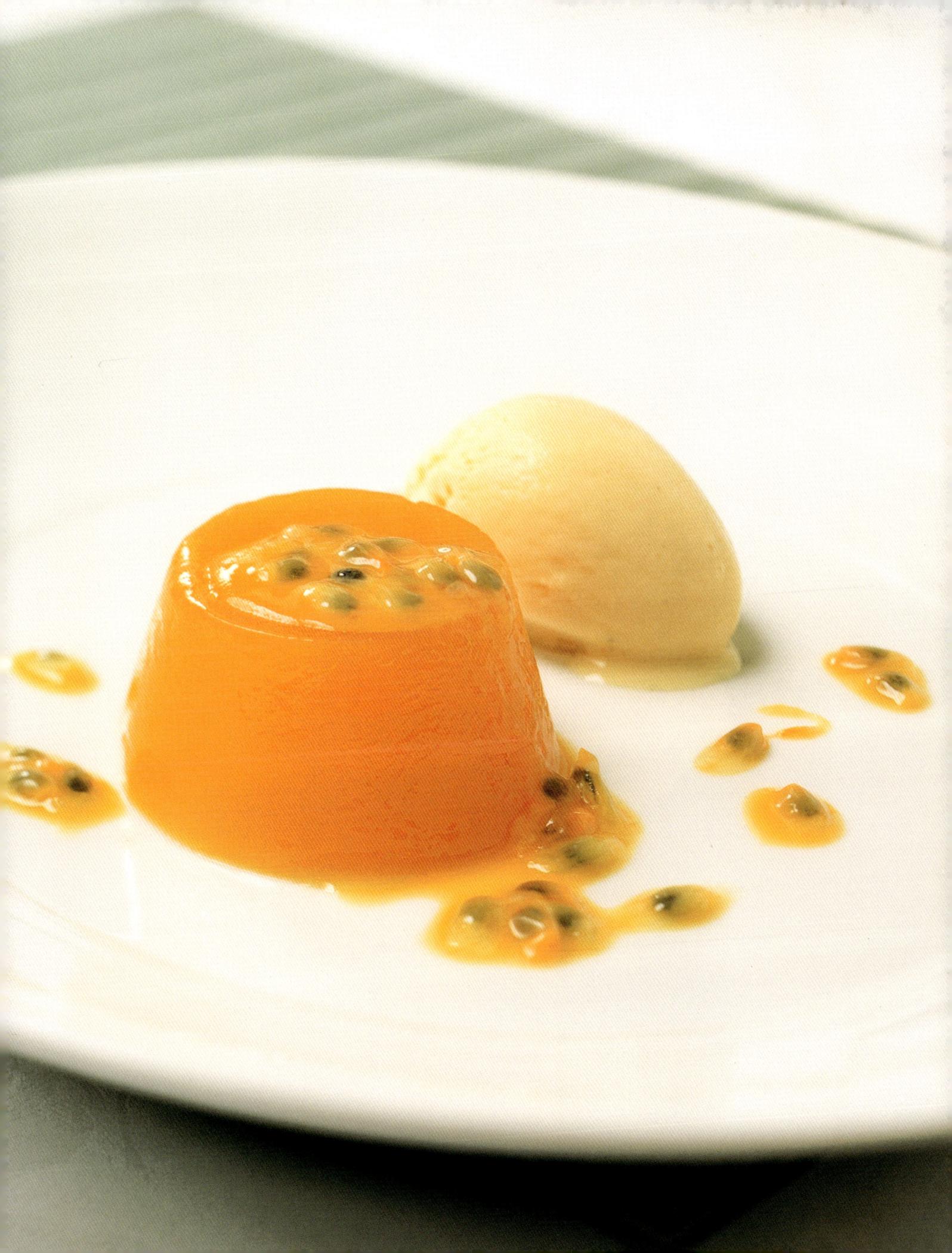

LEMON TART WITH MASCARPONE SORBET

This is my all-time favourite dessert and always features on *Banc's* dessert menu. We also make miniature lemon tarts and serve them as petits fours. The dough will keep well in a fridge for a week. At *Banc* we use it for our lemon tart cases, also for petits fours or rolled out thinly, cut into biscuit shapes, baked and filled with white chocolate mousse, poached pears and warm chocolate sauce.

Serves 12

SHORTBREAD DOUGH (paté sablee)

250g (9oz) flour

200g (8oz) unsalted butter

100g (4oz) sifted icing sugar

pinch of salt

2 egg yolks

grated zest of one lemon

egg wash (beaten egg)

MASCARPONE SORBET

250g (9oz) mascarpone

150ml (5 fl oz) sugar syrup (see page 210)

juice from ½ a lime

grated zest from half a lime

LEMON FILLING

12 whole eggs

500g (18oz) sugar

6 lemons

265ml (9 fl oz) lemon juice

400ml (¾ pint) thickened cream

SHORTBREAD DOUGH Sift the flour onto work surface, make a well in the centre. Dice the butter and place in the centre, and work it with your fingertips until very soft. Sift the icing sugar onto the butter, add the salt and work into the butter. Pour on the egg yolks and mix well.

Gradually draw in the flour and mix until completely amalgamated. Add the lemon zest and rub it into the dough.

Do not over work dough as it will become elastic. Roll the dough between sheets of greaseproof paper to flatten it out — this makes it easier to roll out later. Place in fridge for at least 2 hours before using.

TO BLIND BAKE TART CASE Pre-heat the oven to 200°C (400°F).

Line a 21cm (8in) flan ring with butter and place in the fridge for 10 minutes. On a lightly floured surface roll out the pastry to 6mm (¼in) thickness. Place the flan ring on a baking sheet and line with pastry, leaving a little hanging over the sides; rest in the fridge for 10 minutes. Line the whole interior with greaseproof paper and fill with baking beans. Blind bake the case for 10 minutes, remove from oven and allow to cool slightly. Remove the beans and inspect for any holes or cracks in the pastry. Brush the tart case with egg wash and return to the oven until the glaze is lightly coloured. Remove the case and allow to cool, then trim the sides so it remains flush with the top of the flan ring. Reduce the oven temperature to 140°C (280°F).

THE LEMON FILLING Wash the lemons and grate the zest; squeeze the lemons and strain the juice. Break the eggs into a bowl and add the sugar and whisk until smooth and well blended. Whip the cream in a separate bowl to ribbon stage. Stir the lemon zest and juice into the egg and sugar mix, then whisk in the cream. Allow to infuse in the fridge for 1 hour before passing the zest out through a fine sieve (the zest will become bitter if you bake it in the tart).

Pour the filling into the case and place in the oven to cook for 40–60 minutes, depending on your oven. After 40 minutes, check the tart every few minutes as the filling should be just set. Leave the tart to cool for 4 hours before cutting. Do not put it in the fridge as the pastry will go soft.

MASCARPONE SORBET In a bowl, mix the mascarpone and sugar syrup together, using a wooden spoon. Transfer to an ice-cream machine and churn until smooth and creamy. Add the lime juice and zest and churn for 30 seconds. Take care not to over-churn or the mascarpone will become grainy. Transfer to a clean container and store in a freezer until ready for use.

TO SERVE Cut tart into even-sized slices, serve as is or dust each slice with a little icing sugar and caramelise with a blow torch. Place a slice on each plate and serve with a ball of mascarpone sorbet.

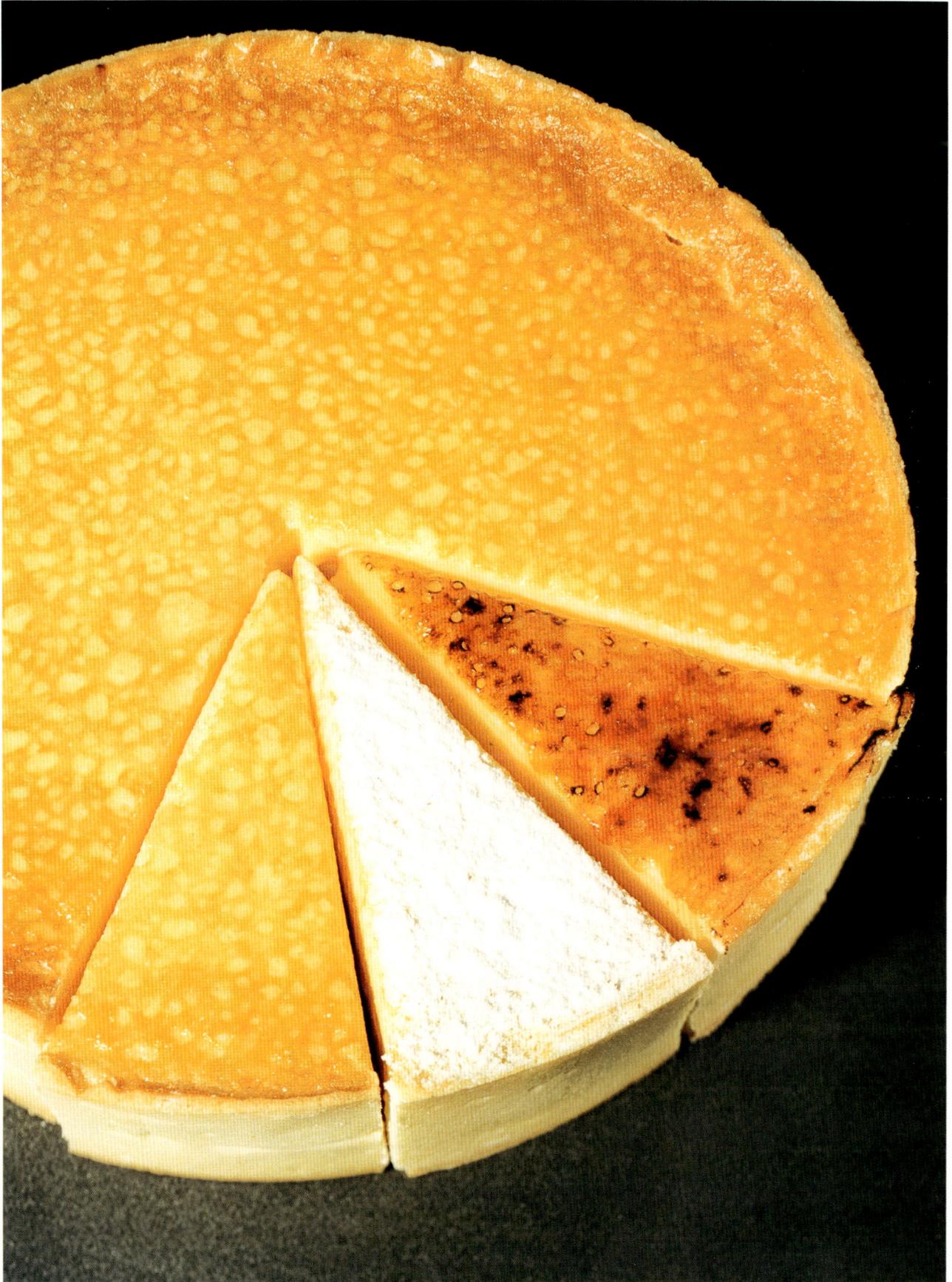

STOCK IN TRADE

All stocks at *Banc* are prepared in the same way. To create a good stock you need to start with the freshest ingredients, and a bit of time on your hands to work through the different stages which include roasting, skimming, passing and reducing. Unfortunately, there are no real short cuts when it comes to making stock, and, what's more, it isn't something you can speed up by making lesser quantities. So, I'd encourage you to make it in 3–5 litre (5–9 pint) batches. Use what you require and freeze the remainder in 250ml (1 cup) batches.

To make a brown chicken, lamb or game stock, follow the same procedure as for veal stock. However, when making the lamb stock, replace the red wine with white, and for game stock use venison bones with some added juniper berries and a bay leaf for extra flavour.

I find, when making my meat stocks, it is best to allow them to simmer for 30 minutes before adding the *mirepoix* or roasted vegetables. This gives time for most of the impurities and scum from the bones to float to the top, where it can be skimmed off in the early stages. Once you add the *mirepoix*, you won't need to skim so often; this prevents loosing the rich flavour of the vegetables.

It is, however, vitally important to keep skimming the stock throughout the process, as the proteins and starches released from the bones and vegetables will leave the stock cloudy if not removed.

It is equally important, when roasting the bones or the vegetables for the stock, to turn them frequently to prevent them from burning. If they should accidentally catch, don't use them as they will give the stock a very bitter flavour. Last of all, don't be tempted to add more water than stipulated to increase the quantity of stock. You will dilute all the flavours and end up with a weak, watery version.

VEAL STOCK

At *Banc*, we make veal stock from 60kg (1 cwt) of bones every second day. After the stock is made we cover the same bones (and vegetables from the first stock) with cold water to make a *remoulage* (a second stock). This is cooked gently for about 2 hours before the bones and vegetables are discarded. The second stock will lack colour, as all of this has been absorbed by the first stock. However, depending on the quality of the bones, I often find the second stock more gelatinous as the bones have broken down further, releasing extra gelatine. The second stock is passed and allowed to cool before being put with freshly roasted veal bones instead of water to create a much deeper, richer stock both in colour and flavour.

Makes: 4 litres
½ **calf's foot**
6.5kg (14½lb) **veal bones**
25ml (5 tsps) **vegetable oil**
1 large onion, chopped
1 carrot, chopped
1 stick of celery, chopped
½ head of garlic
100g (3½oz) **mushroom trimmings**
⅓ **leek with dark green outer leaves removed**
50g (2oz) **tomato paste**
7½ litres (13 pints) **cold water**

Pre-heat the oven to 200°C (400°F). Place the bones and calf's foot in a roasting tray and coat them with half the oil. Roast for 1½–2 hours. Turn the bones frequently to ensure even colouring. When the bones are ready, drain them in a colander. Place the bones in a large saucepan and cover with water. Bring to the boil. Reduce the heat and simmer for about 30 minutes, skimming frequently to remove any scum.
Pour the remaining oil into the tray the bones were cooked in. Add the chopped vegetables and put back in the oven for 20 minutes. Stir occasionally to scrape up the sediment left from the bones and to make sure the vegetables become an even, golden-brown colour. Mix the tomato paste through the vegetables, and continue to cook for a further 10 minutes. Remove from the oven and add to the bones in the saucepan. Cook the stock for 4 hours, continuing to skim it frequently. Pass it through a coarse sieve to remove the bones and vegetables. Pass it through a fine sieve into a clean saucepan. Place the saucepan on the stove and reduce the stock to 1½ litres (2½ pints) to concentrate the flavour. Continue to skim the stock as it reduces. Again, pass it through a fine sieve.

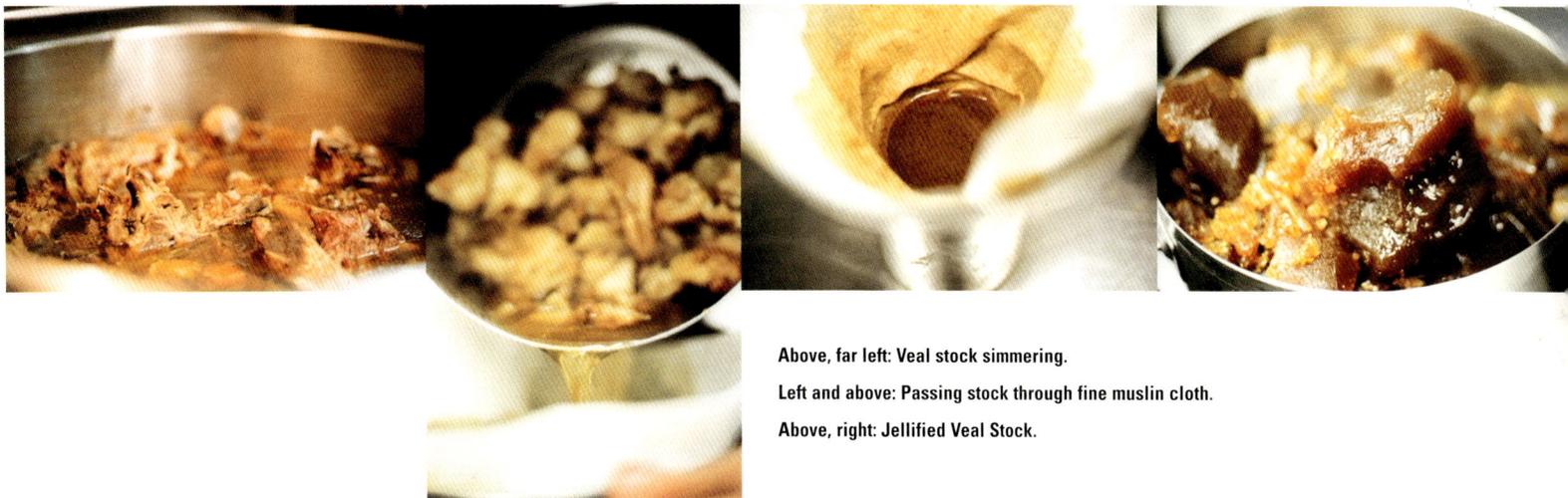

Above, far left: Veal stock simmering.

Left and above: Passing stock through fine muslin cloth.

Above, right: Jellified Veal Stock.

CHICKEN STOCK

Makes: 4 litres

4½kg (10lb) raw chicken carcasses and bones

¼ head of celery

1 large leek, with dark green leaves removed

1 large onion, chopped

250g (9oz) button mushroom stalks

½ head of garlic

4 sprigs fresh thyme

4 sprigs parsley stalks

2 bay leaves

12 white peppercorns, crushed

salt

7½ litres (13 pints) cold water

Remove any excess fat from the chicken carcasses.

Place the carcasses in a large saucepan and cover with water. Bring to the boil. Reduce the heat and simmer for 30 minutes. Skim frequently to remove the scum that floats to the surface. Add the remaining ingredients and continue to cook for a further 3½ hours. Skim the surface frequently.

Pass the stock through a fine sieve and into a large bowl or container. Allow to cool and skim fat from the top.

After using what you need, freeze the remainder in 250ml (1 cup) lots for later use.

BEEF BASE

Makes: 1 litre

1kg (2.2lb) diced beef trimmings

30ml (2 tbsps) vegetable oil

300g (10½oz) button mushroom trimmings

5 shallots, sliced

1 sprig of fresh thyme

3 litres (5¼ pints) reduced veal stock (see opposite page)

salt, freshly ground pepper

In a heavy-based frying pan, heat half the oil. Add the beef trimmings, and cook over a medium heat until they are golden brown all over. Drain the beef trimmings in a colander. Place the frying pan back on the stove and heat the remaining oil. Add the mushroom trimmings and shallots. Cook over a medium heat until they are golden brown all over. When ready, drain vegetables in the colander with the beef.

Place the beef and vegetables in a saucepan and cover with the reduced veal stock. Add the thyme and bring to the boil. Reduce heat and simmer for 1½ hours, skimming frequently to remove the scum that floats to the top.

Pass the stock through a fine sieve into a clean saucepan, and continue to reduce over a medium heat. Skim frequently to remove any scum. When the stock has reduced to about 1 litre (1¾ pints) season with salt and freshly ground pepper to taste. Strain through a double layer of muslin.

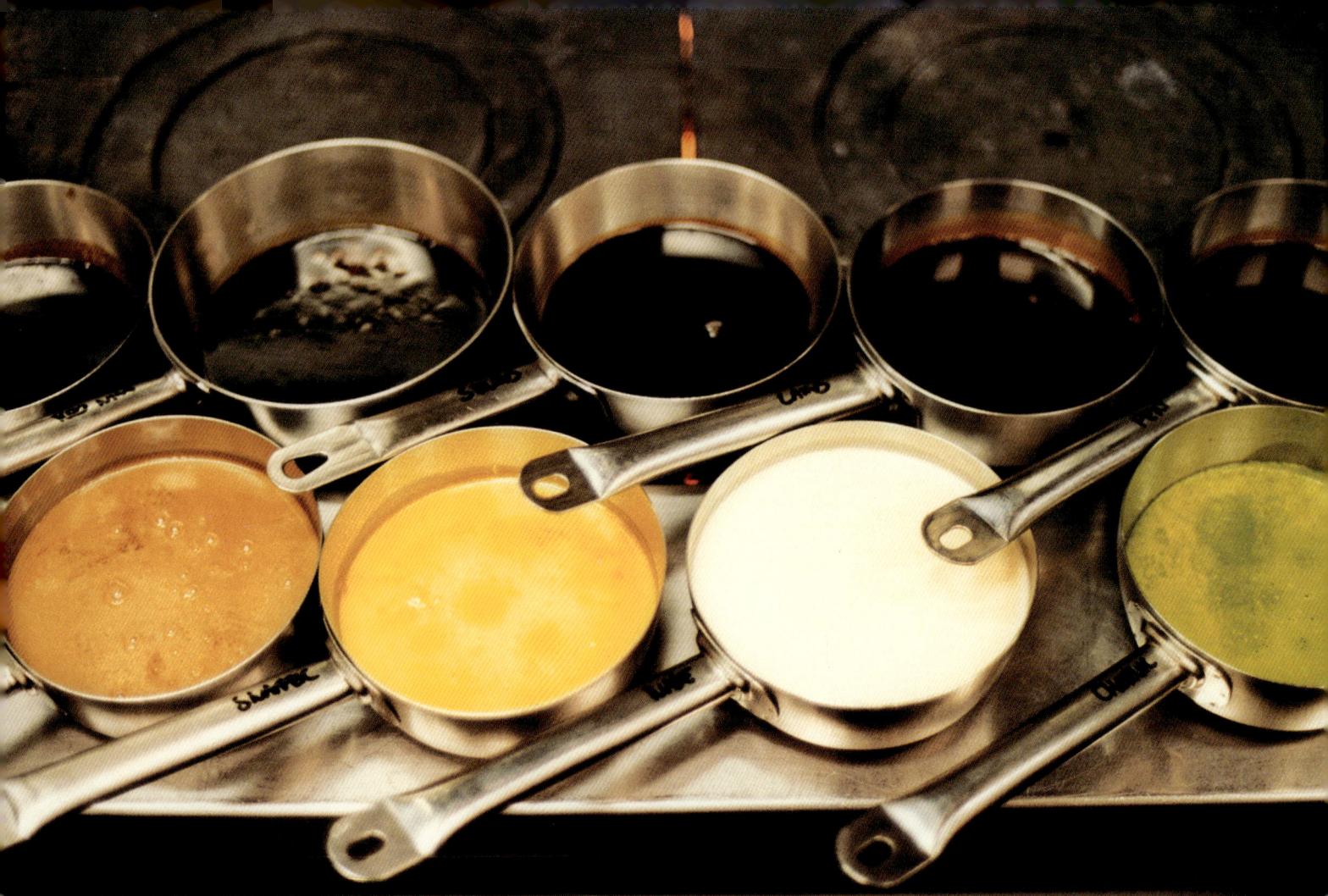

RED WINE SAUCE

Serves: 6–8; makes: ½ litre

750ml (3 cups) red wine

325ml (1½ cups) port

3 sliced shallots

1 clove garlic, sliced

1 sprig of fresh thyme

10ml (2 tsps) vegetable oil

½ litre (17 fl oz) beef base (see page 203)

salt, freshly ground pepper

Make a red wine reduction by heating the oil in a heavy-based saucepan. Add the shallots, garlic and a pinch of salt and sweat down without colouring, until the shallots have softened.

Pour in the red wine and port. Add the thyme. Reduce to a quarter of the volume over a medium heat.

Pass through a fine sieve.

Bring the beef base to the boil and add the red wine reduction to taste. The sauce should have a deep, rich, almost purple colour. Check the seasoning, adding more salt and freshly ground pepper if needed.

Pass through a double layer of muslin.

PÉRIGUEUX SAUCE

When truffle season is in, at *Banc*, we buy several kilograms and use them in various ways. Some are cooked in veal stock flavoured with port and madeira. I leave the truffles in the stock in the fridge and dig them out as we need them. The stock is later used for making our Périgueux Sauce which has a fantastic, earthy, truffle flavour.

Unfortunately, the truffle season soon comes to an end. We are then forced to use preserved truffles and their juices to make the sauce. However, these still give it a great flavour.

Serves: 4–6

20ml (4 tsps) truffle juice

20ml (4 tsps) port

20ml (4 tsps) madeira

400ml (13 fl oz) beef base (see page 203)

25g (1oz) chopped truffles

40g (1½oz) chilled, diced butter

salt, freshly ground pepper

In a small saucepan, reduce the truffle juice, port and madeira to a syrup over a medium heat.

Left, top row, from left: Guinea Fowl Jus; Red
Wine Sauce; Squab Jus; Lamb Jus; and Pèrigueux
Sauce. Bottom row, from left: Cepe Cream Sauce;
Saffron Sauce; Nage of Oysters; and Chervil Cream
Sauce.

Add the beef base, and bring to the boil and reduce until the
sauce coats the back of a spoon. Add the chopped truffle.
Whisk in the butter, piece by piece, until it is fully
incorporated. Remove from the heat and season with salt and
freshly ground pepper.

CEPE CREAM SAUCE

This and the morel sauce that follows are two of my favourite
sauces. They both are delicious served with veal, chicken,
sweetbreads, or the **Twice-cooked Potato with Ragout of
Mushroom** (see page 186–187). You could also add a little to a
mushroom risotto or through pasta.

Serves: 6–8; makes: ½ litre
175g (6oz) dried cepe mushrooms
50ml (3½ tbsps) port
50ml (3½ tbsps) madeira
150ml (5 fl oz) reduced veal stock (see page 202)
375ml (12½ fl oz) cream
salt, freshly ground pepper

Soak the cepes in a mixture of port and madeira for 4 hours.
Place the cepes, port and madeira in a saucepan and bring to
the boil. Reduce by three-quarters to a syrupy consistency.
Add the veal stock, bring to the boil and continue to cook until
reduced by half, skimming frequently.
Add the cream and bring to the boil. Continue to cook until the
sauce has reduced and coats the back of a spoon. Season to
taste with salt and freshly ground pepper.
Pass the sauce through a very fine sieve, pressing on the
cepes to extract as much of their amazing flavour and colour
as possible. Don't discard the cepes, chop them finely and add
them to mushroom risotto.

MOREL SAUCE

Replace the dried cepes with morels and follow the recipe in
exactly the same manner.

BEURRE BLANC

The flavour of the beurre blanc can be varied very easily, by
changing the vinegar or adding different flavourings to the
finished sauce.
Use balsamic vinegar with a dash of port for a balsamic beurre
blanc. This goes very well with quail or squab.
Use a cider vinegar for a cider beurre blanc to go with grilled
scallops or any fish.
Use red wine vinegar to make a red wine beurre blanc to go
with either fish or meat.
Use tarragon vinegar, and add some freshly chopped tarragon
to the finished sauce, to make a beurre blanc to go with
chicken.
After making a plain beurre blanc, whisk in some miso paste to
make miso beurre blanc. Or, try adding saffron threads to the
reduction to make Saffron beurre blanc. Other good flavourings
to add include Pernod and chervil; lime and basil; tomato and
thyme, or simply add some tapenade paste.

Serves: 6–8; makes: 400ml
50ml (3½ tbsps) white wine vinegar
50g (1¾oz) sliced shallot
1 sprig of fresh thyme
4 crushed white peppercorns
50ml (3½ tbsps) cream
225g (8oz) diced chilled butter
salt, freshly ground pepper
lemon juice

Place the white wine vinegar, shallots, thyme and crushed
peppercorns in a saucepan, and reduce by about four-fifths to
a glaze.
Add the cream and bring to the boil, then reduce the heat.
Whisk in the diced butter, piece by piece, until it is fully
incorporated. Remove from the heat and season to taste with
salt, freshly ground pepper and lemon juice.
Pass the sauce through a fine sieve, and keep warm until
ready for use. Do not boil again as the sauce will split, and
don't allow it to cool too much as it will thicken as the butter
begins to solidify.
If the beurre blanc sauce should happen to split, take a clean
saucepan and in it, reduce 50ml (3½ tbsps) cream until it
starts to thicken. Slowly whisk the split beurre blanc into the
cream, bit by bit (just as if you were whisking in the butter),
allowing each addition to become fully incorporated before
adding the next.

BASIC VEGETABLES

When blanching vegetables, cook briefly in boiling, salted water, and transfer to iced water to refresh and to stop the cooking process.

It is important to use large quantities of boiling, salted water so that the temperature doesn't drop when the vegetables are added. It is also important to have plenty of iced water available for refreshing, so that the cooking process stops instantly.

For **Blanched Tomatoes** (see photos, below), use ripe vine-ripened or plum tomatoes. Remove the core, and mark a small cross on the opposite ends of each tomato with a paring knife.

Plunge the tomatoes into boiling water until you see the skin curl away from cross points.

Lift the tomatoes out of the water and plunge straight into a bowl of iced water, to prevent them from cooking any further and becoming soft.

Remove the skin. This will fall off easily.

TOMATO PETALS

Cut peeled blanched tomatoes into quarters and remove all the seeds. The quarters or 'petals' should be lightly seasoned and brushed with olive oil. Gently warm to serve as a garnish.

TOMATO DICE OR CONCASSÉ

Trim all four sides of the tomato petals so that you are left with an even, rectangular shape. Slice this into even-sized strips lengthways and then cut across into even-sized pieces. If you are adding tomato dice to a hot sauce, do it at the last minute so that the tomato doesn't become mushy, and discolour the sauce.

If using as a garnish for a salad or cold entrée, lightly dress the dice with a little extra virgin olive oil, and season to taste with salt and freshly ground pepper.

OLIVE PETALS

To make petals, slice three equal sides off the olive, into even sized, neat discs. We sometimes keep the remaining flesh and stones to infuse into a lamb sauce which is served with Roast Lamb and Ratatouille, or grilled vegetables.

TAPENADE

Tapenade is very simple to make and will keep in the fridge. I like using it in sauces such as the **Tapenade Beurre Blanc** for the **Tuna Niçoise** on pages 168–169, or spoon a little into a lamb jus. A dish we often serve at *Banc* is Roast Rump of Lamb with Grilled Vegetables and Olive Jus.

Makes: 320g (12oz)
250g (9oz) pitted, ripe black olives
25g (1oz) drained anchovy fillets
40g (1½ oz) capers
1 clove garlic, crushed
15–20ml (3–4 tsps) extra virgin olive oil
5g (1 tsp) fresh parsley, chopped
Freshly ground black pepper

In a food processor, purée the olives, anchovies, capers and garlic until they form a smooth paste — this should take about 4 minutes.

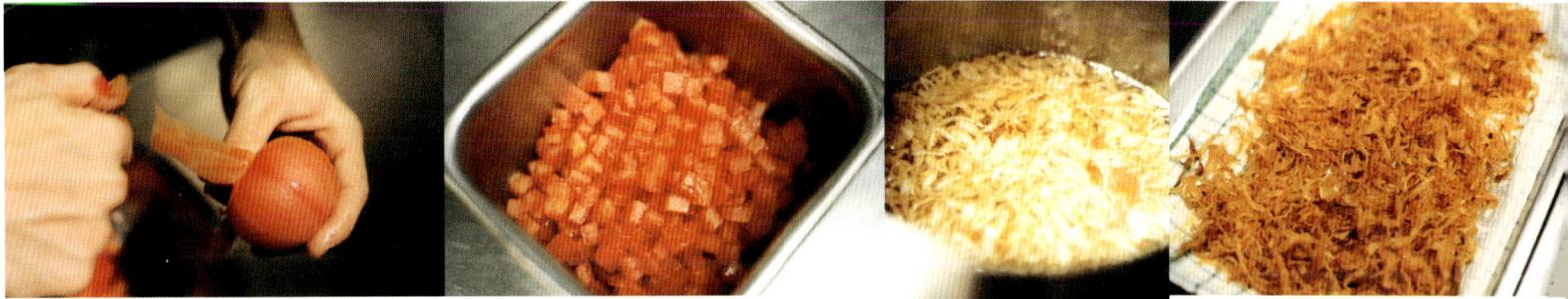

Above, from left: Peeling blanched tomatoes; tomato dice or concassé can be added to a sauce or used as a garnish; deep frying shallots; the crisp, chewy texture of deep-fried shallots makes them an ideal accompaniment to *Banc*'s Veal Zurichoise.

While the processor is still running, add the olive oil. The tapenade texture should be a firm rather than runny paste. Remove from the food processor and season with freshly ground pepper.

Store in a clean, air-tight jar in the fridge. It will keep for around 2–3 months. Spoon out as needed, and add a little fresh chopped parsley to taste.

DEEP-FRIED SHALLOTS

I use deep-fried shallots a lot. I love their crisp, chewy texture. They are ideal sprinkled over **Veal Zurichoise** (pages 176–177) or through salads.

Serves: 4
4 sliced shallots
1 litre (1¾ pints) vegetable oil
salt, freshly ground pepper

Heat oil to 160°C (320°F).
Add the shallots. Stirring frequently, cook until they are crisp and golden brown.
Lift the shallots out of the pan with a slotted spoon, and place on kitchen paper to soak up any excess oil.
Season to taste with salt and freshly ground pepper.
When the oil has cooled, pass it through a sieve and use again.

CREAMED SPINACH

It is amazing how much fresh spinach you need to make a comparatively small cooked dish. Once you have removed the spinach leaves from the stalks, you will be left with 65 per cent stalk and 35 per cent leaf. After you blanch and squeeze the spinach, you will be left with about 15 per cent of your original quantity.

Serves: 4; makes: 250g (9oz)
1½kg (3lb 5oz) fresh spinach
1 diced shallot
1 clove of garlic
140ml (½ cup) cream
20g (¾oz) butter
salt, freshly ground pepper

Pick the spinach, discarding all the stalks, then wash spinach in several changes of cold water to remove any grit or sand.
Blanch spinach, cooking for 1 minute in boiling, salted water, then plunging into iced water to refresh. Remove from iced water and squeeze dry. Chop spinach very finely.
Place the cream in a saucepan with the clove of garlic, reduce by two-thirds, remove the garlic.
Melt the butter in a saucepan. Add the shallots and sweat until softened. Do not allow shallots to brown. Remove the shallots from the saucepan.
To serve, heat the cream in a saucepan, add the chopped spinach and shallot, and warm through. Season to taste.

SAUTERNES JELLY

This jelly takes a bit of effort, but is well worth the trouble. You will notice we make a double stock and then clarify it. This results in a very rich and intense-flavoured jelly, made without using gelatine to set it.

You can flavour the jelly with madeira rather than sauternes if you wish, but I think the sweetness of sauternes marries well with the flavour of the **Duck Liver Parfait** (see pages 158–159). It isn't really possible to make this jelly in smaller quantities than I have described, so if you find it too much, I suggest melting the excess jelly back down to liquid. This can be served as a beautiful, clear broth. Before serving, check seasoning, if it tastes too strong, thin with a little clear chicken stock or water. When storing the jelly in the fridge, once it is cold, wrap it very tightly in several layers of cling wrap to prevent it absorbing any smells or flavours from other items.

Makes: 1 litre of jelly

4kg (8½lb) duck or chicken bones
50ml (3½ tsps) vegetable oil
12 button mushroom stalks
6 sliced shallots
1½ sliced onions
1 sprig fresh thyme
4 litres (7 pints) chicken stock
300ml (10 fl oz) sauternes wine
TO CLARIFY THE JELLY
400g (14oz) duck or chicken mince
10g (2 tsps) julienne of carrot
5g (1 tsp) julienne of leek
5g (1 tsp) julienne of celery
2 button mushrooms, sliced
250ml (1 cup) fresh egg whites
salt, freshly ground pepper

Remove any excess fat from the bones and chop them into 3cm-sized (1in-sized) pieces.

Heat half the oil in a large, heavy-based frying pan and add the bones. Over a medium heat, cook until they are evenly roasted and golden brown in colour. Drain them in a colander. Place the pan back on the stove and add the remaining oil and the vegetables, and roast in the same manner. Add to the colander of bones and strain.

Place half the roasted bones and vegetables in a saucepan. Add the thyme, and pour in the chicken stock. Bring to the boil, then reduce the heat and simmer the stock for 1½ hours. Skim the top frequently to remove any scum.

Pass the stock through a very fine sieve. Discard the bones and vegetables. Allow the stock to cool, during which time a thin layer of fat will come to the top. Skim this off.

In a clean saucepan, add the remaining bones and vegetables. Pour the first batch of stock you made over them. Bring to the boil, then reduce heat and simmer for 1½ hours. Skim the top frequently to remove scum.

Again, pass the stock through a very fine sieve discarding the bones and vegetables. Allow to cool, again skimming off the thin layer of fat that forms.

Reduce the sauternes wine to a syrupy consistency.

TO CLARIFY THE STOCK Place mince in a bowl, add all the other ingredients and season with a pinch of salt and a little freshly ground pepper. Mix ingredients well using a wooden spoon. Pour the cold stock and the sauternes reduction into a clean saucepan. Add the mince mixture to the pan and whisk hard, so that it is evenly spread through the stock.

Bring to the boil, stirring frequently to prevent sticking at the bottom or around the sides of the pan.

You will notice the mince, egg and vegetables will all come to the surface, bringing all the impurities from the stock with them. The stock will be left as clear as water.

At this stage, cease stirring the stock. If you touch the crust on the top, you will notice it is still quite wet. Continue to simmer the stock on a low heat for 30–45 minutes, so that the crust firms up.

Break a small hole in the crust, and carefully ladle the stock out and pass it through a sieve lined with muslin or coffee filter paper.

Set the jelly in the fridge, and chop it finely, on a very clean chopping board, when ready for use.

CHEF'S NOTE When we trim duck or chicken carcasses, we save all the fat and render it down in a saucepan, over a gentle heat. This is used for cooking our **Duck Confit** (see pages 178–179), or as a fat in which to seal and flavour other meats.

CRUSTACEAN OIL

This is another time-consuming recipe, but well worth the effort. We use Crustacean Oil as a sauce with our dish of **Pan-fried Fillet of Salmon with Yabby Tails** (see pages 166–167), or as a dressing with several different seafood dishes.

The crustacean oil will last, unopened, in the fridge for several months. I find the longer you leave it, the more intense the flavour and colour become.

Above, left: Clarifying the Sauternes Jelly.

Above, centre: Roasting prawn shells for Crustacean Oil.

Above, right: Well worth the effort —the finished product, a jar of Crustacean Oil.

Ask your fishmonger for crustacean shells, or save your own in the freezer until you have enough to make a batch of the oil.

Makes:1 litre

700g (1½lb) prawn, lobster or yabby shells, or a mix of all three

25ml (5 tsps) vegetable oil

100g (3½ oz) tomato paste

2 garlic cloves

2 star anise

2 red chillies, split with stalks and seeds removed

12 crushed white peppercorns

2 sprigs fresh thyme

2 sprigs fresh tarragon

2 dried bay leaves

12 crushed coriander seeds

salt

1 litre olive oil

Pre-heat the oven to 130°C (270°F).

Pour 50ml (3½ tbsps) of the olive oil into a large roasting tray, and add the shells. Place in the oven and cook slowly until the shells have become dry and brittle. Stir shells frequently to avoid burning. This will take between 1½ to 2 hours.

Add the tomato paste and stir well into the shells so that they are evenly coated. Return to the oven and continue to roast, stirring from time to time, for another 15 minutes. Remove from the oven.

Add the garlic, star anise, chillies, peppercorns, coriander seeds, herbs and a pinch of salt. Mix through the roasted shells.

Spoon the mix into a sterilised Kilner jar, and pour olive oil in to the top of the jar.

Put the jar into a large cooking pot, wedging some aluminium foil or a tea-towel around it to prevent it from moving or knocking the sides of the pot. Pour in enough water to reach the top of the jar (but do not cover it).

Bring the water to the boil. Reduce the heat and simmer for 45 minutes. Top the pot up with more water if needed.

Carefully remove the jar from the water and allow it to cool down before placing it in the fridge. The longer it stands in the fridge before opening, the more intense the flavour and colour will become.

When ready to use, pass the oil through a double layer of muslin cloth, or a coffee filter paper.

PESTO

When making pesto I like to add some rocket leaves to it. I find the rocket gives a deeper colour and an added nutty and peppery flavour to the pesto.

We have many uses for pesto at *Banc* — we use it for the **Pesto Potatoes** served with the **Tuna Niçoise**, the **Goat's Cheese Pesto** for the **Tomato Terrine**, Pesto Noodles, Pesto-flavoured Spaetzli, and for a quick staff meal of some pasta with a few spoonfuls of pesto through it.

Makes: 500ml (17 fl oz or 2 cups)

100g (3½oz) picked basil leaves

30g (1oz) picked rocket leaves

15g (½oz) grated parmesan cheese

25g (1oz) roasted pine nuts

2 cloves garlic, chopped

350ml (12 fl oz) extra virgin olive oil

15ml (3 tsps) fresh lemon juice

freshly ground pepper

Place the pine nuts, garlic, and parmesan into a blender. Blend until you have a smooth paste. Add 50ml (3 tbsps) of oil and the basil and rocket. Add the remaining oil and continue to blend until it is smooth. Season to taste with freshly ground pepper. Store in the fridge in an air-tight jar.

PESTO OIL

Make the pesto as described above. Line a sieve with muslin, and place over a bowl. Pour the pesto into the sieve and stand in the fridge for 4 hours to allow the oil to drain through. Use the residual pulp for **Pesto Potatoes** (see page 168–169).

TRUFFLE DRESSING

This is a great, but perhaps a little extravagant vinaigrette, that I use on so many dishes. It's fantastic with the **Tartare of Beef** (pages 162–163) and **Beef Carpaccio** (see Beef Rossini, page 174), or served with **Duck Liver Parfait** (pages 158–159) and some sautéed mushrooms. It also gives a whole new taste to the **Warm Potato and Shallot Salad** served with the **Crisp Duck Confit** (pages 180–181). You can also, simply serve it on salad greens such as mâche or rocket or drizzle it over warm asparagus spears or freshly roasted potatoes.

You can make this vinaigrette without the chopped truffles and their juice, just add a little more truffle oil instead. I suggest you always add the truffle oil last, tasting as you go, as it has a very strong flavour. The balsamic vinegar gives the dressing its sweetness, so add a little more or a little less depending on your preference.

Kept in the fridge, the dressing will solidify. Bring back to liquid by standing the container in warm water for 30 seconds.

Makes: 500ml (17 fl oz)

150ml (5 fl oz) veal stock

125ml (4 fl oz) extra virgin olive oil

125ml (4 fl oz) balsamic vinegar

75ml (2½ fl oz) truffle oil

25ml (5 tsps) truffle juice

20g (¾oz) chopped truffle

salt, freshly ground pepper

In a bowl, using a hand-held blender, blend the veal stock and olive oil together. If using truffle juice, blend at this stage. Add the balsamic vinegar and truffle oil to taste as explained above. If using chopped truffle, add to mixture.

Season to taste with salt and freshly ground pepper.

CRÈME ANGLAISE

Makes: 1¼ litres

1 litre (1¾ pint) milk

250g (9oz) sugar

12 egg yolks

1 vanilla pod, split

Bring the milk and vanilla pod to the boil in a heavy-based saucepan.

In a bowl, beat the egg yolks and sugar together, until they have doubled in volume.

Pour half the milk in to the egg yolk mix, and whisk together. Pour this mixture into the saucepan with the remaining milk and cream, and whisk.

Over a very low heat, cook the anglaise until it thickens, stirring continuously with a wooden spoon. Check by running your finger across the back of the spoon, the anglaise is ready when it holds to the spoon.

Remove from the heat and pass through a fine sieve into a clean bowl. Set the bowl over another filled with ice, to cool the mixture down as quickly as possible. Stir from time to time, to prevent a skin forming.

SUGAR SYRUP

Makes: 800ml (26 fl oz)

450g (1lb) caster sugar

390ml (13 fl oz) water

50ml (3½ tbsps) glucose

Mix sugar, water and glucose together in a heavy-based pan. Place on a medium heat, and whisk until sugar has dissolved. Bring to the boil, and allow to boil for 30 seconds. Pass through a fine sieve.

To make lime syrup, just add the zest from a lime as you cook.

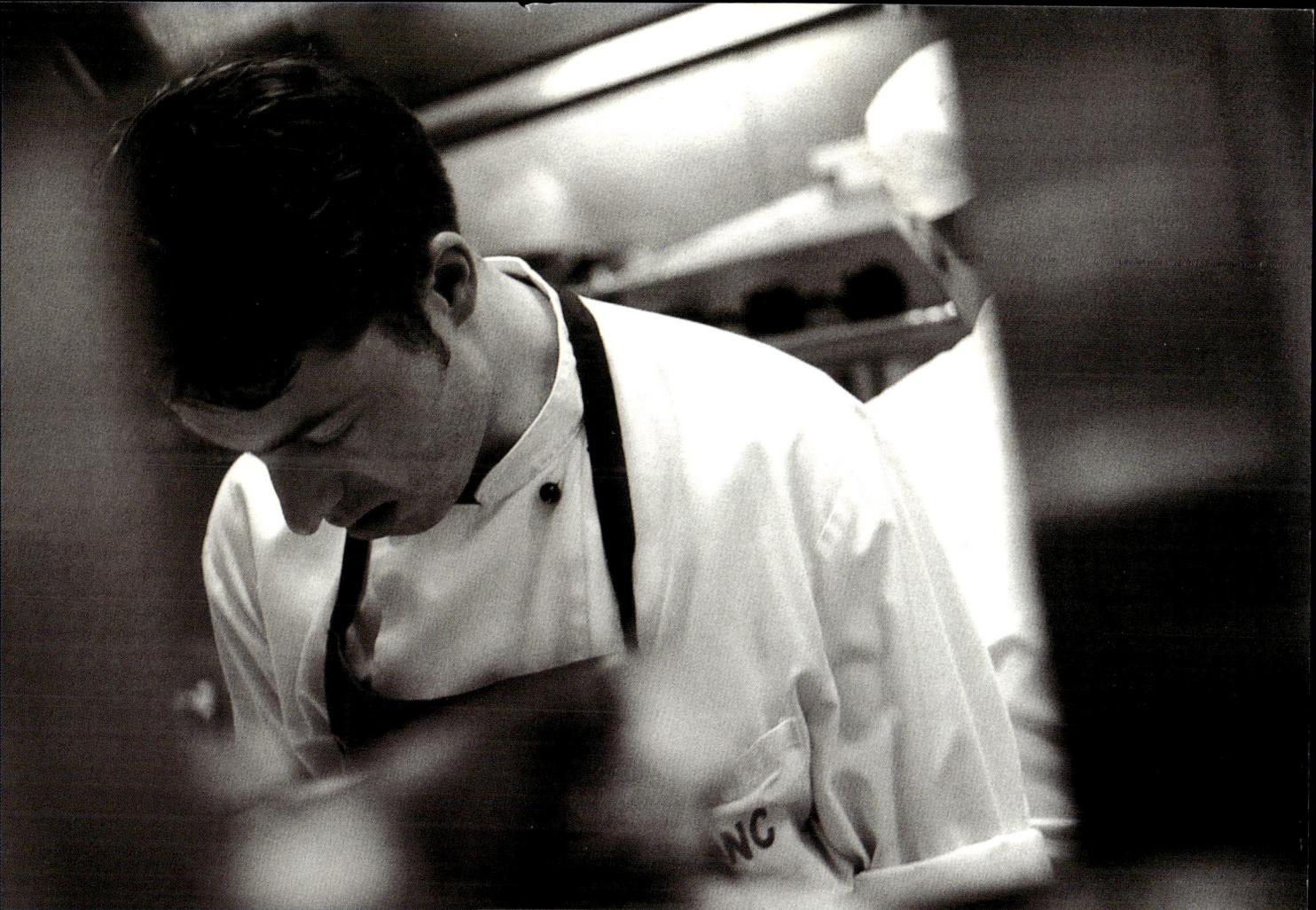

GLOSSARY

Amuse gueule A small appetiser served before a meal. It could be a small canape or a little taste of soup.

Baste To keep poultry, game or fish moist, or to add flavour during cooking, by spooning over the pan juices or fat.

Beignet Traditionally made from choux pastry as a sweet rather than a savoury, these are light, crisp, golden brown pieces of batter which, after frying and draining, are dusted with sugar.

Blanch To briefly immerse food in boiling water to rapidly cook while still preserving the colour, texture and flavour. Always refresh straight after blanching to stop the cooking process. Some foods such as bacon are blanched to reduce their salt content, others can be blanched in hot oil.

Brandade A dish from Provence, normally made from salt cod purée, milk, olive oil, garlic, lemon juice, seasoning and some diced potato.

Braise Braising is best suited to whole joints of meat or whole birds, sitting on a bed of vegetables and covered with the appropriate stock. Cover with a lid and cook very slowly in the oven on a low temperature. The meat should be basted with the stock. Once cooked, the stock can be passed off, reduced and served as a sauce for the meat.

Canapé [bite]-sized, savoury delicacies served with pre-dinner drinks at cocktail parties (see page 188–189)

Caramelise To cook food in such a way that it releases its sugars, which continue to cook until they are a golden brown, caramel colour. Some desserts are dusted with sugar and caramelised under the grill, or with a blow torch.

Caul A fatty membrane from the stomach of an animal. Pork caul is the most common, and is used for enclosing stuffings. As it cooks, it renders down, keeping food moist and full of flavour.

Clarify To remove any solids from a stock by cooking it over heat with egg white, lean mince meat and vegetables added to it. The cooking should continue until the egg white, meat and vegetables rise to the top, forming a crust. This brings all the solids and impurities in the stock to the top as well, leaving it crystal clear when the crust is removed.

Clarified butter Slowly melt butter to cause the milky solids to separate from the fat. The fat is passed off and the solids discarded. Clarified butter can be heated to much higher temperatures than whole butter, before burning.

Confit To preserve or conserve. The process of making confit involves cooking meat in its own fat, or fruit and vegetables in their own juices, and storing them in the fat or juices.

Consommé A stock made with meat, game, poultry, fish or vegetables that has been cooked, and clarified, which results in a clear, concentrated soup.

Dice To cut into small cubes.

Dariole Mould Small, cylinder-shaped moulds used for making such dishes as crème caramel or jellies.

Foie Gras The livers of force-fed geese.

Infuse To extract flavour from ingredients such as herbs and spices by steeping them in liquid which is normally hot.

Julienne This normally describes vegetable which have been cut into very thin strips, the length of a matchstick.

Lardon A thin strip of pork or bacon. They are sometimes inserted into cuts of meat to keep them moist and to add flavour, or sautéed and served with salads or braised meats.

Mirepoix Coarsely chopped vegetables used for stocks and sauce-making. Mirepoix normally consists of carrot, celery, leek and onion. White mirepoix is made without the carrot.

Muslin A very fine cloth used to strain impurities from stock and sauces. Use coffee filters if muslin is unavailable.

Nage Literally it means swim in French. In the culinary sense it refers to shellfish that are gently poached and served in a very light stock or broth.

Pass To ladle liquid through a very fine sieve in order to remove any solids and to leave it clear.

Petits Fours Bite-size sweetmeats, made with various ingredients. Usually served with coffee after the meal.

Pick To sort through salad leaves and herbs to remove any damaged or discoloured leaves. Also to remove the leaves and herbs from their stalks.

Quenelle To form a shape with mousse, vegetable purée or soft cheese. Use two teaspoons or dessert spoons depending on the size you require. Dip the spoons in warm water. Fill the first spoon with the ingredients, and then transfer back and forth from each spoon until a nicely rounded shape is formed.

Reduce To boil a liquid over a high heat to reduce the quantity and to concentrate the flavour. Different recipes will call for different amounts of reduction to achieve the strength and consistency required.

Refresh To plunge blanched vegetables or pasta into iced water to stop the cooking process and to preserve their flavour, texture and colour. Once refreshed, the vegetables or pasta should be briefly re-heated before serving.

Ribbon stage To beat cream, eggs or sugar to the stage where, when the whisk is lifted out, the mixture forms small peaks which hold their shape for a few moments.

Seal/sear Method to brown meat, poultry, game or fish in a little oil or butter in a very hot pan or roasting tray before finishing cooking. This prevents juices from running, colours the food nicely, and reduces cooking time.

Season To add flavour to food with salt, pepper, herbs, spices, citrus juices, vinegar, flavoured oils, etc.

Skim To remove with a ladle any scum that rises to the top of stocks or sauces. If stocks and sauces are not skimmed, the proteins and starches released from the bones and vegetables will boil back into the stock, leaving them cloudy and discoloured.

Sweat To cook vegetables in fat over a low heat, without allowing them to colour, so that they release their juices and flavour and become very tender.

Terrine A china, earthenware or cast-iron dish used for moulding and cooking a mixture of ingredients such as those in **Duck Liver Parfait** (pages 158–159).

Turned Using a turning knife or small paring knife, trim vegetables into an even- sized, barrel shape.

Veloute Used to describe certain soups which have a velvety texture.

Vichyssoise Classic soup made of purée of leeks and potatoes, finished with cream. Usually served chilled.

Zest The peel of citrus fruit. Before using, make sure all the pith is removed as this has a very bitter flavour.

INDEX